REA's Books Are

They have rescued lots of g~~rades and more!~~

(a sample of the <u>hundreds of letters</u> REA receives each year)

"Your books are great! They are very helpful, and have upped my grade in every class. Thank you for such a great product."

Student, Seattle, WA

"Your book has really helped me sharpen my skills and improve my weak areas. Definitely will buy more."

Student, Buffalo, NY

"Compared to the other books that my fellow students had, your book was the most useful in helping me get a great score."

Student, North Hollywood, CA

"I really appreciate the help from your excellent book. Please keep up your great work."

Student, Albuquerque, NM

"Your book was such a better value and was so much more complete than anything your competition has produced (and I have them all)!"

Teacher, Virginia Beach, VA

(more on next page)

(continued from previous page)

"Your books have saved my GPA, and quite possibly my sanity. My course grade is now an 'A', and I couldn't be happier."

Student, Winchester, IN

"These books are the best review books on the market. They are fantastic!"

Student, New Orleans, LA

"Your book was responsible for my success on the exam. . . I will look for REA the next time I need help."

Student, Chesterfield, MO

"I think it is the greatest study guide I have ever used!"

Student, Anchorage, AK

"I encourage others to buy REA because of their superiority. Please continue to produce the best quality books on the market."

Student, San Jose, CA

"Just a short note to say thanks for the great support your book gave me in helping me pass the test . . . I'm on my way to a B.S. degree because of you!"

Student, Orlando, FL

Super Review™

All You Need to Know!

HISTORY OF GREEK ART

Painting, Architecture & Sculpture

F. B. Tarbell, Ph.D.
Professor of Classical Archeology

**and the staff of
Research & Education Association
Carl Fuchs, Chief Editor**

Research & Education Association
61 Ethel Road West
Piscataway, New Jersey 08854

Dr. M. Fogiel, Director

SUPER REVIEW™
OF HISTORY OF GREEK ART

Printed in the United States of America

Library of Congress Control Number 2001090049

International Standard Book Number 0-87891-382-3

SUPER REVIEW is a trademark of Research & Education Association, Piscataway, New Jersey 08854

WHAT THIS Super Review WILL DO FOR YOU

This Super Review provides all that you need to know to do your homework effectively and succeed on exams and quizzes.

The book focuses on the core aspects of the subject, and helps you to grasp the important elements quickly and easily.

Outstanding Super Review features:

• Topics are covered in logical sequence

• Topics are reviewed in a concise and comprehensive manner

• The material is presented in student-friendly language that makes it easy to follow and understand

• Individual topics can be easily located

• Provides excellent preparation for midterms, finals and in-between quizzes

• Written by professionals and experts who function as your very own tutors

Written in the conviction that the greatest of all motives for studying art, is the desire to become acquainted with beautiful and noble things – the things that "soothe the cares and lift the thoughts of man." The historical method of treatment has been adopted as a matter of course, but the emphasis is not laid upon the historical aspects of the subject. The chief aim has been to present characteristic specimens of the finest Greek work that has been preserved to us, and to suggest how they may be intelligently enjoyed.

Dr. Max Fogiel
Program Director

Carl Fuchs
Chief Editor

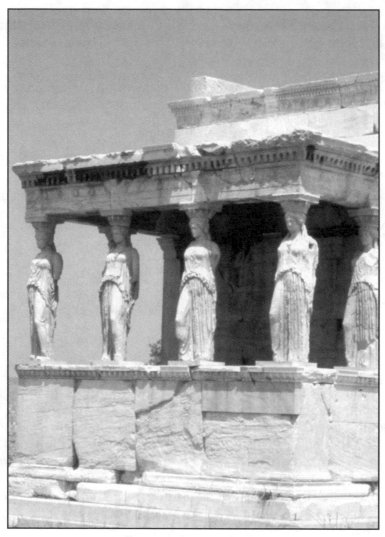

ERECTHEUM. ACROPOLIS, ATHENS.

CONTENTS.

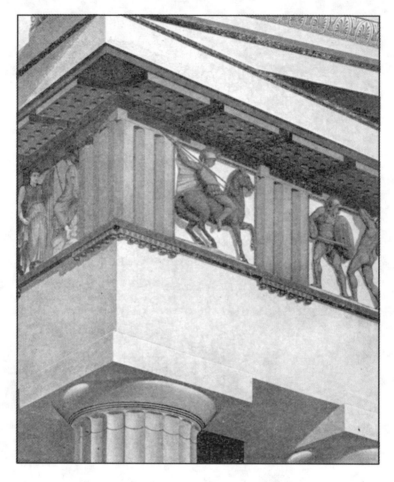

Northwest Corner of the Parthenon, Restored.

ILLUSTRATIONS.

Northwest Corner of the Parthenon, Restored . . *Frontispiece.*

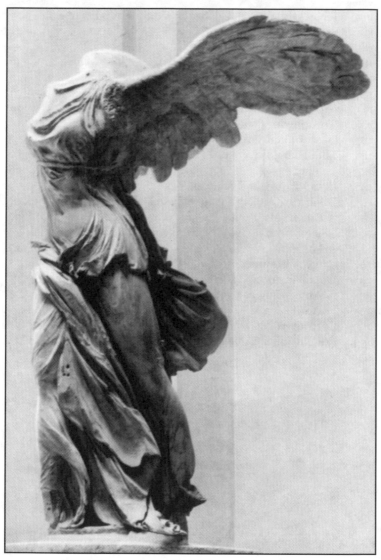

NIKE OF SAMOTHRACE. C. 200–190 B.C. THE LOUVRE, PARIS.

CHAPTER 1

Art in Egypt and Mesopotamia

THE history of Egypt, from the time of the earliest extant monuments to the absorption of the country in the Roman Empire, covers a space of some thousands of years. This long period was not one of stagnation. It is only in proportion to our ignorance that life in ancient Egypt seems to have been on one dull, dead level. Dynasties rose and fell. Foreign invaders occupied the land and were expelled again. Customs, costumes, beliefs, institutions, underwent changes. Of course, then, art did not remain stationary. On the contrary, it had marked vicissitudes, now displaying great freshness and vigor, now uninspired and monotonous, now seemingly dead, and now reviving to new activity. In Babylonia we deal with perhaps even remoter periods of time, but the artistic remains at present known from that quarter are comparatively scanty. From Assyria, however, the daughter of Babylonia, materials abound, and the history of that country can be written in detail for a period of several centuries. Naturally, then, even a mere sketch of Egyptian, Babylonian, and Assyrian art would require much more space than is here at disposal. All that can be attempted is to present a few examples and suggest a few general notions. The main purpose will be to make clearer by comparison and con-

trast the essential qualities of Greek art, to which this volume is devoted.

I begin with Egypt, and offer at the outset a table of the most important periods of Egyptian history. The dates are taken from the sketch prefixed to the catalogue of Egyptian antiquities in the Berlin Museum. In using them the reader must bear in mind that the earlier Egyptian chronology is highly uncertain. Thus the date here suggested for the Old Kingdom, while it cannot be too early, may be a thousand years too late. As we come down, the margin of possible error grows less and less. The figures assigned to the New Kingdom are regarded as trustworthy within a century or two. But only when we reach the Saite dynasty do we get a really precise chronology.

Chief Periods of Egyptian History :

OLD KINGDOM, with capital at Memphis ; Dynasties 4-5 (3000–2155 B. C. or earlier) and Dynasty 6.

MIDDLE KINGDOM, with capital at Thebes ; Dynasties 11-13 (2134–1785 B. C. or earlier).

NEW KINGDOM, with capital at Thebes ; Dynasties 17-20 (1500–1162 B. C.).

SAITE PERIOD ; Dynasty 26 (663–525 B. C.).

One of the earliest Egyptian sculptures now existing, though certainly not earlier than the Fourth Dynasty, is the great Sphinx of Gizeh (c. 2500 B.C.) (Fig.1). The creature crouches in the desert, a few miles to the north of the ancient Memphis, just across the Nile from the modern city of Cairo. With the body of a lion and the head of a man, it represented a solar deity and was an object of worship. It is hewn from the living rock and is of colossal size, the height from the base to the top of the head

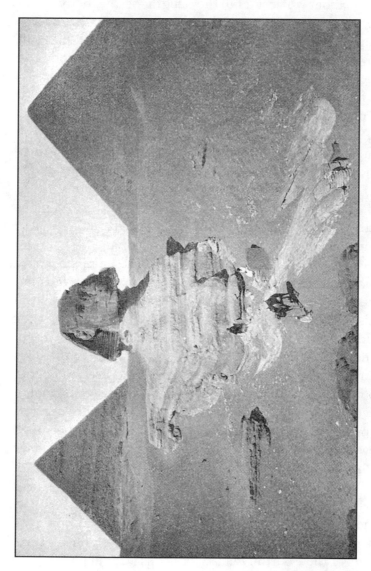

Fig 1 — The Great Sphinx and the Pyramids of Cheops and Chephren. Gizeh.

being about 70 feet and the length of the body about 150 feet. The paws and breast were originally covered with a limestone facing. The present dilapidated condition of the monument is due partly to the tooth of time, but still more to wanton mutilation at the hands of fanatical Mohammedans. The body is now almost shapeless. The nose, the beard, and the lower part of the head-dress are gone. The face is seamed with scars. Yet the strange monster still preserves a mysterious dignity, as though it were guardian of all the secrets of ancient Egypt, but disdained to betray them.

"The art which conceived and carved this prodigious statue," says Professor Maspero,* "was a finished art ; an art which had attained self-mastery, and was sure of its effects. How many centuries had it taken to arrive at this degree of maturity and perfection?" It is impossible to guess. The long process of self-schooling in artistic methods which must have preceded this work is hidden from us. We cannot trace the progress of Egyptian art from its timid, awkward beginnings to the days of its conscious power, as we shall find ourselves able to do in the case of Greek art. The evidence is annihilated, or is hidden beneath the sand of the desert, perhaps to be one day revealed. Should that day come, a new first chapter in the history of Egyptian art will have to be written.

There are several groups of pyramids, large and small, at Gizeh and elsewhere, almost all of which belong to the Old Kingdom. The three great pyramids of Gizeh are among the earliest. They were built by three kings of the Fourth Dynasty, Cheops (Chufu), Chephren (Chafre), and Mycerinus (Menkere). They are gigantic sepulchral monuments, in which the mummies of the

* "Manual of Egyptian Archæology," second edition, 1895, page 208.

kings who built them were deposited. The pyramid of
Cheops (c. 2530 B.C.) (Fig.1,on right),the largest of all,was
originally 481 feet 4 inches in height, and was thus
doubtless the loftiest structure ever reared in pre-
Christian times. The side of the square base measured
755 feet 8 inches. The pyramidal mass consists in the
main of blocks of limestone, and the exterior was origi-
nally cased with fine limestone, so that the surfaces were
perfectly smooth. At present the casing is gone, and
instead of a sharp point at the top there is a platform
about thirty feet square. In the heart of the mass was
the granite chamber where the king's mummy was laid.
It was reached by an ingenious system of passages,
strongly barricaded. Yet all these precautions were in-
effectual to save King Cheops from the hand of the
spoiler. Chephren's pyramid (c. 2500 B.C.) (Fig. 1, on left) is
not much smaller than that of Cheops, its present height
being about 450 feet, while the height of the third of this
group, that of Mycerinus, (c. 2470 B.C.) is about 210 feet.
No wonder that the pyramids came to be reckoned
among the seven wonders of the world.

While kings erected pyramids to serve as their tombs,
officials of high rank were buried in, or rather under,
structures of a different type, now commonly known
under the Arabic name of *mastabas*. The *mastaba* may
be described as a block of masonry of limestone or sun-
dried brick, oblong in plan, with the sides built "batter-
ing," *i. e.*, sloping inward, and with a flat top. It had
no architectural merits to speak of, and therefore need
not detain us. It is worth remarking, however, that
some of these *mastabas* contain genuine arches, formed
of unbaked bricks. The knowledge and use of the arch
in Egypt go back then to at least the period of the Old
Kingdom. But the chief interest of the *mastabas* lies in

the fact that they have preserved to us most of what we possess of early Egyptian sculpture. For in a small,

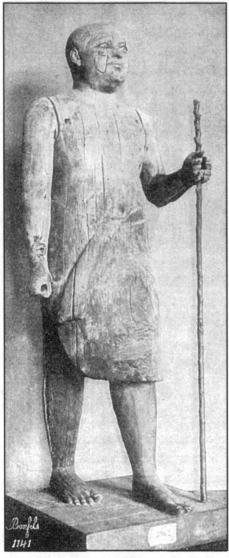

inaccessible chamber (*serdab*) reserved in the mass of masonry were placed one or more portrait statues of the owner, and often of his wife and other members of his household, while the walls of another and larger chamber, which served as a chapel for the celebration of funeral rites, were often covered with painted bas-reliefs, representing scenes from the owner's life or whatever in the way of funeral offering and human activity could minister to his happiness.

One of the best of the portrait statues of this period is the famous "Sheikh-el-Beled" (Chief of the Village), attrib-

FIG. 2.—THE "SHEIKH-EL-BELED." Gizeh Museum.

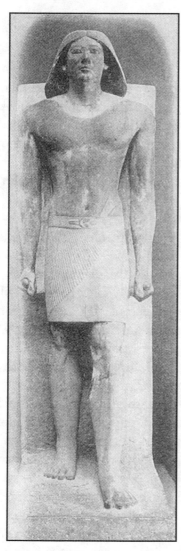

FIG. 3.—RA-ḤOFER. Gizeh Museum.

uted to the Fourth or Fifth Dynasty (Fig. 2). The name was given by the Arab workmen, who, when the figure was first brought to light in the cemetery of Sakkarah, thought they saw in it the likeness of their own sheikh. The man's real name, if he was the owner of the *mastaba* from whose *serdab* he was taken, was Ra-em-ka. The figure is less than life-sized, being a little over three and one half feet in height. It is of wood, a common material for sculpture in Egypt. The arms were made separately (the left of two pieces) and attached at the shoulders. The feet, which had decayed, have been restored. Originally the figure was covered with a coating of linen, and this with stucco, painted. "The eyeballs are of opaque white quartz, set in a bronze sheath, which forms the eyelids; in the center of each there is a bit of rock-crystal, and behind this a shining nail"*—a contrivance which produces a marvel-

*Musée de Gizeh : Notice Sommaire (1892),

ously realistic effect. The same thing, or something like it, is to be seen in other statues of the period. The attitude of Ra-em-ka is the usual one of Egyptian standing figures of all periods : the left leg is advanced ; both feet are planted flat on the ground ; body and head face squarely forward. The only deviation from the most usual type is in the left arm, which is bent at the elbow, that the hand may grasp the staff of office. More often the arms both hang at the sides, the hands clenched, as in the admirable limestone figure of the priest, Ra-nofer (Fig. 3).

The cross-legged scribe of the Louvre (Fig. 4) illustrates another and less stereotyped attitude. This figure was found in the tomb of one Sekhem-ka, along with two statues of the owner and a group of the owner, his wife, and son. The scribe was presumably in the employ of Sekhem-ka. The figure is of limestone, the commonest material for these sepulchral statues, and, according to the unvarying practice, was completely covered with color, still in good preservation. The flesh is of a reddish brown, the regular color for men. The eyes are similar to those of the Sheikh-el-Beled. The man is seated with his legs crossed under him ; a strip of papyrus, held by his left hand, rests upon his lap ; his right hand held a pen.

The head shown in Fig. 5 belongs to a group, if we may give that name to two figures carved from separate blocks of limestone and seated stiffly side by side. Egyptian sculpture in the round never created a genuine, integral group, in which two or more figures are so combined that no one is intelligible without the rest ; that achievement was reserved for the Greeks. The lady in this case was a princess ; her husband, by whom she sits, a high priest of Heliopolis. She is dressed in a long, white smock, in which there is no indication

of folds. On her head is a wig, from under which, in front, her own hair shows. Her flesh is yellow, the conventional tint for women, as brownish red was for men. Her eyes are made of glass.

The specimens given have been selected with the purpose of showing the sculpture of the Old Kingdom at its best. The all-important fact to notice is the realism of these portraits. We shall see that Greek sculpture throughout its great period tends toward the typical and the ideal in the human face and figure. Not so in Egypt. Here the task of the

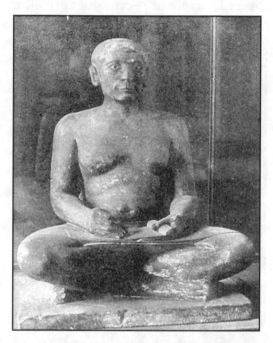

FIG. 4.—CROSS-LEGGED SCRIBE. Paris, Louvre.

artist was to make a counterfeit presentment of his subject and he has achieved his task at times with marvelous skill. Especially the heads of the best statues have an individuality and lifelikeness which have hardly been surpassed in any age. But let not our admiration blind us to the limitations of Egyptian art. The sculptor never attains to freedom in the posing of his figures. Whether the subject sits, stands, kneels, or squats, the body and head always face directly forward. And we

look in vain for any appreciation on the sculptor's part of the beauty of the athletic body or of the artistic possibilities of drapery.

There is more variety of pose in the painted bas-reliefs with which the walls of the *mastaba* chapels are covered. Here are scenes of agriculture, cattle-tending, fishing, bread-making, and so on, represented with admirable vivacity, though with certain fixed conventionalities of style. There are endless entertainment and instruction for us in these pictures of old Egyptian life. Yet no more here than in the portrait statues do we find a feeling for beauty of form or a poetic, idealizing touch.

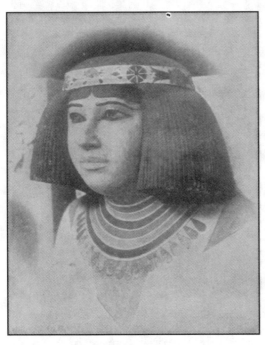

FIG. 5.—HEAD OF NEFERT. Gizeh Museum.

As from the Old Kingdom, so from the Middle Kingdom, almost the only works of man surviving to us are tombs and their contents. These tombs have no longer the simple *mastaba* form, but are either built up of sun-dried brick in the form of a block capped by a pyramid or are excavated in the rock. The former class offers little interest from the architectural point of view. But some

of the rock-cut tombs of Beni-hasan, belonging to the Twelfth Dynasty, exhibit a feature which calls for mention. These tombs have been so made as to leave pillars of the living rock standing, both at the entrance and in the chapel. The simplest of these pillars are square in plan and somewhat tapering. Others, by the chamfering off of their edges, have been made eight-sided. A repetition of the process gave sixteen-sided pillars. The sixteen sides were then hollowed out (channeled). The result is illustrated by Fig. 6. It will be observed that the pillar has a low, round base, with beveled edge ; also, at the top, a square abacus, which is simply a piece of the original four-sided pillar, left untouched. Such polygonal pillars as these are commonly called proto-Doric columns. The name was given in the belief that these were the models from which the Greeks derived their Doric columns, and this belief is still held by many authorities.

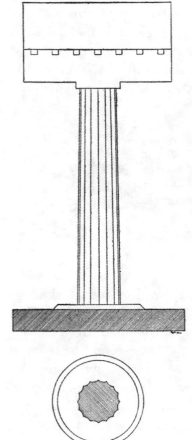

Fig. 6.—"Proto-Doric" Column. Beni-hasan.

With the New Empire we begin to have numerous and extensive remains of temples, while those of an earlier date have mostly disappeared. Fig. 7 may

afford some notion of what an Egyptian temple was like. This one is at Luxor, on the site of ancient Thebes in Upper Egypt. It is one of the largest of all, being over 800 feet in length. Like many others, it was not originally planned on its present scale, but represents two or three successive periods of construction, Ramses II., of the Nineteenth Dynasty, having given it its final form by adding to an already finished building all that now stands before the second pair of towers. As so extended, the building has three pylons, as they are

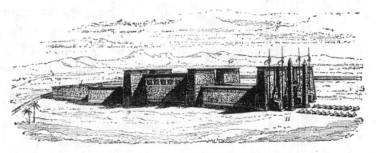

FIG. 7.—TEMPLE OF LUXOR, RESTORED.

called, pylon being the name for the pair of sloping-sided towers with gateway between. Behind the first pylon comes an open court surrounded by a cloister with double rows of columns. The second and third pylons are connected with one another by a covered passage—an exceptional feature. Then comes a second open court ; then a hypostyle hall, *i. e.*, a hall with flat roof supported by columns ; and finally, embedded in the midst of various chambers, the relatively small sanctuary, inaccessible to all save the king and the priests. Notice the double line of sphinxes flanking the avenue of approach, the two granite obelisks at the entrance, and the four colossal seated figures in granite representing Ramses II.—all characteristic features.

Fig. 8 is taken from a neighboring and still more gigantic temple, that of Karnak. Imagine an immense hall, 170 feet deep by 329 feet broad. Down the middle

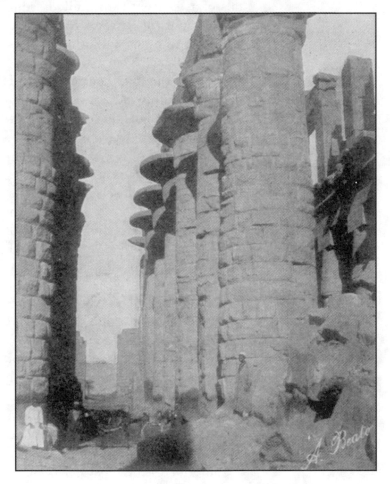

Fig. 8.—View through Hypostyle Hall. Karnak.

run two rows of six columns each (the nearest ones in the picture have been restored), nearly seventy feet high. They have campaniform (bell-shaped) capitals.

On either side are seven rows of shorter columns, somewhat more than forty feet high. These, as may be indistinctly seen at the right of our picture, have capitals of a different type, called, from their origin rather than from their actual appearance, lotiform or lotusbud capitals. There was a clerestory over the four central rows of columns, with windows in its walls. The general plan, therefore, of this hypostyle hall has some resemblance to that of a Christian basilica, but the columns are much more numerous and closely set. Walls and columns were covered with hieroglyphic texts and sculptured and painted scenes. The total effect of this colossal piece of architecture, even in its ruin, is one of overwhelming majesty. No other work of human hands strikes the beholder with such a sense of awe.

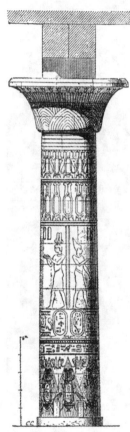

FIG. 9.—COLUMN OF HYPOSTYLE HALL. Karnak.

Fig. 9 is a restoration of one of the central columns of this hall. Except for one fault, say Messrs. Perrot and Chipiez,* "this column would be one of the most admirable creations of art; it would hardly be inferior to the most perfect columns of Greece." The one fault—a grave one to a critical eye—is the meaningless and inappropriate block inserted between the capital and

* " Histoire de l'Art : Égypte," page 576. The translation given above differs from that in the English edition of Perrot and Chipiez, " Art in Ancient Egypt," Vol. II., page 123.

the horizontal beam which it is the function of the column to support. The type of column used in the side aisles of the hall at Karnak is illustrated by Fig. 10, taken from another temple. It is much less admirable, the contraction of the capital toward the top producing an unpleasant effect.

Other specimens of these two types of column vary widely from those of Karnak, for Egyptian architects did not feel obliged, like Greek architects, to conform, with but slight liberty of deviation, to established canons of form and proportion. Nor are these two by any means the only forms of support used in the temple architecture of the New Kingdom. The "proto-Doric" column continued in favor under the New Kingdom, though apparently not later; we find it, for example, in some of the outlying buildings at Karnak. Then there was the column whose capital was adorned with four heads in relief of the goddess Hathor, not to speak of other varieties. Whatever the precise form of the support, it was always used to carry

FIG. 10.—COLUMN OF MEDINET HABU.

a horizontal beam. Although the Egyptians were familiar from very early times with the principle of the arch, and although examples of its use occur often enough under the New Kingdom, we do not find columns or piers used, as in Gothic architecture, to carry a vaulting. In fact, the genuine vault is absent from Egyptian temple architecture, although in the Temple of Abydos false or corbelled vaults (*cf.* page 49) do occur.

Egyptian architects were not gifted with a fine feeling for structural propriety or unity. A few of their small temples are simple and coherent in plan and fairly tasteful in details. But it is significant that a temple could always be enlarged by the addition of parts not contemplated in the original design. The result in such a case was a vast, rambling edifice, whose merits consisted in the imposing character of individual parts, rather than in an organic and symmetrical relation of parts to whole.

Statues of the New Kingdom are far more numerous than those of any other period, but few of them will compare in excellence with the best of those of the Old Kingdom. Colossal figures of kings abound, chiseled with infinite patience from granite and other obdurate rocks. All these and others may be passed over in order to make room for a statue in the Louvre (Fig. 11), which is chosen, not because of its artistic merits, but because of its material and its subject. It is of bronze, somewhat over three feet in height, thus being the largest Egyptian bronze statue known. It was cast in a single piece, except for the arms, which were cast separately and attached. The date of it is in dispute, one authority assigning it to the Eighteenth Dynasty and another bringing it down as late as the seventh century B. C. Be that as it may, the art of casting hollow

bronze figures is of high antiquity in Egypt. The figure represents a hawk-headed god, Horus, who once held up some object, probably a vase for libations. Egyptian divinities are often represented with the heads of animals—Anubis with the head of a jackal, Hathor with that of a cow, Sebek with that of a crocodile, and so on. This in itself shows a lack of nobility in the popular theology. Moreover it is clear that the best talents of sculptors were engaged upon portraits of kings and queens and other human beings, not upon figures of the gods. The latter exist by the thousand, to be sure, but they are generally small statuettes, a few inches high, in bronze, wood, or faïence. And even if sculptors had been encouraged to do their best in bodying forth the forms of gods, they would hardly have achieved high success. The exalted imagination was lacking.

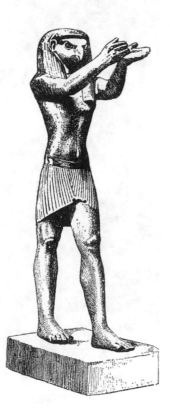

Among the innumerable painted bas-reliefs covering the walls of tombs and temples, those of the great Temple of Abydos in Upper Egypt hold a high place. One enthusiastic art critic has gone so far as to pronounce them "the most perfect, the most noble bas-reliefs ever chiseled." A specimen of this work, now, alas! more defaced than is here shown, is

FIG. 11.—BRONZE STATUE OF HORUS.
Paris, Louvre.

given in Fig. 12. King Seti I. of the Nineteenth Dynasty stands in an attitude of homage before a seated divinity,

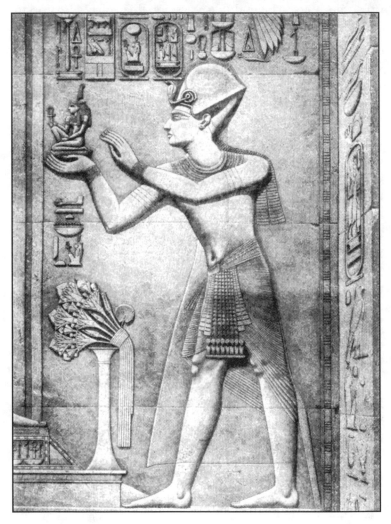

FIG. 12.—BAS-RELIEF. Abydos.

of whom almost nothing appears in the illustration. On the palm of his right hand he holds a figure of Maat,

goddess of truth. In front of him is a libation-standard, on which rests a bunch of lotus flowers, buds, and leaves. The first remark to be made about this work is that it is genuine relief. The forms are everywhere modeled, whereas in much of what is commonly called bas-relief in Egypt, the figures are only outlined and the spaces within the outlines are left flat. As regards the treatment of the human figure, we have here the stereotyped Egyptian conventions. The head, except the eye, is in profile, the shoulders in front view, the abdomen in three-quarters view, the legs again in profile. As a result of the distortion of the body, the arms are badly attached at the shoulders. Furthermore the hands, besides being very badly drawn, have in this instance the appearance of being mismated with the arms, while both feet look like right feet. The dress consists of the usual loin-cloth and of a thin, transparent over-garment, indicated only by a line in front and below. Now surely no one will maintain that these methods and others of like sort which there is no opportunity here to illustrate are the most artistic ever devised. Nevertheless serious technical faults and shortcomings may coexist with great merits of composition and expression. So it is in this relief of Seti. The design is stamped with unusual refinement and grace. The theme is hackneyed enough, but its treatment here raises it above the level of commonplace.

Egyptian bas-reliefs were always completely covered with paint, laid on in uniform tints. Paintings on a flat surface differ in no essential respect from these painted bas-reliefs. The conventional and untruthful methods of representing the human form, as well as other objects —buildings, landscapes, etc.—are the same in the former as in the latter. The coloring, too, is of the same

sort, there being no attempt to render gradations of color due to the play of light and shade. Fig. 13, a lute-player from a royal tomb of the Eighteenth Dynasty, illustrates some of these points. The reader who would form an idea of the composition of extensive scenes must consult works more especially devoted to Egyptian art. He will be rewarded with many a vivid picture of ancient Egyptian life.

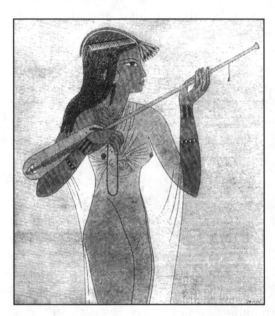

FIG. 13.—WALL-PAINTING. Thebes.

Art was at a low ebb in Egypt during the centuries of Libyan and Ethiopian domination which succeeded the New Kingdom. There was a revival under the Saite monarchy in the seventh and sixth centuries B. C. To this period is assigned a superb head of dark green stone (Fig. 14), currently residing in the Berlin Museum. It has been broken from a standing or kneeling statue. The form of the closely-shaven skull and the features of the strong face, wrinkled by age, have been reproduced by the sculptor with unsurpassable fidelity. The number of works emanating from the same school as this is very small,

but in quality they represent the highest development of Egyptian sculpture. It is fit that we should take our leave of Egyptian art with such a work as this before us, a work which gives us the quintessence of the artistic genius of the race.

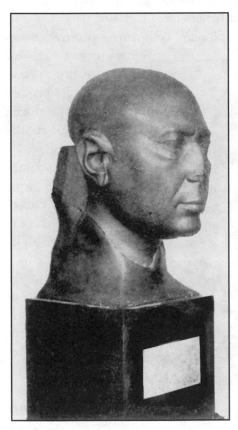

FIG. 14.—PORTRAIT HEAD. Berlin.

Babylonia was the seat of a civilization perhaps more hoary than that of Egypt. The known remains of Babylonian art, however, are at present far fewer than those of Egypt and will probably always be so. There being practically no stone in the country and wood being very scarce, buildings were constructed entirely of bricks, some of them merely sundried, others kiln-baked. The natural wells of bitumen supplied a tenacious mortar.* The ruins that have been explored at Tello, Nippur, and elsewhere, belong to city walls, houses, and temples. The most peculiar and conspicuous feature of

* Compare Genesis XI. 3: "And they had brick for stone, and slime had they for mortar."

the temple was a lofty rectangular tower of several stages, each stage smaller than the one below it. The arch was known and used in Babylonia from time immemorial. As for the ornamental details of buildings, we know very little about them, except that large use was made of enameled bricks.

The only early Babylonian sculptures of any consequence that we possess are a collection of broken reliefs and a dozen sculptures in the round, found in a group of mounds called Tello and now in the Louvre. The reliefs are extremely rude. The statues are much better and are therefore probably of later date; they are commonly assigned by students of Babylonian antiquities to about 3000 B. C. Fig. 15 reproduces one of them.

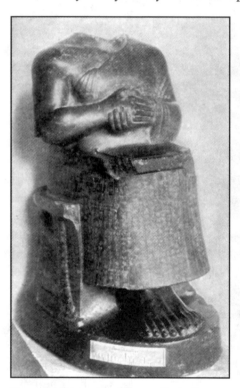

FIG. 15.—STATUE OF GUDEA. Paris, Louvre.

The material, as of the other statues found at the same place, is a dark and excessively hard igneous rock (dolerite). The person represented is one Gudea, the ruler of a small semi-independent principality. On his lap he has a tablet on which is engraved the plan of a fortress, very interest-

ing to the student of military antiquities. The forms of the body are surprisingly well given, even the knuckles of the fingers being indicated. As regards the drapery, it is noteworthy that an attempt has been made to ren-

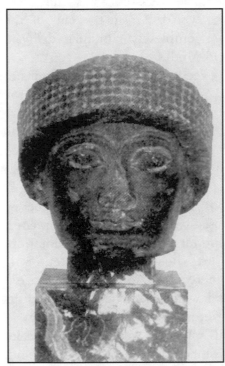

FIG. 16.—HEAD, FROM TELLO.
Museum of Fine Arts, Boston.

der folds on the right breast and the left arm. The skirt of the dress is covered with an inscription in cuneiform characters.

Fig. 16 belongs to the same group of sculptures as the seated figure just discussed. Although this head gives no such impression of lifelikeness as the best Egyptian portraits, it yet shows careful study. Cheeks, chin, and mouth are well rendered. The eyelids, though too wide open, are still good ; notice the inner corners. The eyebrows are less successful. Their general form is that of the half of a figure 8 bisected vertically, and the hairs are indicated by slanting lines arranged in herring-bone fashion. Altogether, the reader will probably feel more respect than enthusiasm for this early Babylonian art, and will have no keen regret that the specimens of it are so few.

The Assyrians were by origin one people with the Chaldeans and were therefore a branch of the great Semitic family. It is not until the ninth century B. C. that the great period of Assyrian history begins. Then for two and a half centuries Assyria was the great conquering power of the world. Near the end of the seventh century it was completely annihilated by a coalition of Babylonia and Media.

With an insignificant exception or two the remains of Assyrian buildings and sculptures all belong to the period of Assyrian greatness. The principal sites where explorations have been carried on are Koyunjik (Nineveh), Nimroud, and Khorsabad, and the ruins uncovered are chiefly those of royal palaces. These buildings were of enormous extent. The palace of Sennacherib at Nineveh, for example, covered more than twenty acres. Although the country possessed building stone in plenty, stone was not used except for superficial ornamentation, baked and unbaked bricks being the architect's sole reliance. This was a mere blind following of the example of Babylonia, from which Assyria derived all its culture. The palaces were probably only one story in height. Their principal splendor was in their interior decoration of painted stucco, enameled bricks, and, above all, painted reliefs in limestone or alabaster.

The great Assyrian bas-reliefs covered the lower portions of the walls of important rooms. Designed to enrich the royal palaces, they drew their principal themes from the occupations of the kings. We see the monarch offering sacrifice before a divinity, or, more often, engaged in his favorite pursuits of war and hunting. These extensive compositions cannot be adequately illustrated by two or three small pictures. The most that can be done is to show the sculptor's method

of treating single figures. Fig. 17 is a slab from the
earliest series we possess, that belonging to the palace of

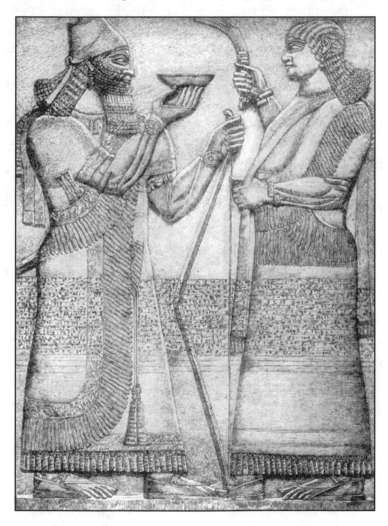

FIG. 17.—ASSYRIAN RELIEF. London, British Museum.

Asshur-nazir-pal (884—860 B. C.) at Nimroud. It
represents the king facing to right, with a bowl for

libation in his right hand and his bow in his left, while a eunuch stands fronting him. The artistic style exhibited here remains with no essential change throughout the whole history of Assyrian art. The figures are in profile, except that the king's further shoulder is thrown forward in much the fashion which we have found the rule in Egypt, and the eyes appear as in front view. Both king and attendant are enveloped in long robes, in which there is no indication of folds, though fringes and tassels are elaborately rendered. The faces are of a strongly marked Semitic cast, but without any

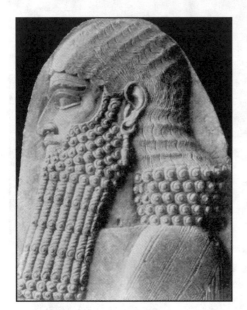

FIG. 18.—ASSYRIAN RELIEF. Paris, Louvre.

attempt at portraiture. The hair of the head ends in several rows of snail-shell curls, and the king's beard has rows of these curls alternating with more natural-looking portions. Little is displayed of the body except the fore-arms, whose anatomy, though intelligible, is coarse and false. As for minor matters, such as the too high position of the ears, and the unnatural shape of the king's right hand, it is needless to dwell upon them. A cuneiform inscription runs right across the relief, interrupted only by the fringes of the robes.

Fig. 18 shows more distinctly the characteristic

Assyrian method of representing the human head. Here are the same Semitic features, the eye in front view, and the strangely curled hair and beard. The only novelty is the incised line which marks the iris of the

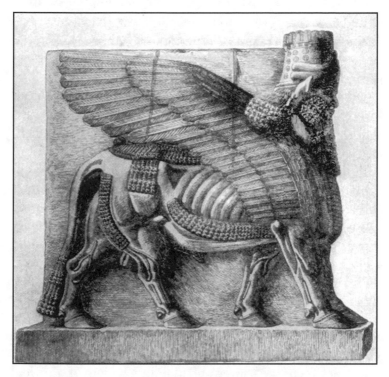

FIG. 19.—WINGED BULL. Paris, Louvre.

eye. This peculiarity is first observed in work of Sargon's time (722-705 B. C.).

A constant and striking feature of the Assyrian palaces was afforded by the great, winged, human-headed bulls, which flanked the principal doorways. The one herewith given (Fig. 19) is from Sargon's palace at Khorsabad. The peculiar methods of Assyrian

sculpture are not ill suited to this fantastic creature, an embodiment of force and intelligence. One special peculiarity will not escape the attentive observer. Like all his kind, except in Sennacherib's palace, this bull has five legs. He was designed to be looked at from directly in front or from the side, not from an intermediate point of view.

Assyrian art was not wholly without capacity for improvement. Under Asshur-bani-pal (668-626), the Sardanapalus of the Greeks, it reached a distinctly higher level than ever before. It is from his palace at Nineveh that the slab partially shown in Fig. 20 was obtained. Two demons, with human bodies, arms, and legs, but with lions' heads, asses' ears, and eagles' talons, confront one another angrily, brandishing daggers in their right hands. Mesopotamian art was fond of such creatures, but we do not know precisely what meaning was attached to the present scene. We need therefore consider only stylistic qualities. As the two demons wear only short skirts reaching from the waist to the knees, their bodies are more exposed than those of men usually are. We note the inaccurate anatomy of breast, abdomen, and back, in dealing with which the sculptor had little experience to guide him. A marked difference is made between the outer and the inner view of the leg, the former being treated in the same style as the arms in Fig. 17. The arms are here better, because less exaggerated. The junction of human shoulders and animal necks is managed with no sort of verisimilitude. But the heads, conventionalized though they are, are full of vigor. One can almost hear the angry snarl, and see the lightning flash from the eyes.

It is, in fact, in the rendering of animals that Assyrian art attains to its highest level. In Asshur-bani-pal's

palace extensive hunting scenes give occasion for intro-
ducing horses, dogs, wild asses, lions, and lionesses, and
these are portrayed with a keen eye for characteristic
forms and movements. One of the most famous of these

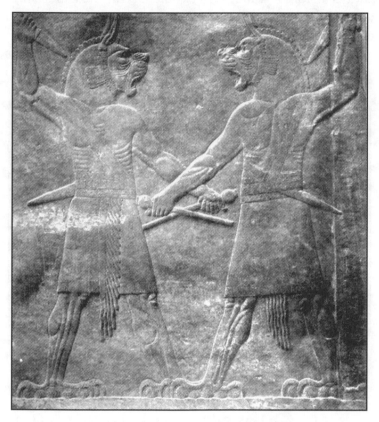

FIG. 20.—ASSYRIAN RELIEF. London, British Museum.

animal figures is the lioness shown in Fig. 21. The
creature has been shot through with three great arrows.
Blood gushes from her wounds. Her hind legs are
paralyzed and drag helplessly behind her. Yet she still
moves forward on her fore-feet and howls with rage and

agony. Praise of this admirable figure can hardly be too strong. This and others of equal merit redeem Assyrian art.

As has been already intimated, these bas-reliefs were always colored, though, it would seem, only partially, whereas Egyptian bas-reliefs were completely covered with color.

Of Assyrian stone sculpture in the round nothing has yet been said. A few pieces exist, but their style is so

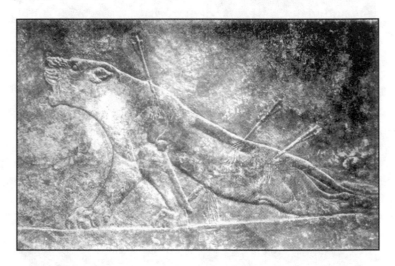

FIG. 21.—WOUNDED LIONESS. : London, British Museum.

essentially like that of the bas-reliefs that they call for no separate discussion. More interesting is the Assyrian work in bronze. The most important specimens of this are some hammered reliefs, now in the British Museum, which originally adorned a pair of wooden doors in the palace of Shalmaneser III. at Balawat. The art of casting statuettes and statues in bronze was also known and practiced, as it had been much earlier in Babylonia, but the examples preserved to us are few. For the decora-

tive use which the Assyrians made of color, our principal witnesses are their enameled bricks. These are ornamented with various designs—men, genii, animals, and floral patterns—in a few rich colors, chiefly blue and yellow. Of painting, except in the sense of mural decoration, there is no trace.

Egypt and Mesopotamia are, of all the countries around the Mediterranean, the only seats of an important, indigenous art, antedating that of Greece. Other countries of Western Asia—Syria, Phrygia, Phenicia, Persia, and so on—seem to have been rather recipients and transmitters than originators of artistic influences. For Egypt, Assyria, and the regions just named did not remain isolated from one another. On the contrary, intercourse both friendly and hostile was active, and artistic products, at least of the small and portable kind, were exchanged. The paths of communication were many, but there is reason for thinking that the Phenicians, the great trading nation of early times, were especially instrumental in disseminating artistic ideas. To these influences Greece was exposed before she had any great art of her own. Among the remains of prehistoric Greece we find, besides some objects of foreign manufacture, others, which, though presumably of native origin, are yet more or less directly inspired by Egyptian or oriental models. But when the true history of Greek art begins, say about 600 B. C., the influences from Egypt and Asia sink into insignificance. It may be that the impulse to represent gods and men in wood or stone was awakened in Greece by the example of older communities. It may be that one or two types of figures were suggested by foreign models. It may be that a hint was taken from Egypt for the form of the

Doric column and that the Ionic capital derives from an Assyrian prototype. It is almost certain that the art of casting hollow bronze statues was borrowed from Egypt. And it is indisputable that some ornamental patterns used in architecture and on pottery were rather appropriated than invented by Greece. There is no occasion for disguising or underrating this indebtedness of Greece to her elder neighbors. But, on the other hand, it is important not to exaggerate the debt. Greek art is essentially self-originated, the product of a unique, incommunicable genius. As well might one say that Greek literature is of Asiatic origin, because, after all, the Greek alphabet came from Phenicia, as call Greek art the offspring of Egyptian or oriental art because of the impulses received in the days of its beginning.*

* This comparison is perhaps not original with the present writer.

CHAPTER 2

Prehistoric Art in Greece

NOT so long ago it would have been impossible to write with any considerable knowledge of prehistoric art in Greece. The Iliad and Odyssey, to be sure, tell of numerous artistic objects, but no definite pictures of these were called up by the poet's words. Of actual remains only a few were known. Some implements of stone, the mighty walls of Tiryns, Mycenæ, and many another ancient citadel, four "treasuries," as they were often called, at Mycenæ and one at the Bœotian Orchomenus—these made up pretty nearly the total of the visible relics of that early time. To-day the case is far different. Thanks to the faith, the liberality, and the energy of Heinrich Schliemann, an immense impetus has been given to the study of prehistoric Greek archæology. His excavations at Troy, Mycenæ, Tiryns, and elsewhere aroused the world. He labored, and other men, better trained than he, have entered into his labors. The material for study is constantly accumulating, and constant progress is being made in classifying and interpreting this material. A civilization antedating the Homeric poems stands now dimly revealed to us. Mycenæ, the city "rich in gold," the residence of Agamemnon, whence he ruled over "many islands and all Argos,"* is seen to have had no merely legendary preeminence. So conspicuous, in fact, does Mycenæ appear in the light as well of archæology as of epic, that

* Iliad II., 108.

it has become common, somewhat misleading though it is, to call a whole epoch and a whole civilization "Mycenæan." This "Mycenæan" civilization was widely extended over the Greek islands and the eastern portions of continental Greece in the second millennium before our era. Exact dates are very risky, but it is reasonably safe to say that this civilization was in full development as early as the fifteenth century B. C., and that it was not wholly superseded till considerably later than 1000 B. C.

It is our present business to gain some acquaintance with this epoch on its artistic side. It will be readily understood that our knowledge of the long period in question is still very fragmentary, and that, in the absence of written records, our interpretation of the facts is hardly better than a groping in the dark. Fortunately we can afford, so far as the purposes of this book are concerned, to be content with a slight review. For it seems clear that the "Mycenæan" civilization developed little which can be called artistic in the highest sense of that term. The real history of Greek art—that is to say, of Greek architecture, sculpture, and painting —begins much later. Nevertheless it will repay us to get some notion, however slight, of such prehistoric Greek remains as can be included under the broadest acceptation of the word "art."

In such a survey it is usual to give a place to early walls of fortification, although these, to be sure, were almost purely utilitarian in their character. The classic example of these constructions is the citadel wall of Tiryns in Argolis. Fig. 22 shows a portion of this fortification on the east side, with the principal approach. Huge blocks of roughly dressed limestone—some of those in the lower courses estimated to weigh thirteen

or fourteen tons apiece—are piled one upon another, the interstices having been filled with clay and smaller stones. This wall is of varying thickness, averaging at the bottom about twenty-five feet. At two places, viz., at the south end and on the east side near the southeast corner, the thickness is increased, in order to give room in the wall for a row of store chambers with communicating gallery. Fig. 23 shows one of these galleries in its present condition. It will be seen

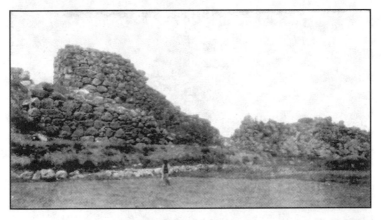

FIG. 22.—CITADEL OF TIRYNS.

that the roof has been formed by pushing the successive courses of stones further and further inward from both sides until they meet. The result is in form a vault, but the principle of the arch is not there, inasmuch as the stones are not jointed radially, but lie on approximately horizontal beds. Such a construction is sometimes called a "corbelled" arch or vault.

Similar walls to those of Tiryns are found in many places, though nowhere else are the blocks of such gigantic size. The Greeks of the historical period viewed these imposing structures with as much astonish-

ment as do we, and attributed them (or at least those in Argolis) to the Cyclopes, a mythical folk, conceived in this connection as masons of superhuman strength.

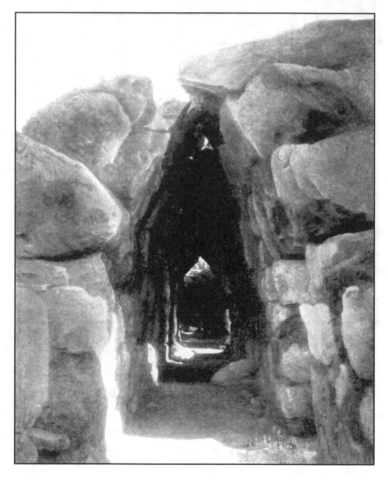

FIG. 23.—GALLERY IN THE EASTERN WALL. Tiryns.

Hence the adjective Cyclopian or Cyclopean, whose meaning varies unfortunately in modern usage, but which is best restricted to walls of the Tirynthian type ;

that is to say, walls built of large blocks not accurately fitted together, the interstices being filled with small stones. This style of masonry seems to be always of early date.

Portions of the citadel wall of Mycenæ are Cyclopean. Other portions, quite probably of later date, show a very different character (Fig. 24). Here the blocks on the outer surface of the wall, though irregular in shape,

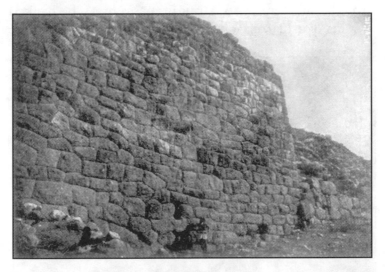

FIG. 24.—PORTION OF CITADEL WALL. Mycenæ.

are fitted together with close joints. This style of masonry is called polygonal and is to be carefully distinguished from Cyclopean, as above defined. Finally, still other portions of this same Mycenæan wall show on the outside a near approach to what is called ashlar masonry, in which the blocks are rectangular and laid in even, horizontal courses. This is the case near the Lion Gate, the principal entrance to the citadel (Fig. 25).

Next to the walls of fortification the most numerous

early remains of the builder's art in Greece are the "bee-hive" tombs, of which many examples have been discovered in Argolis, Laconia, Attica, Bœotia, Thessaly, and Crete. At Mycenæ alone there are eight now known, all of them outside the citadel. The largest and most imposing of these, and indeed of the entire class, is the one commonly referred to by the misleading name of the "Treasury of Atreus." Fig. 26 gives a section through this tomb. A straight passage, A B, flanked by walls of ashlar masonry and open to the sky, leads to

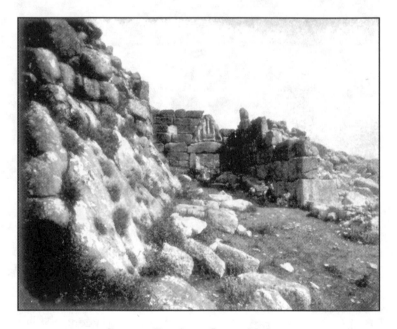

FIG. 25.—THE LION GATE. Mycenæ.

a doorway, B. This doorway, once closed with heavy doors, was framed with an elaborate architectural composition, of which only small fragments now exist and these widely dispersed—in London, Berlin, Carlsruhe, Munich, Athens, and Mycenæ itself. In the decoration

of this façade rosettes and running spirals played a conspicuous part, and on either side of the doorway stood a column which tapered downwards and was ornamented with spirals arranged in zigzag bands. This downward-tapering column, so unlike the columns of classic times, seems to have been in common use in Mycenæan archi-

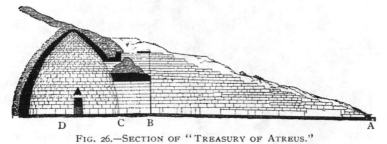

D C B A

FIG. 26.—SECTION OF "TREASURY OF ATREUS."

tecture. Inside the doors comes a short passage, B C, roofed by two huge lintel blocks, the inner one of which is estimated to weigh 132 tons. The principal chamber, D, which is embedded in the hill, is circular in plan, with a lower diameter of about forty-seven feet. Its wall is formed of horizontal courses of stone, each pushed further inward than the one below it, until the opening was small enough to be covered by a single stone. The method of roofing is therefore identical in principle with that used in the galleries and store chambers of Tiryns ; but here the blocks have been much more carefully worked and accurately fitted, and the exposed ends have been so beveled as to give to the whole interior a smooth, curved surface. Numerous horizontal rows of small holes exist, only partly indicated in our illustration, beginning in the fourth course from the bottom and continuing at intervals probably to the top. In some of these holes bronze nails still remain. These must have served for the attachment

of some sort of bronze decoration. The most careful study of the disposition of the holes has led to the conclusion that the fourth and fifth courses were completely covered with bronze plates, presumably ornamented, and that above this there were rows of single ornaments, possibly rosettes.

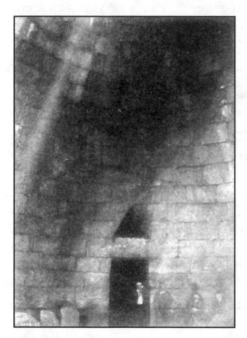

Fig. 27 will give some idea of the present appearance of this chamber, which is still complete, except for the loss of the bronze decoration and two or three stones at the top. The small doorway which is seen here, as well as in Fig. 26, leads into a rectangular chamber, hewn in the living rock. This is much smaller than the main chamber.

FIG. 27.—INTERIOR OF " TREASURY OF ATREUS."

At Orchomenus in Bœotia are the ruins of a tomb scarcely inferior in size to the "Treasury of Atreus" and once scarcely less magnificent. Here too, besides the "bee-hive" construction, there was a lateral, rectangular chamber—a feature which occurs only in these two cases. Excavations conducted here by Schliemann in 1880–81 brought to light the broken fragments of a ceiling of greenish schist with which this lateral cham-

ber was once covered. Fig. 28 shows this ceiling restored. The beautiful sculptured decoration con-

FIG. 28.—CEILING OF TOMB-CHAMBER AT ORCHOMENUS, RESTORED.

sists of elements which recur in almost the same combination on a fragment of painted stucco from the

palace of Tiryns. The pattern is derived from Egypt.
The two structures just described were long ago broken into and despoiled. If they stood alone, we could only guess at their original purpose. But some other examples of the same class have been left unmolested or less completely ransacked, until in recent years they could be studied by scientific investigators. Furthermore we have the evidence of numerous rock-cut chambers of analogous shape, many of which have been recently opened in a virgin condition. Thus it has been put beyond a doubt that these subterranean "beehive" chambers were sepulchral monuments, the bodies having been laid in graves within. The largest and best built of these tombs, if not all, must have belonged to princely families.

Even the dwelling-houses of the chieftains who ruled at Tiryns and Mycenæ are known to us by their remains. The palace of Tiryns occupied the entire southern end of the citadel, within the massive walls above described. Its ruins were uncovered in 1884–85. The plan and the lower portions of the walls of an extensive complex of gateways, open courts, and closed rooms were thus revealed. There are remains of a similar building at Mycenæ, but less well preserved, while the citadels of Athens and Troy present still more scanty traces of an analogous kind. The walls of the Tirynthian palace were not built of gigantic blocks of stone, such as were used in the citadel wall. That would have been a reckless waste of labor. On the contrary, they were built partly of small irregular pieces of stone, partly of sundried bricks. Clay was used to hold these materials together, and beams of wood ("bond timbers") were laid lengthwise here and there in the wall to give additional strength. Where columns were needed, they

were in every case of wood, and consequently have long since decomposed and disappeared. Considerable remains, however, were found of the decorations of the interior. Thus there are bits of what must once have been a beautiful frieze of alabaster, inlaid with pieces of blue glass. A restored piece of this, sufficient to give the pattern, is seen in Fig. 29. Essentially the same design, somewhat simplified, occurs on objects of stone, ivory, and glass found at Mycenæ and in a "bee-hive" tomb of Attica. Again, there are fragments of painted stucco which decorated the walls of rooms in the palace

FIG. 29.—ALABASTER FRIEZE FROM TIRYNS, RESTORED.

of Tiryns. The largest and most interesting of these fragments is shown in Fig. 30. A yellow and red bull is represented against a blue background, galloping furiously to left, tail in air. Above him is a man of slender build, nearly naked. With his right hand the man grasps one of the bull's horns ; his right leg is bent at the knee and the foot seems to touch with its toes the bull's back ; his outstretched left leg is raised high in air. We have several similar representations on objects of the Mycenæan period, the most interesting of which will be presently described (see page 67). The comparison

of these with one another leaves little room for doubt that the Tirynthian fresco was intended to portray the chase of a wild bull. But what does the man's position signify? Has he been tossed into the air by the infuriated animal? Has he adventurously vaulted upon

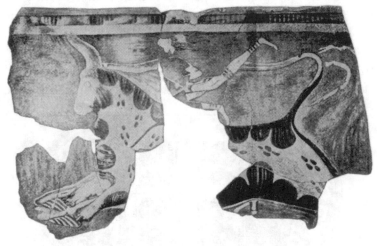

FIG. 30.—WALL-FRESCO FROM TIRYNS.

the creature's back? Or did the painter mean him to be running on the ground, and, finding the problem of drawing the two figures in their proper relation too much for his simple skill, did he adopt the child-like expedient of putting one above the other? This last seems much the most probable explanation, especially as the same expedient is to be seen in several other designs belonging to this period.

At Mycenæ also, both in the principal palace which corresponds to that of Tiryns and in a smaller house, remains of wall-frescoes have been found. These, like those of Tiryns, consisted partly of merely ornamental patterns, partly of genuine pictures, with human and

animal figures. But nothing has there come to light at once so well preserved and so spirited as the bull-fresco from Tiryns.

Painting in the Mycenæan period seems to have been nearly, if not entirely, confined to the decoration of house-walls and of pottery. Similarly sculpture had no existence as a great, independent art. There is no trace of any statue in the round of life-size or anything approaching that. This agrees with the impression we get from the Homeric poems, where, with possibly one exception,* there is no allusion to any sculptured image. There are, to be sure, primitive statuettes, one class of which, very rude and early, in fact pre-Mycenæan in character, is illustrated by Fig. 31. Images of this sort have been found principally on the islands of the Greek Archipel-

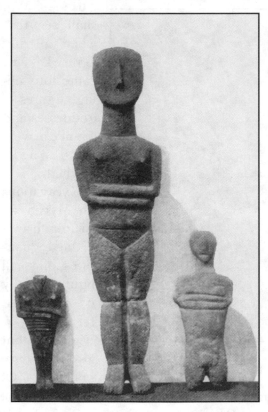

Fig. 31.—Primitive Statuettes from the Greek Islands. London, British Museum.

* Iliad VI., 273, 303.

ago. They are made of marble or limestone, and represent a naked female figure standing stiffly erect, with arms crossed in front below the breasts. The head is of extraordinary rudeness, the face of a horse-shoe shape, often with no feature except a long triangular nose. What religious ideas were associated with these barbarous little images by their possessors we can hardly guess. We shall see that when a truly Greek art came into being, figures of goddesses and women were decorously clothed.

Excavations on Mycenæan sites have yielded quantities of small figures, chiefly of painted terra-cotta (*cf.* Fig. 43), but also of bronze or lead. Of

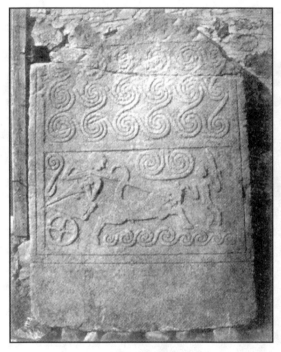

FIG. 32.—GRAVESTONE FROM MYCENÆ.
Athens, National Museum.

sculpture on a larger scale we possess nothing except the gravestones found at Mycenæ and the relief which has given a name, albeit an inaccurate one, to the Lion Gate. The gravestones are probably the earlier. They were found within a circular enclosure just inside the Lion Gate, above a group of six graves—the so-called pit-

graves or shaft-graves of Mycenæ. The best preserved
of these gravestones is shown in Fig. 32. The field,
bordered by a double fillet, is divided horizontally into
two parts. The upper part is filled with an ingeniously
contrived system of running spirals. Below is a battle-
scene : a man in a chariot is driving at full speed, and
in front there is a naked foot soldier (enemy?), with a
sword in his uplifted left hand. Spirals, apparently
meaningless, fill in the vacant spaces. The technique
is very simple. The figures having been outlined, the
background has been cut away to a shallow depth ;
within the outlines there is no modeling, the surfaces
being left flat. It is needless to dwell on the short-
comings of this work, but it is worth while to remind
the reader that the gravestone commemorates one who
must have been an important personage, probably a
chieftain, and that the best available talent would have
been secured for the purpose.

The famous relief above the Lion Gate of Mycenæ
(Figs. 25, 33), though probably of somewhat later date
than the sculptured gravestones, is still generally be-
lieved to go well back into the second millennium before
Christ. It represents two lionesses (not lions) facing
one another in heraldic fashion, their fore-paws resting
on what is probably to be called an altar or pair of
altars ; between them is a column, which tapers down-
ward (*cf.* the columns of the "Treasury of Atreus," page
53), surmounted by what seems to be a suggestion of
an entablature. The heads of the lionesses, originally
made of separate pieces and attached, have been lost.
Otherwise the work is in good preservation, in spite of
its uninterrupted exposure for more than three thousand
years. The technique is quite different from that of the
gravestones, for all parts of the relief are carefully

modeled. The truth to nature is also far greater here,
the animals being tolerably life-like. The design is one
which recurs with variations on two or three engraved

FIG. 33.—RELIEF ABOVE THE LION GATE, MYCENÆ.

gems of the Mycenæan period (*cf.* Fig. 40), as well as
in a series of later Phrygian reliefs in stone. Placed in

this conspicuous position above the principal entrance to the citadel, it may perhaps have symbolized the power of the city and its rulers.

If sculpture in stone appears to have been very little practiced in the Mycenæan age, the arts of the gold-smith, silversmith, gem-engraver, and ivory-carver were in great requisition. The shaft-graves of Mycenæ con-tained, besides other things, a rich treasure of gold ob-jects—masks, drinking-cups, diadems, ear-rings, finger-rings, and so on ; also several silver vases. One of the

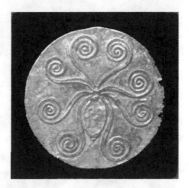

FIG. 34.—GOLD ORNAMENT. FIG. 35.—GOLD ORNAMENT.

latter may be seen in Fig. 43. It is a large jar, about two and one half feet in height, decorated below with horizontal flutings and above with continuous spirals in *repoussé* (*i.e.*, hammered) work. Most of the gold objects must be passed over, interesting though many of them are. But we may pause a moment over a group of circular ornaments in thin gold-leaf about two and one half inches in diameter, of which 701 speci-mens were found, all in a single grave. The patterns on these discs were not executed with a free hand, but

by means of a mold. There are fourteen patterns in all, some of them made up of spirals and serpentine curves, others derived from vegetable and animal forms. Two of the latter class are shown in Figs. 34, 35. One is a butterfly, the other a cuttle-fish, both of them skilfully conventionalized. It is interesting to note how the antennæ of the butterfly and still more the arms of the cuttle-fish are made to end in the favorite spiral.

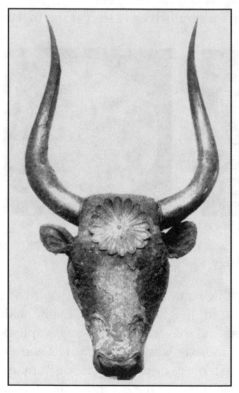

FIG. 36.—SILVER COW'S HEAD. Athens, National Museum.

The sculptures and gold objects which have been thus far described or referred to were in all probability executed by native, or at any rate by resident, workmen, though some of the patterns clearly betray oriental influence. Other objects must have been, others may have been, actually imported from Egypt or the East. It is impossible to draw the line with certainty between native and imported. Thus the admirable silver head of a cow from one of the shaft-graves (Fig. 36) has been claimed as an Egyptian or a Phenician produc-

tion, but the evidence adduced is not decisive. Similarly with the fragment of a silver vase shown in Fig. 37. This has a design in relief (*repoussé*) representing the siege of a walled town or citadel. On the walls is a group of women making frantic gestures. The defenders, most of them naked, are armed with bows and arrows and slings. On the ground lie sling-stones and throwing-sticks,* which may be supposed to have been hurled by the enemy. In the background there are four nondescript trees, perhaps intended for olive trees.

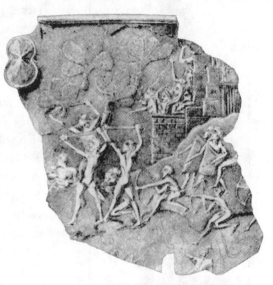

FIG. 37.—FRAGMENT OF SILVER VASE. Athens, National Museum.

Another variety of Mycenæan metal-work is of a much higher order of merit than the dramatic but rude relief on this silver vase. I refer to a number of inlaid dagger-blades, which were found in two of the shaft-graves. Fig. 38 reproduces one side of the finest of these. It is about nine inches long. The blade is of bronze, while the rivets by which the handle was attached are of gold. The design was inlaid in a separate thin slip of bronze, which was then inserted

* So explained by Mr. A. J. Evans in *The Journal of Hellenic Studies*, XIII., page 199.

into a sinking on the blade. The materials used are various. The lions and the naked parts of the men are of gold, the shields and trunks of the men of electrum (a mixture of gold and silver), the hair of the men, the manes of the lions, and some other details of an unidentified dark substance; the background, to the edges of the inserted slip, was covered with a black enamel. The scene is a lion-hunt. Four men, one armed only with a bow, the others with lances and huge shields of two different forms, are attacking a lion. A fifth hunter has fallen and lies under the lion's fore-paws. The beast has already been run through with a lance, the point of which is seen protruding from his haunch; but he still shows fight, while his two companions dash away at full speed. The design is skilfully composed to fill the triangular

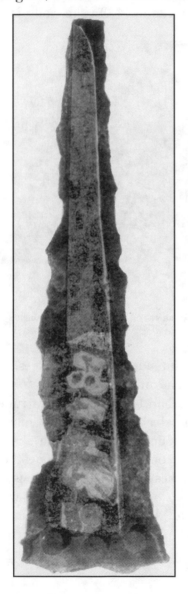

FIG. 38.—INLAID DAGGER-BLADE. Athens, National Museum.

space, and the attitudes of men and beasts are varied, expressive, and fairly truthful. Another of these dagger-blades has a representation of panthers hunting ducks by the banks of a river in which what may be lotus plants are growing. The lotus would point toward Egypt as the ultimate source of the design. Moreover, a dagger of similar technique has been found in Egypt in the tomb of a queen belonging to the end of the Seventeenth Dynasty. On the other hand, the dress and the shields of the men engaged in the lion-hunt are identical with those on a number of other "Mycenæan" articles—gems, statuettes, etc.—which it is difficult to regard as all of foreign importation. The probability, then, seems to be that while the technique of the dagger-blades was directly or indirectly derived from Egypt, the specimens found at Mycenæ were of local manufacture.

The greatest triumph of the goldsmith's art in the "Mycenæan" period does not come from Mycenæ. The two gold cups shown in Fig. 39 were found in 1888 in a bee-hive tomb at Vaphio in Laconia. Each cup is double ; that is to say, there is an outer cup, which has been hammered into shape from a single disc of gold and which is therefore without a joint, and an inner cup, similarly made, whose upper edge is bent over the outer cup so as to hold the two together. The horizontal parts of the handles are attached by rivets, while the intervening vertical cylinders are soldered. The designs in *repoussé* work are evidently pendants to one another. The first represents a hunt of wild bulls. One bull, whose appearance indicates the highest pitch of fury, has dashed a would-be captor to earth and is now tossing another on his horns. A second bull, entangled in a stout net, writhes and bellows in the vain effort to

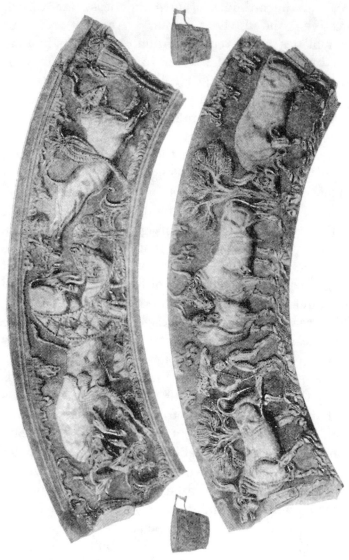

FIG. 39. — TWO GOLD CUPS. Athens, National Museum.

escape. A third gallops at full speed from the scene of his comrade's captivity. The other design shows us four tame bulls. The first submits with evident impatience to his master. The next two stand quietly, with an almost comical effect of good nature and contentment. The fourth advances slowly, browsing. In each composition the ground is indicated, not only beneath the men and animals, but above them, wherever the design affords room. It is an example of the same naïve perspective which seems to have been employed in the Tirynthian bull-fresco (Fig. 30). The men, too, are of the same build here as there, and the bulls have similarly curving horns. There are several trees on the cups, two of which are clearly characterized as palms, while the others resemble those in Fig. 37, and may be intended for olives. The bulls are rendered with amazing spirit and understanding. True, there are palpable defects, if one examines closely. For example, the position of the bull in the net is quite impossible. But in general the attitudes and expressions are as lifelike as they are varied. Evidently we have here the work of an artist who drew his inspiration directly from nature.

Engraved gems were in great demand in the Mycenæan period, being worn as ornamental beads, and the work of the gem-engraver, like that of the goldsmith, exhibits excellent qualities. The usual material was some variety of ornamental stone—agate, jasper, rock-crystal, etc. There are two principal shapes, the one lenticular, the other elongated or glandular (Figs. 40, 41). The designs are engraved in intaglio, but, our illustrations being made, as is usual, from plaster impressions, they appear as cameos. Among the subjects the lion plays an important part, sometimes

represented singly, sometimes in pairs, sometimes de-
vouring a bull or stag. Cattle, goats, deer, and fantastic
creatures (sphinxes, griffins, etc.) are also common.
So are human figures, often engaged in war or the
chase. In the best of these gems the work is executed
with great care, and the designs, though often inaccu-
rate, are nevertheless vigorous. Very commonly, how-
ever, the distortion of the figure is carried beyond all
bounds. Fig. 40 was selected for illustration, not be-
cause it is a particularly
favorable specimen of its
class, but because it offers
an interesting analogy to the
relief above the Lion Gate.
It represents two lions ram-
pant, their fore-paws resting
on an altar (?), their heads,
oddly enough, combined
into one. The column which figures in the relief above
the gate is absent from the gem, but is found on
another specimen from Mycenæ, where the animals,
however, are winged griffins. Fig. 41 has only a stand-
ing man, of the wasp-waisted figure and wearing the
girdle with which other representations have now made
us familiar.

FIGS. 40, 41.—ENGRAVED GEMS FROM
MYCENÆ.

It remains to glance at the most important early
varieties of Greek pottery. We need not stop here to
study the rude, unpainted, mostly hand-made vases
from the earliest strata at Troy and Tiryns, nor the
more developed, yet still primitive, ware of the island of
Thera. But the Mycenæan pottery is of too great im-
portance to be passed over. This was the characteristic
ware of the Mycenæan civilization. The probability is
that it was manufactured at several different places,

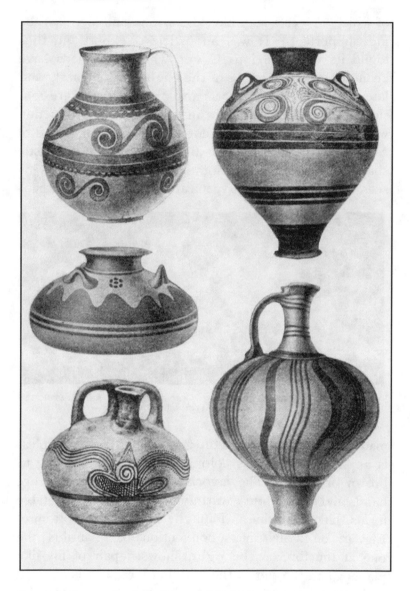

Fig. 42. — Vases of Mycenæan Style.

of which Mycenæ may have been one and perhaps the most important. It was an article of export and thus found its way even into Egypt, where specimens have been discovered in tombs of the Eighteenth Dynasty and later. The variations in form and ornamentation are considerable, as is natural with an article whose production was carried on at different centers and during a period of centuries. Fig. 42 shows a few of the characteristic shapes and decorations ; some additional pieces may be seen in Fig. 43. The Mycenæan vases are mostly wheel-

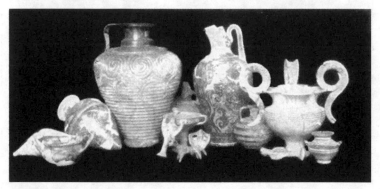

FIG. 43.—VASES (SILVER, TERRA-COTTA, AND ALABASTER) AND STATUETTES FROM MYCENÆ.

made. The decoration, in the great majority of examples, is applied in a lustrous color, generally red, shading to brown or black. The favorite elements of design are bands and spirals and a variety of animal and vegetable forms, chiefly marine. Thus the vase at the bottom of Fig. 42, on the left, has a conventionalized nautilus ; the one at the top, on the right, shows a pair of lily-like plants ; and the jug in the middle of Fig. 43 is covered with the stalks and leaves of what is perhaps meant for seaweed. Quadrupeds and men belong to the latest period of the style, the vase-painters of the early and

central Mycenæan periods having abstained, for some reason or other, from those subjects which formed the stock in trade of the gem-engravers.

The Mycenæan pottery was gradually superseded by pottery of an essentially different style, called Geometric, from the character of its painted decorations. It is

FIG. 44.—DIPYLON VASE, WITH DETAILS.
NEW YORK, METROPOLITAN MUSEUM OF ART.

impossible to say when this style made its first appearance in Greece, but it seems to have flourished for some hundreds of years and to have lasted till as late as the end of the eighth century B. C. It falls into several local varieties, of which the most important is the Athenian. This is commonly called Dipylon pottery, from the fact that the cemetery near the Dipylon, the chief gate of ancient Athens, has supplied the greatest number of specimens. Some of these Dipylon vases are of great size and served as funeral monuments. Fig. 44 gives a good example of this class. It is four

feet high. Both the shape and the decoration are very different from those of the Mycenæan style. The surface is almost completely covered by a system of ornament in which zigzags, meanders, and groups of concentric circles play an important part. In this system of Geometric patterns zones or friezes are reserved for designs into which human and animal figures enter. The center of interest is in the middle of the upper frieze, between the handles. Here we see a corpse upon a funeral bier, drawn by a two-horse wagon. To right and left are mourners arranged in two rows, one above the other. The lower frieze, which encircles the vase about at its middle, consists of a line of two-horse chariots and their drivers. The drawing of these designs is illustrated on a larger scale on the right and left of the vase in Fig. 44 ; it is more childish than anything we have seen from the Mycenæan period. The horses have thin bodies, legs, and necks, and their heads look as much like fishes as anything. The men and women are just as bad. Their heads show no feature save, at most, a dot for the eye and a projection for the nose, with now and then a sort of tassel for the hair ; their bodies are triangular, except those of the charioteers, whose shape is perhaps derived from one form of Greek shield ; their thin arms, of varying lengths, are entirely destitute of natural shape ; their long legs, though thigh and calf are distinguished, are only a shade more like reality than the arms. Such incapacity on the part of the designer would be hard to explain, were he to be regarded as the direct heir of the Mycenæan culture. But the sources of the Geometric style are probably to be sought among other tribes than those which were dominant in the days of Mycenæ's splendor. Greek tradition tells of a great

movement of population, the so-called Dorian migration, which took place some centuries before the beginning of recorded history in Greece. If that invasion and conquest of Peloponnesus by ruder tribes from the North be a fact, then the hypothesis is a plausible one which would connect the gradual disappearance of

FIG. 45.—PLATE FROM RHODES. British Museum.

Mycenæan art with that great change. Geometric art, according to this theory, would have originated with the tribes which now came to the fore.

Besides the Geometric pottery and its offshoots, several other local varieties were produced in Greece in

the eighth and seventh centuries. These are some-
times grouped together under the name of " oriental-
izing " styles, because, in a greater or less degree, they
show in their ornamentation the influence of oriental
models, of which the pure Geometric style betrays no
trace. It is impossible here to describe all these local
wares, but a single plate from Rhodes (Fig. 45) may
serve to illustrate the degree of proficiency in the draw-
ing of the human figure which had been attained about
the end of the seventh century. Additional interest is
lent to this design by the names attached to the three
men. The combatants are Menelaus and Hector ; the
fallen warrior is Euphorbus. Here for the first time we
find depicted a scene from the Trojan War. From this
time on the epic legends form a large part of the reper-
tory of the vase-painters.

CHAPTER 3

Greek Architecture

THE supreme achievement of Greek architecture was the temple. In imperial Rome, or in any typical city of the Roman Empire, the most extensive and imposing buildings were secular—basilicas, baths, amphitheaters, porticoes, aqueducts. In Athens, on the other hand, or in any typical Greek city, there was little or nothing to vie with the temples and the sacred edifices associated with them. Public secular buildings, of course, there were, but the little we know of them does not suggest that they often ranked among the architectural glories of the country. Private houses were in the best period of small pretensions. It was to the temple and its adjunct buildings that the architectural genius and the material resources of Greece were devoted. It is the temple, then, which we have above all to study.

Before beginning, however, to analyze the artistic features of the temple, it will be useful to consider the building materials which a Greek architect had at his disposal and his methods of putting them together. Greece is richly provided with good building stone. At many points there are inexhaustible stores of white marble. The island of Paros, one of the Cyclades, and Mount Pentelicus in Attica—to name only the two best and most famous quarries—are simply masses of white marble, suitable as well for the builder as the sculptor. There are besides various beautiful colored marbles, but it was left to the Romans to bring these into use. Then

there are many commoner sorts of stone ready to the builder's hand, especially the rather soft, brown limestones which the Greeks called by the general name of *poros*.* This material was not disdained, even for important buildings. Thus the Temple of Zeus at Olympia, one of the two most important religious centers in the Greek world, was built of local *poros*. The same was the case with the numerous temples of Acragas (Girgenti) and Selinus in Sicily. An even meaner material, sun-dried brick, was sometimes, perhaps often, employed for cella walls. Where *poros* or crude brick was used, it was coated over with a very fine, hard stucco, which gave a surface like that of marble.

It is remarkable that no use was made in Greece of baked bricks before the period of Roman domination. Roof-tiles of terra-cotta were in use from an early period, and Greek travelers to Babylonia brought back word of the use of baked bricks in that country. Nevertheless Greek builders showed no disposition to adopt baked bricks for their masonry.

This probably hangs together with another important fact, the absence of lime-mortar from Greek architecture. Lime-stucco was in use from time immemorial. But lime-mortar, *i.e.*, lime mixed with sand and used as a bond for masonry, is all but unknown in Greek work.† Consequently in the walls of temples and other carefully constructed buildings an elaborate system of bonding by means of clamps and dowels was resorted to. Fig. 46 illustrates this and some other points. The blocks of marble are seen to be perfectly rectangular and of uniform length and height. Each end of every block is

* The word has no connection with *porous*.

† The solitary exception at present known is an Attic tomb built of crude bricks laid in lime-mortar.

worked with a slightly raised and well-smoothed border, for the purpose of securing without unnecessary labor a perfectly accurate joint. The shallow holes, III, III, in the upper surfaces are pry-holes, which were of use in prying the blocks into position. The adjustment having been made, contiguous blocks in the same course were bonded to one another by clamps, I, I, embedded horizontally, while the sliding of one course upon another was prevented by upright dowels, II, II. Greek clamps and dowels were

FIG. 46.—GREEK METHOD OF BUILDING A WALL.

usually of iron and they were fixed in their sockets by means of molten lead run in. The form of the clamp differs at different periods. The double-T shape shown in the illustration is characteristic of the best age (*cf.* also Fig. 48).

Another important fact to be noted at the outset is the absence of the arch from Greek architecture. It is reported by the Roman philosopher, Seneca, that the principle of the arch was "discovered" by the Greek philosopher, Democritus, who lived in the latter half of the fifth century B. C. That he independently discovered the arch as a practical possibility is most unlikely, seeing that it had been used for ages in Egypt and Mesopotamia ; but it may be that he discussed, however imperfectly, the mathematical theory of the subject. If so, it would seem likely that he had prac-

tical illustrations about him ; and this view receives some support from the existence of a few subterranean vaults which perhaps go back to the good Greek period. Be that as it may, the arch plays absolutely no part in the columnar architecture of Greece. In a Greek temple or similar building only the flat ceiling was known. Above the exterior portico and the vestibules of a temple the ceiling was sometimes of stone or marble, sometimes of wood ; in the interior it was always of wood. It follows that no very wide space could be ceiled over without extra supports. At Priene in Asia Minor we find a temple (Fig. 49) whose cella, slightly over thirty feet in breadth, has no interior columns. The architect of the Temple of Athena on the island of Ægina (Fig. 52) was less venturesome. Although the cella there is only 21¼ feet in breadth, we find, as in large temples, a double row of columns to help support the ceiling. And when a really large room was built, like the Hall of Initiation at Eleusis or the Assembly Hall of the Arcadians at Megalopolis, such a forest of pillars was required as must have seriously interfered with the convenience of congregations.

FIG. 47.—PLAN OF SMALL TEMPLE. Rhamnus. A, *cella ;* B, *pronaos.*

We are now ready to study the plan of a Greek temple. The essential feature is an enclosed chamber, commonly called by the Latin name *cella*, in which

stood, as a rule, the image of the god or goddess to whom the temple was dedicated. Fig. 47 shows a very simple plan. Here the side walls of the cella are prolonged in front and terminate in *antæ* (see below, page 88). Between the antæ are two columns. This type of temple is called a *templum in antis*. Were the vestibule (*pronaos*) repeated at the other end of the building, it would be called an *opisthodomos*, and the whole building would be a double *templum in antis*. In Fig. 48 the vestibules are formed by rows of columns extending across the

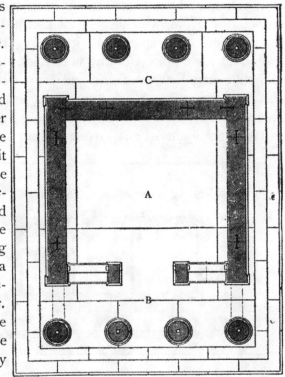

FIG. 48.—PLAN OF TEMPLE OF WINGLESS VICTORY. Athens. A, *cella;* B, *pronaos;* C, *opisthodomos.*

whole width of the cella, whose side walls are not prolonged. Did a vestibule exist at the front only, the temple would be called *prostyle;* as it is, it is *amphiprostyle.* Only small Greek temples have as simple a plan as those just described. Larger temples are *peripteral, i. e.,* are surrounded by a colonnade or *peristyle*

(Figs. 49, 50). In Fig. 49 the cella with its vestibules has the form of a double *templum in antis;* in Fig. 50 it is amphiprostyle. A further difference should be noted. In Fig. 49, which is the plan of an Ionic temple, the antæ and columns of the vestibules are in line with columns of the outer row, at both the ends and the sides ; in Fig. 50, which is the plan of a Doric temple, the exterior columns are set without regard to the cella walls and the columns of the vestibules. This is a regular difference between Doric and Ionic temples, though the rule is subject to a few exceptions in the case of the former.

The plan of almost any Greek temple will be found to

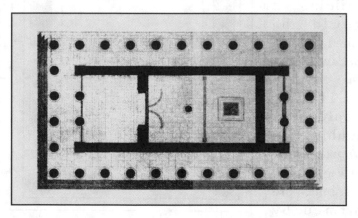

FIG. 49.—PLAN OF TEMPLE AT PRIENE.

be referable to one or other of the types just described, although there are great differences in the proportions of the several parts. It remains only to add that in almost every case the principal front was toward the east or nearly so. When Greek temples were converted into Christian churches, as often happened, it was necessary, in order to conform to the Christian ritual, to

reverse this arrangement and to place the principal entrance at the western end.

The next thing is to study the principal elements of a Greek temple as seen in elevation. This brings us to the subject of the Greek "orders." There are two principal orders in Greek architecture, the Doric and the Ionic. Figs. 51 and 61 show a characteristic specimen of each. The term "order," it should be said, is commonly restricted in architectural parlance to the column and entablature. Our illustrations, however, show all the features of a Doric and

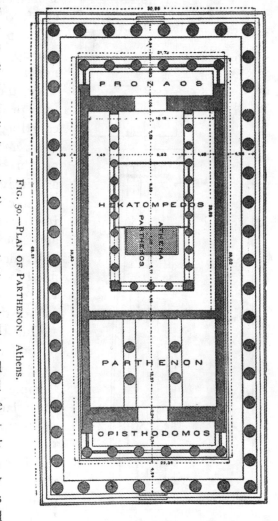

FIG. 50.—PLAN OF PARTHENON. Athens.

PRONAOS

HEKATOMPEDOS

ATHENA

PARTHENOS

PARTHENON

OPISTHODOMOS

an Ionic façade. There are several points of agreement between the two : in each the columns rest on a base, lower steps of which are called the *stereobate,*

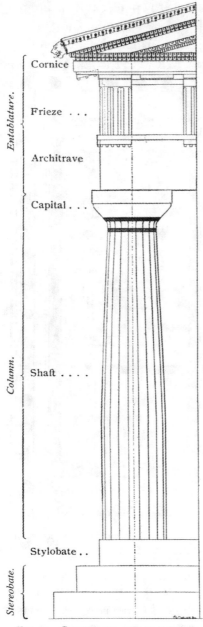

Entablature.

Cornice

Frieze . . .

Architrave

Capital . . .

Column.

Shaft

Stylobate . .

Stereobate.

FIG 51.—CORNER OF A DORIC FAÇADE.

whereas the uppermost step is called the *stylobate ;* in each the shaft of the column tapers from the lower to the upper end, is channeled or fluted vertically, and is surmounted by a projecting member called a *capital ;* in each the *entablature* consists of three members— architrave, frieze, and cornice. There the important points of agreement end. The differences will best be fixed in mind by a detailed examination of each order separately.

Our typical example of the Doric order (Fig. 51) is taken from the Temple of Aphaia on the island of Ægina— a temple probably erected about 480 B. C. (*cf.* Fig. 52.) The column consists of two parts, shaft and capital. It is of sturdy proportions, its height being about five and one half times the lower diameter

of the shaft. If the shaft tapered upward at a uniform rate, it would have the form of a truncated cone. Instead of that, the shaft has an *entasis* or swelling. Imagine a vertical section to be made through the middle of the column. If, then, the diminution of the shaft were uniform, the sides of this section would be straight lines. In reality, however, they are slightly curved lines, convex outward. This addition to the form of a truncated cone is the entasis. It is greatest at about one third or one half the height of the shaft, and there amounts, in cases that have been measured, to from $\frac{1}{80}$ to $\frac{1}{140}$ of the lower diameter of the shaft.* In some early Doric temples, as the one at Assos in Asia Minor, there is no entasis. The channels or flutes in our typical column are twenty in number. More rarely we find sixteen ; much more rarely larger multiples of four. These channels are so placed that one comes directly under the middle of each face of the capital. They are comparatively shallow, and are separated from one another by sharp edges or *arrises*. The capital, though worked out of one block, may be regarded as consisting of two parts — a cushion-shaped member called an *echinus*, encircled below by three to five *annulets*, (*cf.* Figs. 59, 60) and a square slab called an *abacus*, the latter so placed that its sides are parallel to the sides of the building. The *architrave* is a succession of horizontal beams resting upon the columns. The face of this member is plain, except that along the upper edge there runs a slightly projecting flat band called a *tænia*, with regulæ and guttæ at equal intervals ; these last are best considered in connection with the frieze. The *frieze* is made

* Observe that the entasis is so slight that the lowest diameter of the shaft is always the greatest diameter. The illustration is unfortunately not quite correct, since it gives the shaft a uniform diameter for about one third of its height.

up of alternating triglyphs and metopes. A *triglyph* is a block whose height is nearly twice its width ; upon its face are two furrows triangular in plan, and its outer edges are chamfered off. Thus we may say that the triglyph has two furrows and two half-furrows ; these do not extend to the top of the block. A triglyph is placed over the center of each column and over the center of

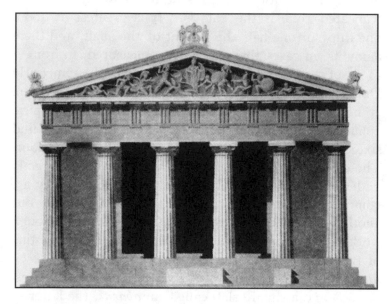

FIG. 52.—WEST FRONT OF THE TEMPLE OF APHAIA, RESTORED.

each intercolumniation. But at the corners of the buildings the intercolumniations are diminished, with the result that the corner triglyphs do not stand over the centers of the corner columns, but farther out (*cf.* Fig. 52). Under each triglyph there is worked upon the face of the architrave, directly below the tænia, a *regula*, shaped like a small cleat, and to the under surface of this regula is attached a row of six cylindrical or conical

guttæ. Between every two triglyphs, and standing a little farther back, there is a square or nearly square slab or block called a *metope.* This has a flat band across the top ; for the rest, its face may be either plain or sculptured in relief. The uppermost member of the entablature, the *cornice,* consists principally of a projecting portion, the *corona,* on whose inclined under surface or soffit are rectangular projections, the so-called *mutules* (best seen in the frontispiece), one over each triglyph and each metope. Three rows of six guttæ each are attached to the under surface of a mutule. Above the cornice, at the east and west ends of the building, come the triangular *pediments* or gables, formed by the sloping roof and adapted for groups of sculpture. The pediment is protected above by a "raking" cornice, which has not the same form as the horizontal cornice, the principal difference being that the under surface of the raking cornice is concave and without mutules. Above the raking cornice comes a

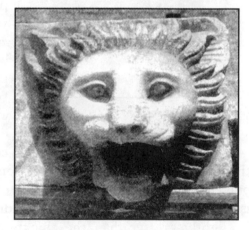

FIG. 53.—FRAGMENT OF SIMA, WITH LION'S HEAD.
Athens, Acropolis Museum.

sima or gutter-facing, which in buildings of good period has a curvilinear profile. This sima is sometimes continued along the long sides of the building, and sometimes not. When it is so continued, water-spouts are inserted into it at intervals, usually in the form of lions' heads. Fig. 53

shows a fine lion's head of this sort from a sixth century temple on the Athenian Acropolis. If it be added that upon the apex and the lower corners of the pediment there were commonly pedestals which supported statues or other ornamental objects (Fig. 52), mention will have been made of all the main features of the exterior of a Doric peripteral temple.

Every other part of the building had likewise its

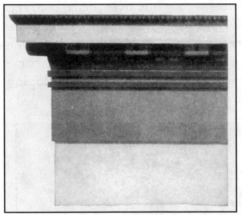

FIG. 54.—HALF OF ANTA-CAPITAL OF THE ATHENIAN PROPYLÆA, WITH COLOR RESTORED.

established form, but it will not be possible here to describe or even to mention every detail. The most important member not yet treated of is the *anta*. An anta may be described as a pilaster forming the termination of a wall. It stands directly opposite a column and is of the same height with it, its function being to receive one end of an architrave block, the other end of which is borne by the column. The breadth of its front face is slightly greater than the thickness of the wall ; the breadth of a side face depends upon whether or not the anta supports an architrave on that side (Figs. 47, 48, 49, 50). The Doric anta has a special capital, quite unlike the capital of the column. Fig. 54 shows an example from a building erected in 437–32 B. C. Its most striking feature is the *Doric cyma*, or *hawk's-beak molding*, the characteristic molding of the Doric style (Fig.

55), used also to crown the horizontal cornice and in other situations (Fig. 51 and frontispiece). Below the capital the anta is treated precisely like the wall of which it forms a part ; that is to say, its surfaces are plain, except for the simple base-molding, which extends also along the foot of the wall. The method of ceiling the peristyle and vestibules by means of ceiling-beams on which rest slabs decorated with square, recessed panels or *coffers* may be indistinctly seen in Fig. 56. Within the cella, when columns were used to help support the wooden ceiling, there seem to have been regularly two ranges, one above the other. This is the only case, so far as we know, in which Greek archi-

FIG. 55.—HAWK'S-BEAK MOLDING, COLORED.

tecture of the best period put one range of columns above another. There were probably no windows of any kind, so that the cella received no daylight, except such as entered by the great front doorway, when the doors were open.* The roof-beams were of wood. The roof was covered with terra-cotta or marble tiles.

Such are the main features of a Doric temple (those last mentioned not being peculiar to the Doric style). Little has been said thus far of variation in these features. Yet variation there was. Not to dwell on local differences, as between Greece proper and the Greek colonies in Sicily, there was a development constantly going on, changing the forms of details and the relative proportions of parts and even introducing new

* This whole matter, however, is in dispute. Some authorities believe that large temples were *hypæthral*, *i. e.*, open, or partly open, to the sky, or in some way lighted from above. In Fig. 56 an open grating has been inserted above the doors, but for such an arrangement in a Greek temple there is no evidence, so far as I am aware.

features originally foreign to the style. Thus the column grows slenderer from century to century. In early examples it is from four to five lower diameters in

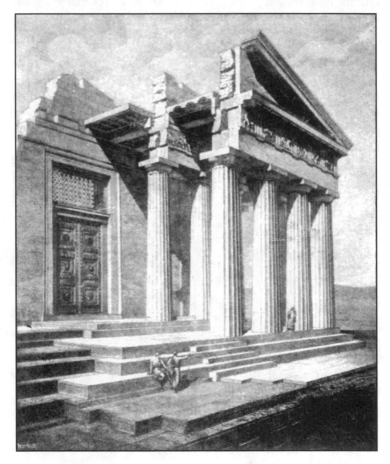

FIG. 56.—EAST FRONT OF THE PARTHENON, RESTORED AND DISSECTED.

height; in the best period (fifth and fourth centuries) about five and one half; in the post-classical period, six to seven. The difference in this respect between early

FIG. 57. — TEMPLE OF POSIDON (?), Pæstum.

and late examples may be seen by comparing the fifth century Temple of Posidon (?) at Pæstum in southern Italy (Fig. 57) with the third (?) century Temple of Zeus at Nemea (Fig. 58). Again, the echinus of the capital is in the early period widely flaring, making in some very early examples an angle at the start of not

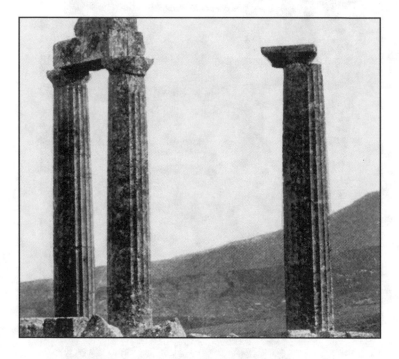

FIG. 58.—COLUMNS OF THE TEMPLE OF ZEUS. Nemea.

more than fifteen or twenty degrees with the horizontal (Fig. 59); in the best period it rises more steeply, starting at an angle of about fifty degrees with the horizontal and having a profile which closely approaches a straight line, until it curves inward under the abacus (Fig. 51); in the post-classical period it is low and sometimes quite conical (Fig. 60). In general, the

degeneracy of post-classical Greek architecture is in nothing more marked than in the loss of those subtle curves which characterize the best Greek work. Other differences must be learned from more extended treatises.

The Ionic order was of a much more luxuriant character than the Doric. Our typical example (Fig. 61) is taken from the Temple of Priene in Asia Minor—a temple erected about 340-30 B. C. The column has a base consisting of a plain square *plinth*, two *trochili* with moldings, and a *torus* fluted horizontally. The Ionic

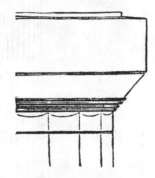

FIG. 59.—EARLY DORIC CAPITAL FROM SELINUS.

FIG. 60.—LATE DORIC CAPITAL FROM SAMOTHRACE.

shaft is much slenderer than the Doric, the height of the column (including base and capital) being in different examples from eight to ten times the lower diameter of the shaft. The diminution of the shaft is naturally less than in the Doric, and the entasis, where any has been detected, is exceedingly slight. The flutes, twenty-four in number, are deeper than in the Doric shaft, being in fact nearly or quite semicircular, and they are separated from one another by flat bands or fillets. For the form of the capital it will be better to refer to Fig. 62, taken from an Attic building of the latter half of the fifth century. The principal parts are an *ovolo* and a *spiral roll*

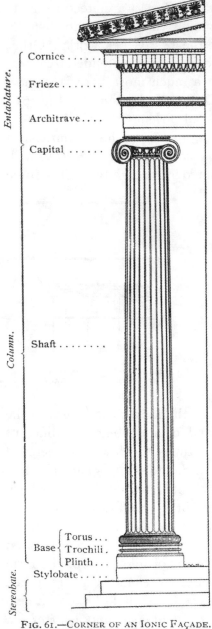

Entablature.
Cornice
Frieze
Architrave
Capital

Column.
Shaft

Base { Torus . . .
Trochili .
Plinth . . .
Stylobate

Stereobate.

Fig. 61.—Corner of an Ionic Façade.

(the latter name not in general use). The ovolo has a convex profile, and is sometimes called a quarter-round ; it is enriched with an *egg-and-dart* ornament. The spiral roll may be conceived as a long cushion, whose ends are rolled under to form the *volutes*. The part connecting the volutes is slightly hollowed, and the channel thus formed is continued into the volutes. As seen from the side (Fig. 63), the end of the spiral roll is called a *bolster ;* it has the appearance of being drawn together by a number of encircling bands. On the front, the angles formed by the spiral roll are filled by a conventionalized floral ornament (the so-called *palmette*). Above the spiral roll is a low abacus, oblong or square in plan. In Fig. 62 the profile of the abacus is an ovolo on which the

egg-and-dart ornament was painted (*cf.* Fig. 66, where the ornament is sculptured). In Fig. 61, as in Fig. 71, the profile is a complex curve called a *cyma reversa*, convex above and concave below, enriched with a sculptured *leaf-and-dart* ornament.* Finally, attention may be called to the *astragal* or *pearl-beading* just under the ovolo in Figs.

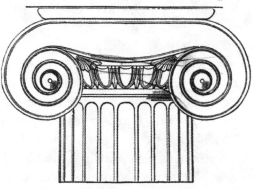

FIG. 62.—CAPITAL FROM TEMPLE OF WINGLESS VICTORY.

61, 71. This might be described as a string of beads and buttons, two buttons alternating with a single bead.

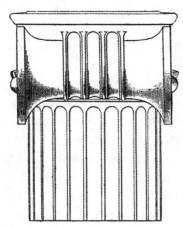

FIG. 63.—CAPITAL FROM TEMPLE OF WINGLESS VICTORY. Side view.

In the normal Ionic capital the opposite faces are of identical appearance. If this were the case with the capital at the corner of a building, the result would be that on the side of the building all the capitals would present their bolsters instead of their volutes to the spectator. The only way to prevent this was to distort the

* The egg-and-dart is found only on the ovolo; the leaf-and-dart only on the *cyma reversa* or the *cyma recta* (concave above and convex below). Both ornaments are in origin leaf-patterns, one row of leaves showing their points behind another row.

corner capital into the form shown by Fig. 64 ; *cf.* also Figs. 61 and 70.

The Ionic architrave is divided horizontally into three (or sometimes two) bands, each of the upper ones projecting slightly over the one below it. It is crowned by a sort of cornice enriched with moldings. The frieze is not divided like the Doric frieze, but presents an uninterrupted surface. It may be either plain or covered with relief-sculpture. It is finished off with moldings along the upper edge. The cornice (*cf.* Fig. 65) consists of two principal parts. First comes a projecting block, into whose face rectangular cuttings have

FIG. 64.—IONIC CORNER CAPITAL, AS SEEN FROM BELOW.

been made at short intervals, thus leaving a succession of cogs or *dentels;* above these are moldings. Secondly there is a much more widely projecting block, the *corona*, whose under surface is hollowed to lighten the weight and whose face is capped with moldings. The raking cornice is like the horizontal cornice except that it has no dentels. The sima or gutter-facing, whose profile is here a *cyma recta* (concave above and convex below), is enriched with sculptured floral ornament.

In the Ionic buildings of Attica the base of the column consists of two tori separated by a trochilus. The proportions of these parts vary considerably. The base in Fig. 66 (from a building finished about 408 B. C.) is worthy of attentive examination by reason of its harmonious proportions. In the Roman form of this base, too often imitated nowadays, the trochilus has too small a diameter. The Attic-Ionic cornice never has dentels, unless the cornice of the Caryatid portico

of the Erechtheum ought to be reckoned as an instance
(Fig. 67).

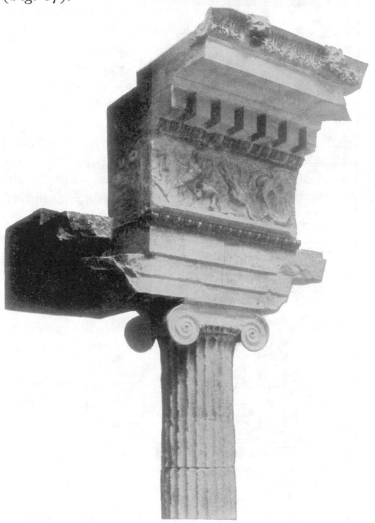

FIG. 65.—ENTABLATURE AND UPPER PART OF COLUMN FROM THE
MAUSOLEUM. British Museum.

The capital shown in Fig. 66 is a special variety of
the Ionic capital, of rather rare occurrence. Its dis-

tinguishing features are : the insertion between ovolo and spiral roll of a torus ornamented with a braided pattern, called a *guilloche ;* the absence of the palmettes from the corners formed by the spiral roll; and the fact that the channel of the roll is double instead of single, which gives a more elaborate character to that member. Finally, in the Erechtheum the upper part or necking of the shaft is enriched with an exquisitely wrought band of floral ornament, the so-called honeysuckle pattern. This feature is met with in some other examples.

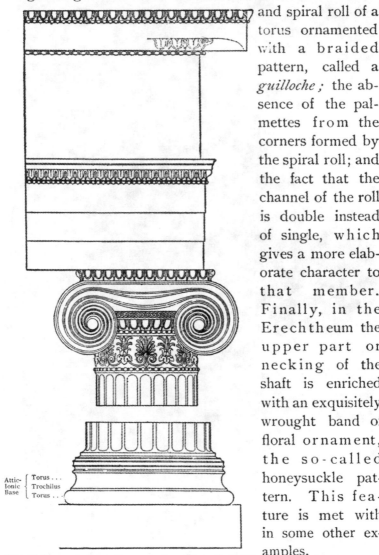

Attic- ⌈ Torus . . .
Ionic ⟨ Trochilus
Base ⌊ Torus . . ·

FIG. 66–ORDER OF THE ERECHTHEUM, EAST PORTICO.

As in the Doric style, so in the Ionic, the anta-capital is quite unlike the column-capital. Fig. 68 shows an anta-capital

from the Erechtheum, with an adjacent portion of the wall-band ; *cf.* also Fig. 69. Perhaps it is inaccurate in this case to speak of an anta-capital at all, seeing

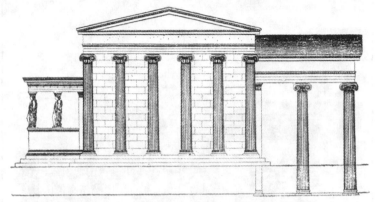

FIG. 67.—THE ERECHTHEUM, FROM THE EAST, RESTORED.

that the anta simply shares the moldings which crown the wall. The floral frieze under the moldings is, however, somewhat more elaborate on the anta than on

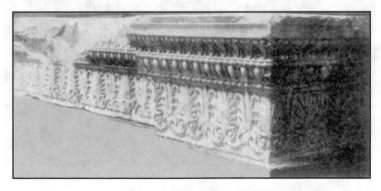

FIG. 68.—ANTA-CAPITAL AND WALL-BAND, FROM THE ERECHTHEUM.
British Museum.

the adjacent wall. The Ionic method of ceiling a peristyle or portico may be partly seen in Fig. 69. The principal ceiling-beams here rest upon the architrave,

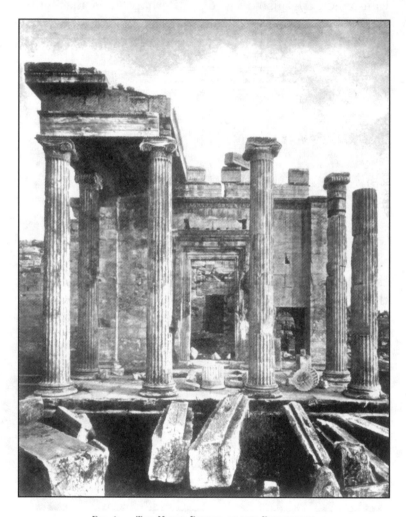

FIG. 69. — THE NORTH PORTICO OF THE ERECHTHEUM.

instead of upon the frieze, as in a Doric building (*cf.* Fig. 56). Above were the usual coffered slabs. The same illustration shows a well-preserved and finely proportioned doorway, but unfortunately leaves the details of its ornamentation indistinct.

The Ionic order was much used in the Greek cities of Asia Minor for peripteral temples. The most considerable remains of such buildings, at Ephesus, Priene, etc.,

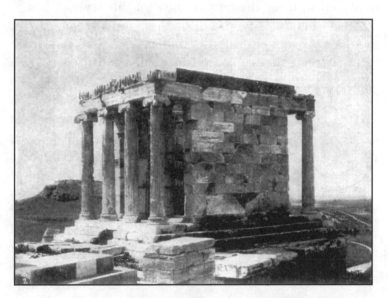

FIG. 70.–TEMPLE OF ATHENA NIKE, ATHENS

belong to the fourth century or later. In Greece proper there is no known instance of a peripteral Ionic temple, but the order was sometimes used for small prostyle and amphiprostyle buildings, such as the Temple of Athena Nike in Athens (Fig. 70). Furthermore, Ionic columns were sometimes employed in the interior of Doric temples, as at Bassæ in Arcadia and (probably) in the temple built by Scopas at Tegea. In the

Propylæa or gateway of the Athenian Acropolis we even find the Doric and Ionic orders juxtaposed, the exterior architecture being Doric and the interior Ionic, with no wall to separate them. One more interesting occurrence of the Ionic order in Greece proper may be mentioned, viz., in the Philippeum at Olympia (about 336 B.C.). This is a circular building, surrounded by an Ionic colonnade. Still other types of building afforded opportunity enough for the employment of this style.

After what has been said of the gradual changes in the Doric order, it will be understood that the Ionic order was not the same in the sixth century as in the fifth, nor in the fifth the same as in the third. The most striking change concerns the spiral roll of the capital. In the good period the portion of this member which connects the volutes is

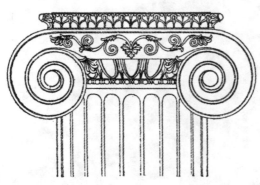

FIG. 71.—IONIC CAPITAL FROM SAMOTHRACE.

bounded below by a depressed curve, graceful and vigorous. With the gradual degradation of taste this curve tended to become a straight line, the result being the unlovely, mechanical form shown in Fig. 71 (from a building of Ptolemy Philadelphus, who reigned from 283 to 246 B.C.). Better formed capitals than this continued for some time to be made in Greek lands ; but the type just shown, or rather something resembling it in the disagreeable feature noted, became canonical with Roman architects.

The Corinthian order, as it is commonly called, hardly deserves to be called a distinct order. Its only peculiar feature is the capital ; otherwise it agrees with the Ionic order. The Corinthian capital is said to have been invented in the fifth century ; and a solitary specimen, of a meager and rudimentary type, found in 1812 in the Temple of Apollo at Bassæ, but since lost, was perhaps an original part of that building (about 430 B. C.). At present the earliest extant specimens are from the Monument of Lysicrates in Athens (c. 334 B. C.). It was from such a form as this that the luxuriant type of Corinthian capital so much in favor with Roman architects and their public was derived.

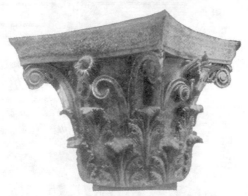

FIG. 72.—CORINTHIAN CAPITAL FROM EPIDAURUS.

In its usual form (as in Fig.72), the Corinthian capital has a cylindrical core, which expands slightly toward the top so as to become bell-shaped ; around the lower part of this core are two rows of conventionalized acanthus leaves, eight in each row ; from these rise eight principal stalks (each, in fully developed examples, wrapped about its base with an acanthus leaf) which combine, two and two, to form four volutes (*helices*), one under

each corner of the abacus, while smaller stalks, branching from the first, cover the rest of the upper part of the core ; there is commonly a floral ornament on the middle of each face at the top ; finally the abacus has, in plan, the form of a square whose sides have been hollowed out and whose corners have been truncated. In the form shown in Fig. 73 we find, first, a row of sixteen simple leaves, like those of a reed, with the points of a second row showing between them ; then a single row of eight acanthus leaves ; then the scroll-work, supporting a palmette on each side ; and finally an abacus whose profile is made up of a trochilus and an ovolo. This capital, though extremely elegant, is open to the charge of appearing weak at its middle. There is a much less ornate variety, also reckoned as Corinthian, which has no scroll-work, but only a row of acanthus leaves with a row of reed leaves above them around a bell-shaped core, the

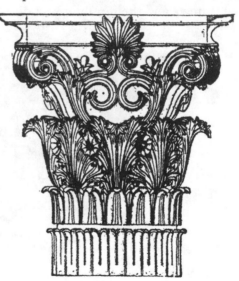

FIG. 73.—CORINTHIAN CAPITAL FROM THE CHORAGIC MONUMENT OF LYSICRATES. Athens.

whole surmounted by a square abacus. In the Choragic Monument of Lysicrates the cornice has dentels, and this was always the case, so far as we know, where the Corinthian capital was used. In Corinthian buildings the anta, where met with, has a capital like that of the

column. But there is very little material to generalize from until we descend to Roman times.

Some allusion has been made in the foregoing to other types of columnar buildings besides the temple. The principal ones of which remains exist are *propylæa* and *stoas*. Propylæa is the Greek name for a form of gateway, consisting essentially of a cross wall between side walls, with a portico on each front. Such gateways occur in many places as entrances to sacred precincts. The finest example, and one of the noblest monuments of Greek architecture, is that at the west end of the Athenian Acropolis. The stoa may be defined as a building having an open range of columns on at least one side. Usually its length was much greater than its depth. Stoas were often built in sacred precincts, as at Olympia, and also for secular purposes along public streets, as in Athens. These and other buildings into which the column entered as an integral feature involved no new architectural elements or principles.

One highly important fact about Greek architecture has thus far been only touched upon ; that is, the liberal use it made of color. The ruins of Greek temples are to-day monochromatic, either glittering white, as is the temple at Sunium, or of a golden brown, as are the Parthenon and other buildings of Pentelic marble, or of a still warmer brown, as are the limestone temples of Pæstum and Girgenti (Acragas). But this uniformity of tint is due only to time. A "White City," such as made the pride of Chicago in 1893, would have been unimaginable to an ancient Greek. Even to-day the attentive observer may sometimes see upon old Greek buildings, as, for example, upon ceiling-beams of the Parthenon, traces left by patterns from which the color has vanished. In other instances remains of actual

color exist. So specks of blue paint may still be seen, or might a few years ago, on blocks belonging to the Athenian Propylæa. But our most abundant evidence for the original use of color comes from architectural fragments that were long buried. During the excavation of Olympia (1875–81) this matter of the coloring of architecture was constantly in mind and a large body of facts relating to it was accumulated. Every new and important excavation adds to the store. At present our information is much fuller in regard to the polychromy of Doric than of Ionic buildings. It appears that, just as the forms and proportions of a building and of all its details were determined by precedent, yet not so absolutely as to leave no scope for the exercise of individual genius, so there was an established system in the coloring of a building, yet a system which varied somewhat according to time and place and the taste of the architect. Some have made attempts to suggest what the coloring of the Parthenon was like, and thus to illustrate the general scheme of Doric polychromy. The colors used were chiefly dark blue, sometimes almost black, and red ; green and yellow also occur, and some details were gilded. The coloration of the building was far from total. Plain surfaces, as walls, were unpainted. So too were the columns, including, probably, their capitals, except between the annulets. Thus color was confined to the upper members—the triglyphs, the under surface (soffit) of the cornice, the sima, the anta-capitals (*cf.* Fig. 54), the ornamental details generally, the coffers of the ceiling, and the backgrounds of sculpture. The triglyphs, regulæ, and mutules were blue ; the tænia of the architrave and the soffit of the cornice between the mutules with the adjacent narrow bands

were red ; the backgrounds of sculpture, either blue or
red ; the hawk's-beak molding, alternating blue and red ;
and so on. The principal uncertainty regards the treat-
ment of the unpainted members. Were these left of a
glittering white, or were they toned down, in the case of
marble buildings, by some application or other, so as to
contrast less glaringly with the painted portions? The
latter supposition receives some confirmation from
Vitruvius, a Roman writer on architecture of the age of
Augustus, and seems to some modern writers to be
demanded by æsthetic considerations. On the other
hand, the evidence of the Olympia buildings points the
other way. Perhaps the actual practice varied. As for
the coloring of Ionic architecture, we know that the
capital of the column was painted, but otherwise our
information is very scanty.

If it be asked what led the Greeks to a use of color so
strange to us and, on first acquaintance, so little to our
taste, it may be answered that possibly the example of
their neighbors had something to do with it. The
architecture of Egypt, of Mesopotamia, of Persia, was
polychromatic. But probably the practice of the Greeks
was in the main an inheritance from the early days of
their own civilization. According to a well-supported
theory, the Doric temple of the historical period is a
translation into stone or marble of a primitive edifice
whose walls were of sun-dried bricks and whose columns
and entablature were of wood. Now it is natural and
appropriate to paint wood ; and we may suppose that
the taste for a partially colored architecture was thus
formed. This theory does not indeed explain every-
thing. It does not, for example, explain why the
columns or the architrave should be uncolored. In

short, the Greek system of polychromy presents itself to us as a largely arbitrary system.

More interesting than the question of origin is the question of æsthetic effect. Was the Greek use of color in good taste? It is not easy to answer with a simple yes or no. Many of the attempts to represent the facts by restorations on paper have been crude and vulgar enough. On the other hand, some experiments in decorating modern buildings with color, in a fashion, to be sure, much less liberal than that of ancient Greece, have produced pleasing results. At present the question is rather one of faith than of sight ; and most students of the subject have faith to believe that the appearance of a Greek temple in all its pomp of color was not only sumptuous, but harmonious and appropriate.

When we compare the architecture of Greece with that of other countries, we must be struck with the remarkable degree in which the former adhered to established usage, both in the general plan of a building and in the forms and proportions of each feature. Some measure of adherence to precedent is indeed implied in the very existence of an architectural style. What is meant is that the Greek measure was unusual, perhaps unparalleled. Yet the following of established canons was not pushed to a slavish extreme. A fine Greek temple could not be built according to a hard and fast rule. While the architect refrained from bold and lawless innovations, he yet had scope to exercise his genius. The differences between the Parthenon and any other contemporary Doric temple would seem slight, when regarded singly ; but the preeminent perfection of the Parthenon lay in just those skilfully calculated differences.

A Greek columnar building is extremely simple in form.* The outlines of an ordinary temple are those of an oblong rectangular block surmounted by a triangular roof. With a qualification to be explained presently, all the lines of the building, except those of the roof, are either horizontal or perpendicular. The most complicated Greek columnar buildings known, the Erechtheum and the Propylæa of the Athenian Acropolis, are simplicity itself when compared to a Gothic cathedral, with its irregular plan, its towers, its wheel windows, its multitudinous diagonal lines.

The extreme simplicity which characterizes the general form of a Greek building extends also to its sculptured and painted ornaments. In the Doric style these are very sparingly used ; and even the Ionic style, though more luxuriant, seems reserved in comparison with the wealth of ornamental detail in a Gothic cathedral. Moreover, the Greek ornaments are simple in character. Examine again the hawk's-beak, the egg-and-dart, the leaf-and-dart, the astragal, the guilloche, the honeysuckle, the meander or fret. These are almost the only continuous patterns in use in Greek architecture. Each consists of a small number of elements recurring in unvarying order ; a short section is enough to give the entire pattern. Contrast this with the string-course in the nave of the Cathedral of Amiens, where the motive of the design undergoes constant variation, no piece exactly duplicating its neighbor, or with the intricate interlacing patterns of Arabic decoration, and you will have a striking illustration of the Greek love for the finite and comprehensible.

When it was said just now that the main lines of a

* The substance of this paragraph and the following is borrowed from Boutmy, " Philosophie de l'Architecture en Grèce " (Paris, 1870).

Greek temple are either horizontal or perpendicular, the statement called for qualification. The elevations of the most perfect of Doric buildings, the Parthenon, could not be drawn with a ruler. Some of the apparently straight lines are really curved. The stylobate is not level, but convex, the rise of the curve amounting to $\frac{1}{450}$ of the length of the building ; the architrave has also a rising curve, but slighter than that of the stylobate. Then again, many of the lines that would commonly be taken for vertical are in reality slightly inclined. The columns slope inward and so do the principal surfaces of the building, while the anta-capitals slope forward. These refinements, or some of them, have been observed in several other buildings. They are commonly regarded as designed to obviate certain optical illusions supposed to arise in their absence. But perhaps, as one writer has suggested, their principal office was to save the building from an appearance of mathematical rigidity, to give it something of the semblance of a living thing.

Be that as it may, these manifold subtle curves and sloping lines testify to the extraordinary nicety of Greek workmanship. A column of the Parthenon, with its inclination, its tapering, its entasis, and its fluting, could not have been constructed without the most conscientious skill. In fact, the capabilities of the workmen kept pace with the demands of the architects. No matter how delicate the adjustment to be made, the task was perfectly achieved. And when it came to the execution of ornamental details, these were wrought with a free hand and, in the best period, with fine artistic feeling. The wall-band of the Erechtheum is one of the most exquisite things which Greece has left us.

Simplicity in general form, harmony of proportion, refinement of line—these are the great features of Greek columnar architecture.

One other type of Greek building, into which the column does not enter, or enters only in a very subordinate way, remains to be mentioned—the theater. Theaters abounded in Greece. Every considerable city and many a smaller place had at least one, and the

FIG. 74.—THEATER. Epidaurus.

ruins of these structures rank with temples and walls of fortification among the commonest classes of ruins in Greek lands. But in a sketch of Greek art they may be rapidly dismissed. That part of the theater which was occupied by spectators—the auditorium, as we may call it—was commonly built into a natural slope, helped out by means of artificial embankments and supporting walls. There was no roof. The building, therefore, had no exterior, or none to speak of. Such beauty

as it possessed was due mainly to its proportions. The theater at the sanctuary of Asclepius near Epidaurus, the work of the same architect who built the round building with the Corinthian columns referred to on page 103, was distinguished in ancient times for "harmony and beauty," as the Greek traveler, Pausanias (about 165 A. D.), puts it. It is fortunately one of the best preserved. Fig. 74, a view taken from a considerable distance, will give some idea of that quality which Pausanias justly admired. Fronting the auditorium was the stage building, of which little but foundations remains anywhere. So far as can be ascertained, this stage building had but small architectural pretensions until the post-classical period (*i. e.*, after Alexander). But there was opportunity for elegance as well as convenience in the form given to the stone or marble seats with which the auditorium was provided.

Greek Sculpture - General Considerations

In the Mycenæan period, as we have seen, the art of sculpture had little existence, except for the making of small images and the decoration of small objects. We have now to take up the story of the rise of this art to an independent and commanding position, of its perfection and its subsequent decline. The beginner must not expect to find this story told with as much fulness and certainty as is possible in dealing with the art of the Renaissance or any more modern period. The impossibility of equal fulness and certainty here will become apparent when we consider what our materials for constructing a history of Greek sculpture are.

First, we have a quantity of notices, more or less relevant, in ancient Greek and Roman authors, chiefly of the time of the Roman Empire. These notices are of the most miscellaneous description. They come from writers of the most unlike tastes and the most unequal degrees of trustworthiness. They are generally very vague, leaving most that we want to know unsaid. And they have such a haphazard character that, when taken all together, they do not begin to cover the field. Nothing like all the works of the greater sculptors, let alone the lesser ones, are so much as mentioned by name in extant ancient literature.

Secondly, we have several hundreds of original inscriptions belonging to Greek works of sculpture and containing the names of the artists who made them. It

was a common practice, in the case especially of inde-
pendent statues in the round, for the sculptor to attach
his signature, generally to the pedestal. Unfortunately,
while great numbers of these inscribed pedestals have
been preserved for us, it is very rarely that we have the
statues which once belonged on them. Moreover, the
artists' names which we meet on the pedestals are in
a large proportion of cases names not even mentioned
by our literary sources. In fact, there is only one in-
disputable case where we possess both a statue and the
pedestal belonging to it, the latter inscribed with the
name of an artist known to us from literary tradition.
(See pages 212–3.)

Thirdly, we have the actual remains of Greek sculp-
ture, a constantly accumulating store, yet only an
insignificant remnant of what once existed. These
works have suffered sad disfigurement. Not one life-
sized figure has reached us absolutely intact ; but few
have escaped serious mutilation. Most of those found
before the beginning of this century, and some of those
found since, have been subjected to a process known as
''restoration.'' Missing parts have been supplied, often
in the most arbitrary and tasteless manner, and injured
surfaces, *e. g.*, of faces, have been polished, with irrep-
arable damage as the result.

Again, it is important to recognize that the creations
of Greek sculpture which have been preserved to us are
partly original Greek works, partly copies executed in
Roman times from Greek originals. Originals, and
especially important originals, are scarce. The statues
of gold and ivory have left not a vestige behind. Those
of bronze, once numbered by thousands, went long ago,
with few exceptions, into the melting-pot. Even
sculptures in marble, though the material was less valu-

able, have been thrown into the lime-kiln or used as building stone or wantonly mutilated or ruined by neglect. There does not exist to-day a single certified original work by any one of the six greatest sculptors of Greece, except the Hermes of Praxiteles (see page 221). Copies are more plentiful. As nowadays many museums and private houses have on their walls copies of paintings by the " old masters," so, and far more usually, the public and private buildings of imperial Rome and of many of the cities under her sway were adorned with copies of famous works by the sculptors of ancient Greece. Any piece of sculpture might thus be multiplied indefinitely ; and so it happens that we often possess several copies, or even some dozens of copies, of one and the same original. Most of the masterpieces of Greek sculpture which are known to us at all are known only in this way.

The question therefore arises, How far are these copies to be trusted? It is impossible to answer in general terms. The instances are very few where we possess at once the original and a copy. The best case of the kind is afforded by Fig. 75, compared with Fig. 132. Here the head, fore-arms, and feet of the copy are modern and consequently do not enter into consideration. Limiting one's attention to the antique parts of the figure, one sees that it is a tolerably close, and yet a hard and lifeless, imitation of the original. This gives us some measure of the degree of fidelity we may expect in favorable cases. Generally speaking, we have to form our estimate of the faithfulness of a copy by the quality of its workmanship and by a comparison of it with other copies, where such exist. Often we find two or more copies agreeing with one another as closely as possible. This shows—and the conclusion is confirmed by other evidence—that means existed in Roman times of repro-

ducing statues with the help of measurements mechanically taken. At the same time, a comparison of copies

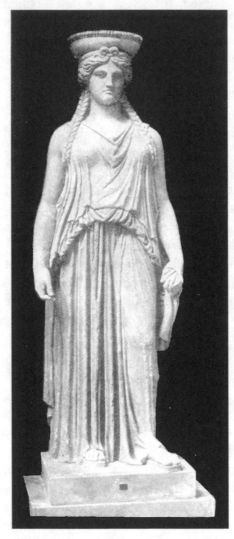

makes it apparent that copyists, even when aiming to be exact in the main, often treated details and accessories with a good deal of freedom. Of course, too, the skill and conscientiousness of the copyists varied enormously. Finally, besides copies, we have to reckon with variations and modernizations in every degree of earlier works. Under these circumstances it will easily be seen that the task of reconstructing a lost original from extant imitations is a very delicate and perilous one. Who could adequately appreciate the Sistine Madonna, if the inimitable touch of

FIG. 75.—COPY OF A CARYATID OF THE ERECH-
THEUM. Rome, Vatican Museum.

Raphael were known to us only at second-hand?

Any history of Greek sculpture attempts to piece together the several classes of evidence above described. It classifies the actual remains, seeking to assign to each piece its place and date of production and to infer from direct examination and comparison the progress of artistic methods and ideas. And this it does with constant reference to what literature and inscriptions have to tell us. But in the fragmentary state of our materials, it is evident that the whole subject must be beset with doubt. Great and steady progress has indeed been made since Winckelmann, the founder of the science of classical archæology, produced the first "History of Ancient Art" (published in 1763) ; but twilight still reigns over many an important question. This general warning should be borne in mind in reading this or any other hand-book of the subject.

We may next take up the materials and the technical processes of Greek sculpture. These may be classified as follows :

(1) Wood. Wood was often, if not exclusively, used for the earliest Greek temple-images, those rude *xoana*, of which many survived into the historical period, to be regarded with peculiar veneration. We even hear of wooden statues made in the developed period of Greek art. But this was certainly exceptional. Wood plays no part worth mentioning in the fully developed sculpture of Greece, except as it entered into the making of gold and ivory statues or of the cheaper substitutes for these.

(2) Stone and marble. Various uncrystallized limestones were frequently used in the archaic period and here and there even in the fifth century. But white marble, in which Greece abounds, came also early into

use, and its immense superiority to limestone for statuary purposes led to the abandonment of the latter. The choicest varieties of marble were the Parian and Pentelic (*cf.* page 77). Both of these were exported to every part of the Greek world.

A Greek marble statue or group is often not made of a single piece. Thus the Aphrodite of Melos (page 249) was made of two principal pieces, the junction coming just above the drapery, while several smaller parts, including the left arm, were made separately and attached. The Laocoön group (page 265), which Pliny expressly alleges to have been made of a single block, is in reality made of six. Often the head was made separately from the body, sometimes of a finer quality of marble, and then inserted into a socket prepared for it in the neck of the figure. And very often, when the statue was mainly of a single block, small pieces were attached, sometimes in considerable numbers. Of course the joining was done with extreme nicety, and would have escaped ordinary observation.

In the production of a modern piece of marble sculpture, the artist first makes a clay model and then a mere workman produces from this a marble copy. In the best period of Greek art, on the other hand, there seems to have been no mechanical copying of finished models. Preliminary drawings or even clay models, perhaps small, there must often have been to guide the eye ; but the sculptor, instead of copying with the help of exact measurements, struck out freely, as genius and training inspired him. If he made a mistake, the result was not fatal, for he could repair his error by attaching a fresh piece of marble. Yet even so, the ability to work in this way implies marvelous precision of eye and hand. To this ability and this method we may ascribe some-

thing of the freedom, the vitality, and the impulsiveness of Greek marble sculpture—qualities which the mechanical method of production tends to destroy. Observe too that, while pediment-groups, metopes, friezes, and reliefs upon pedestals would often be executed by subordinates following the design of the principal artist, any important single statue or group in marble was in all probability chiseled by the very hand of the master.

Another fact of importance, a fact which few are able to keep constantly enough in their thoughts, is that Greek marble sculpture was always more or less painted. This is proved both by statements in ancient authors and by the fuller and more explicit evidence of numberless actual remains. (See especially pages 148, 247.) From these sources we learn that eyes, eyebrows, hair, and perhaps lips were regularly painted, and that draperies and other accessories were often painted in whole or in part. As regards the treatment of flesh the evidence is conflicting. Some instances are reported where the flesh of men was colored a reddish brown, as in the sculpture of Egypt. But the evidence seems to me to warrant the inference that this was unusual in marble sculpture. On the "Alexander" sarcophagus the nude flesh has been by some process toned down to an ivory tint, and this treatment may have been the rule, although most sculptures which retain remains of color show no trace of this. Observe that wherever color was applied, it was laid on in "flat" tints, *i. e.*, not graded or shaded.

This polychromatic character of Greek marble sculpture is at variance with what we moderns have been accustomed to since the Renaissance. By practice and theory we have been taught that sculpture and painting are entirely distinct arts. And in the austere renuncia-

tion by sculpture of all color there has even been seen a special distinction, a claim to precedence in the hierarchy of the arts. The Greeks had no such idea. The sculpture of the older nations about them was polychromatic ; their own early sculpture in wood and coarse stone was almost necessarily so ; their architecture, with which sculpture was often associated, was so likewise. The coloring of marble sculpture, then, was a natural result of the influences by which that sculpture was molded. And, of course, the Greek eye took pleasure in the combination of form and color, and presumably would have found pure white figures like ours dull and cold. We are better circumstanced for judging Greek taste in this matter than in the matter of colored architecture, for we possess Greek sculptures which have kept their coloring almost intact. A sight of the "Alexander" sarcophagus, if it does not revolutionize our own taste, will at least dispel any fear that a Greek artist was capable of outraging beautiful form by a vulgarizing addition.

(3) Bronze. This material (an alloy of copper with tin and sometimes lead), always more expensive than marble, was the favorite material of some of the most eminent sculptors (Myron, Polyclitus, Lysippus) and for certain purposes was always preferred. The art of casting small, solid bronze images goes far back into the prehistoric period in Greece. At an early date, too (we cannot say how early), large bronze statues could be made of a number of separate pieces, shaped by the hammer and riveted together. Such a work was seen at Sparta by the traveler Pausanias, and was regarded by him as the most ancient existing statue in bronze. A great impulse must have been given to bronze sculpture by the introduction of the process of hollow-casting.

Pausanias repeatedly attributes the invention of this process to Rhœcus and Theodorus, two Samian artists, who flourished apparently early in the sixth century. This may be substantially correct, but the process is much more likely to have been borrowed from Egypt than invented independently.

In producing a bronze statue it is necessary first to make an exact clay model. This done, the usual Greek practice seems to have been to dismember the model and take a casting of each part separately. The several bronze pieces were then carefully united by rivets or solder, and small defects were repaired by the insertion of quadrangular patches of bronze. The eye-sockets were always left hollow in the casting, and eyeballs of glass, metal, or other materials, imitating cornea and iris, were inserted.* Finally, the whole was gone over with appropriate tools, the hair, for example, being furrowed with a sharp graver and thus receiving a peculiar, metallic definiteness of texture.

A hollow bronze statue being much lighter than one in marble and much less brittle, a sculptor could be much bolder in posing a figure of the former material than one of the latter. Hence when a Greek bronze statue was copied in marble in Roman times, a disfiguring support, not present in the original, had often to be added (*cf.* Figs. 101, 104, etc.). The existence of such a support in a marble work is, then, one reason among others for assuming a bronze original. Other indications pointing the same way are afforded by a peculiar sharpness of edge, *e.g.*, of the eyelids and the eyebrows, and by the metallic treatment of the hair. These points are well illustrated by Fig. 76. Notice especially the curls, which in the original would have been made of

* Marble statues also sometimes had inserted eyes.

separate strips of bronze, twisted and attached after the casting of the figure.

Bronze reliefs were not cast, but produced by hammering. This is what is called *repoussé* work. These bronze reliefs were of small size, and were used for ornamenting helmets, cuirasses, mirrors, and so on.

(4) Gold and ivory. Chryselephantine statues, *i.e.*, statues of gold and ivory, must, from the costliness of the materials, have been always comparatively rare. Most of them, though not all, were temple-images, and the most famous ones were of colossal size. We are very imperfectly informed as to how these figures were made. The colossal ones contained a strong framework of timbers and metal bars, over which was built a figure of wood. To this the gold and ivory were attached, ivory being used for flesh and gold for all other parts. The gold on the Athena of the Parthenon (*cf.* page 186) weighed a good deal over a ton. But costly as these works were, the ad-

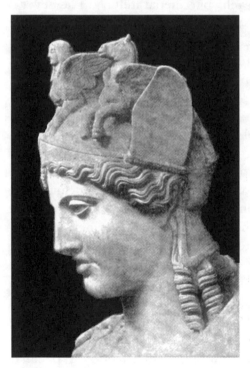

FIG. 76.—HEAD OF THE FARNESE ATHENA.

miration felt for them seems to have been untainted by any thought of that fact.

(5) Terra-cotta. This was used at all periods for small figures, a few inches high, immense numbers of which have been preserved to us. But large terra-cotta figures, such as were common in Etruria, were probably quite exceptional in Greece.

Greek sculpture may be classified, according to the purposes which it served, under the following heads :

(1) Architectural sculpture. A temple could hardly be considered complete unless it was adorned with more or less of sculpture. The chief place for such sculpture was in the pediments and especially in the principal or eastern pediment. Relief-sculpture might be applied to Doric metopes or an Ionic frieze. And finally, single statues or groups might be placed, as acroteria, upon the apex and lower corners of a pediment. Other sacred buildings besides temples might be similarly adorned. But we hear very little of sculpture on secular buildings.

(2) Cult-images. As a rule, every temple or shrine contained at least one statue of the divinity, or of each divinity, worshiped there.

(3) Votive sculptures. It was the habit of the Greeks to present to their divinities all sorts of objects in recognition of past favors or in hope of favors to come. Among these votive objects or *anathemata* works of sculpture occupied a large and important place. The subjects of such sculptures were various. Statues of the god or goddess to whom the dedication was made were common ; but perhaps still commoner were figures representing human persons, either the dedicators themselves or others in whom they were nearly interested. Under this latter head fall most of the many statues of

victors in the athletic games. These were set up in
temple precincts, like that of Zeus at Olympia, that of
Apollo at Delphi, or that of Athena on the Acropolis of
Athens, and were, in theory at least, intended rather as
thank-offerings than as means of glorifying the victors
themselves.

(4) Sepulchral sculpture. Sculptured grave monu-
ments were common in Greece at least as early as the
sixth century. The most usual monument was a slab of
marble—the form varying according to place and time
—sculptured with an idealized representation in relief of
the deceased person, often with members of his family.

(5) Honorary statues. Statues representing dis-
tinguished men, contemporary or otherwise, could be
set up by state authority in secular places or in sanctu-
aries. The earliest known case of this kind is that of
Harmodius and Aristogiton, shortly after 510 B. C. (*cf.*
pages 160–4). The practice gradually became common,
reaching an extravagant development in the period after
Alexander.

(6) Sculpture used merely as ornament, and having
no sacred or public character. This class belongs
mainly, if not wholly, to the latest period of Greek art.
It would be going beyond our evidence to say that
never, in the great age of Greek sculpture, was a statue
or a relief produced merely as an ornament for a private
house or the interior of a secular building. But certain
it is that the demand for such things before the time of
Alexander, if it existed at all, was inconsiderable. It
may be neglected in a broad survey of the conditions of
artistic production in the great age.

The foregoing list, while not quite exhaustive, is suf-
ficiently so for present purposes. It will be seen how
inspiring and elevating was the rôle assigned to the

sculptor in Greece. His work, destined to be seen by intelligent and sympathetic multitudes, appealed, not to the coarser elements of their nature, but to the most serious and exalted. Hence Greek sculpture of the best period is always pure and noble. The grosser aspects of Greek life, which flaunt themselves shamelessly in Attic comedy, as in some of the designs upon Attic vases, do not invade the province of this art.

It may be proper here to say a word in explanation of that frank and innocent nudity which is so characteristic a trait of the best Greek art. The Greek admiration for the masculine body and the willingness to display it were closely bound up with the extraordinary importance in Greece of gymnastic exercises and contests and with the habits which these engendered. As early as the seventh century, if not earlier, the competitors in the foot-race at Olympia dispensed with the loin-cloth, which had previously been the sole covering worn. In other Olympic contests the example thus set was not followed till some time later, but in the gymnastic exercises of every-day life the same custom must have early prevailed. Thus in contrast to primitive Greek feeling and to the feeling of "barbarians" generally, the exhibition by men among men of the naked body came to be regarded as something altogether honorable. There could not be better evidence of this than the fact that the archer-god, Apollo, the purest god in the Greek pantheon, does not deign in Greek art to veil the glory of his form.

Greek sculpture had a strongly idealizing bent. Gods and goddesses were conceived in the likeness of human beings, but human beings freed from every blemish, made august and beautiful by the artistic imagination. The subjects of architectural sculpture were mainly mythological, historical scenes being very rare in purely

Greek work; and these legendary themes offered little temptation to a literal copying of every-day life. But what is most noteworthy is that even in the representation of actual human persons, *e. g.*, in athlete statues and upon grave monuments, Greek sculpture in the best period seems not to have even aimed at exact portraiture. The development of realistic portraiture belongs mainly to the age of Alexander and his successors.

Mr. Ruskin goes so far as to say that a Greek " never expresses personal character," and " never expresses momentary passion."* These are reckless verdicts, needing much qualification. For the art of the fourth century they will not do at all, much less for the later period. But they may be of use if they lead us to note the preference for the typical and permanent with which Greek sculpture begins, and the very gradual way in which it progresses toward the expression of the individual and transient. However, even in the best period the most that we have any right to speak of is a prevailing tendency. Greek art was at all times very much alive, and the student must be prepared to find exceptions to any formula that can be laid down.

* " Aratra Pentelici," Lecture VI., §§ 191, 193.

CHAPTER 5

The Archaic Period of Greek Sculpture First Half: 625 (?) - 550 B.C.

THE date above suggested for the beginning of the period with which we have first to deal must not be regarded as making any pretense to exactitude. We have no means of assigning a definite date to any of the most primitive-looking pieces of Greek sculpture. All that can be said is that works which can be confidently dated about the middle of the sixth century show such a degree of advancement as implies more than half a century of development since the first rude beginnings.

Tradition and the more copious evidence of actual remains teach us that these early attempts at sculpture in stone or marble were not confined to any one spot or narrow region. On the contrary, the centers of artistic activity were numerous and widely diffused—the islands of Crete, Paros, and Naxos; the Ionic cities of Asia Minor and the adjacent islands of Chios and Samos; in Greece proper, Bœotia, Attica, Argolis, Arcadia, Laconia; in Sicily, the Greek colony Selinus; and doubtless many others. It is very difficult to make out how far these different spots were independent of one another; how far, in other words, we have a right to speak of local "schools" of sculpture. Certainly there was from the first a good deal of action and reaction between some of these places, and one chief problem of the subject is to discover the really originative centers of artistic impulse, and to trace the spread of artistic types

FIG. 77.—ARCHAIC FEMALE FIGURE FROM
DELOS. Athens, National Museum.

and styles and methods from place to place. Instead of attempting here to discuss or decide this difficult question, it will be better simply to pass in review a few typical works of the early archaic period from various sites.

The first place may be given to a marble image (Fig. 77) found in 1878 on the island of Delos, that ancient center of Apolline worship for the Ionians. On the left side of the figure is engraved in early Greek characters a metrical inscription, recording that the statue was dedicated to Artemis by one Nicandra of Naxos. Whether it was intended to represent the goddess Artemis or the woman Nicandra, we cannot tell; nor is the question of much importance to us. We have here an extremely rude attempt to represent a draped female

form. The figure stands stiffly erect, the feet close together, the arms hanging straight down, the face looking directly forward. The garment envelops the body like a close-fitting sheath, without a suggestion of folds. The trunk of the body is flat or nearly so at the back, while in front the prominence of the breasts is suggested by the simple device of two planes, an upper and a lower, meeting at an angle. The shapeless arms were not detached from the sides, except just at the waist. Below the girdle the body is bounded by parallel planes in front and behind and is rounded off at the sides. A short projection at the bottom, slightly rounded and partly divided, does duty for the feet. The features of the face are too much battered to be commented upon. The most of the hair falls in a rough mass upon the back, but on either side a bunch, divided by grooves into four locks, detaches itself and is brought forward upon the breast. This primitive image is not an isolated specimen of its type. Several similar figures or fragments of figures have been found on the island of Delos, in Bœotia, and elsewhere. A small statuette of this type, found at Olympia, but probably produced at Sparta, has its ugly face tolerably preserved.

Another series of figures, much more numerously represented, gives us the corresponding type of male figure. One of the earliest examples of this series is shown in Fig. 78, a life-sized statue of Naxian marble, found on the island of Thera in 1836. The figure is completely nude. The attitude is like that of the female type just described, except that the left foot is advanced. Other statues, agreeing with this one in attitude, but showing various stages of development, have been found in many places, from Samos on the east to Actium on the west. Several features of this class of figures have been thought

to betray Egyptian influence.* The rigid position might be adopted independently by primitive sculpture anywhere. But the fact that the left leg is invariably advanced, the narrowness of the hips, and the too high position frequently given to the ears— did this group of coincidences with the stereotyped Egyptian standing figures come about without imitation? There is no historical difficulty in the way of assuming Egyptian influence, for as early as the seventh century Greeks certainly visited Egypt and it was perhaps in this century that the Greek colony of Naucratis was founded in the delta

FIG. 78.—"APOLLO" OF THERA. Athens, National Museum.

of the Nile. Here was a chance for Greeks to see

* See Wolters's edition of Friederichs's "Gipsabgüsse antiker Bildwerke," pages 11, 12.

Egyptian statues ; and besides, Egyptian statuettes may have reached Greek shores in the way of commerce. But be the truth about this question what it may, the early Greek sculptors were as far as possible from slavishly imitating a fixed prototype. They used their own eyes and strove, each in his own way, to render what they saw. This is evident, when the different examples of the class of figures now under discussion are passed in review.

Our figure from Thera is hardly more than a first attempt. There is very little of anatomical detail, and what there is is not correct ; especially the form and the muscles of the abdomen are not understood. The head presents a number of characteristics which were destined long to persist in Greek sculpture. Such are the protuberant eyeballs, the prominent cheek-bones, the square, protruding chin. Such, too, is the formation of the mouth, with its slightly upturned corners—a feature almost, though not quite, universal in Greek faces for more than a century. This is the sculptor's childlike way of imparting a look of cheerfulness to the countenance, and with it often goes an upward slant of the eyes from the inner to the outer corners. In representing this youth as wearing long hair, the sculptor followed the actual fashion of the times, a fashion not abandoned till the fifth century and in Sparta not till later. The appearance of the hair over the forehead and temples should be noticed. It is arranged symmetrically in flat spiral curls, five curls on each side. Symmetry in the disposition of the front hair is constant in early Greek sculpture, and some scheme or other of spiral curls is extremely common.

It was at one time thought that these nude standing figures all represented Apollo. It is now certain that

Apollo was sometimes intended, but equally certain that the same type was used for men. Greek sculpture had not yet learned to differentiate divine from human beings.

FIG. 79.—"APOLLO" OF TENEA.
Munich.

The so-called "Apollo" of Tenea (Fig. 79), probably in reality a grave-statue representing the deceased, was found on the site of the ancient Tenea, a village in the territory of Corinth. It is unusually well preserved, there being nothing missing except the middle portion of the right arm, which has been restored. This figure shows great improvement over his fellow from Thera. The rigid attitude, to be sure, is preserved unchanged, save for a slight bending of the arms at the elbows ; and we meet again the prominent eyes, cheek-bones, and chin, and the smiling mouth. But the arms are much more detached from the sides and the modeling of the figure generally is much more detailed. There are still faults in plenty, but some parts are rendered very well, particularly the lower legs and feet, and the figure seems alive. The position of the feet, flat upon the ground and parallel to one another, shows us how to complete in imagination the "Apollo"

of Thera and other mutilated members of the series.

Greek sculpture even in its earliest period could not limit itself to single standing figures. The desire to adorn the pediments of temples and temple-like buildings gave rise to more complex compositions. The earliest pediment-sculptures known were found on the Acropolis of Athens in the excavations of 1885-90 (see page 147). The most primitive of these is a low relief

FIG. 80.—ARCHAIC PEDIMENT-FIGURES. Athens, Acropolis Museum.

of soft *poros* (see page 78), representing Heracles slaying the many-headed hydra. Somewhat later, but still very rude, is the group shown in Fig. 80, which once occupied the right-hand half of a pediment. The material here is a harder sort of *poros*, and the figures are practically in the round, though on account of the connection with the background the work has to be classed as high relief. We see a triple monster, or rather three monsters, with human heads and trunks and arms, the human bodies passing into long

snaky bodies coiled together. A single pair of wings was divided between the two outermost of the three beings, while snakes' heads, growing out of the human

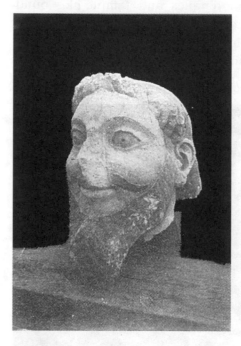

bodies, rendered the aspect of the group still more portentous. The center of the pediment was probably occupied by a figure of Zeus, hurling his thunderbolt at this strange enemy. We have therefore here a scene from one of the favorite subjects of Greek art at all periods—the *gigantomachy*, or battle of gods and giants. Fig. 81 gives a better idea of the nearest of the three heads.* It was

FIG. 81.—HEAD BELONGING TO AN ARCHAIC PEDIMENT-GROUP. Athens, Acropolis Museum.

completely covered with a crust of paint, still pretty well preserved. The flesh was red; the hair, moustache, and beard, blue; the irises of the eyes, green; the eyebrows, edges of the eyelids, and pupils, black. A considerable quantity of early *poros* sculptures was found on the Athenian Acropolis. These were all liberally painted. The poor quality of the material was thus largely or wholly concealed.

* It is doubtful whether this head belongs where it is placed in Fig. 80, or in another pediment-group, of which fragments have been found.

Fig. 82 shows another Athenian work, found on the Acropolis in 1864–65. It is of marble and is obviously of later date than the *poros* sculptures. In 1887 the pedestal of this statue was found, with a part of the right foot. An inscription on the pedestal shows that the statue was dedicated to some divinity, doubtless Athena, whose precinct the Acropolis was. The figure then probably represents the dedicator, bringing a calf for sacrifice. The position of the body and legs is here the same as in the "Apollo" figures, but the subject has compelled the sculptor to vary the position of the arms.

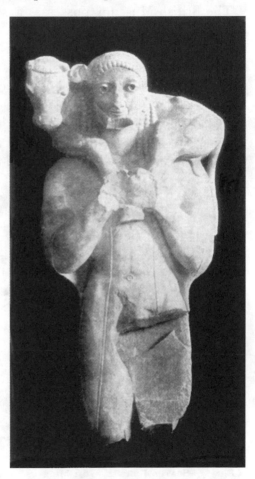

FIG. 82.—MALE FIGURE CARRYING A CALF, c. 570 B.C., Athens, Acropolis Museum.

Another difference from the "Apollo" figures lies in the fact that this statue is not wholly naked. The garment, however, is hard to make out, for it clings

closely to the person of the wearer and betrays its exist-
ence only along the edges. The sculptor had not yet
learned to represent the folds of drapery.

The British Museum possesses a series of ten seated
figures of Parian marble, which were once ranged along
the approach to an important temple of Apollo near Mi-
letus. Fig. 83 shows three of these. They are placed
in their assumed chronological order, the earliest
furthest off. Only the first two belong in the period
now under review. The figures are heavy and lumpish,
and are enveloped, men and women alike, in draperies,
which leave only the heads, the fore-arms, and the toes

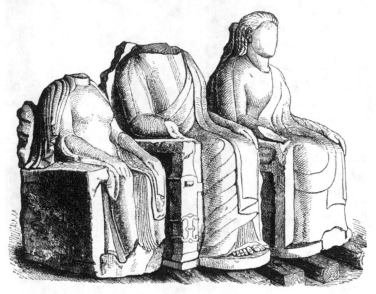

FIG. 83.--SEATED FIGURES FROM MILETUS. London, British Museum.

exposed. It is interesting to see the successive sculptors
attacking the problem of rendering the folds of loose
garments. Not until we reach the latest of the three
statues do we find any depth given to the folds ; and

that figure belongs distinctly in the latter half of the archaic period.

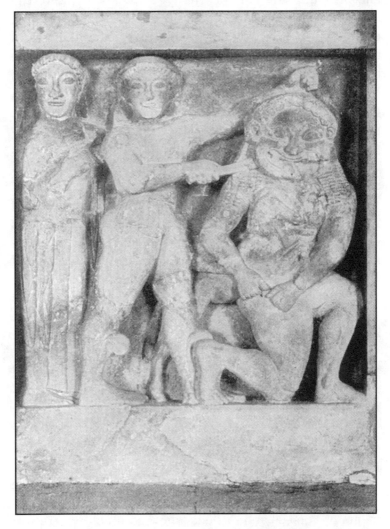

FIG. 84.—METOPE FROM SELINUS. Palermo.

Transporting ourselves now from the eastern to the western confines of Greek civilization, we may take a

look at a sculptured metope from Selinus in Sicily (Fig. 84). That city was founded, according to our best ancient authority, about the year 629 B.C., and the temple from which our metope is taken is certainly one of the oldest, if not the oldest, of the many temples of the place. The material of the metope, as of the whole temple, is a local *poros*, and the work is executed in high relief. The subject is Perseus cutting off the head of Medusa. The Gorgon is trying to run away—the position given to her legs is used in early Greek sculpture and vase-painting to signify rapid motion—but is overtaken by her pursuer. From the blood of Medusa sprang, according to the legend, the winged horse, Pegasus ; and the artist, wishing to tell as much of the story as possible, has introduced Pegasus into his composition, but has been forced to reduce him to miniature size. The goddess Athena, the protectress of Perseus, occupies what remains of the field. There is no need of dwelling in words on the ugliness of this relief, an ugliness only in part accounted for by the subject. The student should note that the body of each of the three figures is seen from the front, while the legs are in profile. The same distortion occurs in a second metope of this same temple, representing Heracles carrying off two prankish dwarfs who had tried to annoy him, and is in fact common in early Greek work. We have met something similar in Egyptian reliefs and paintings (*cf.* page 33), but this method of representing the human form is so natural to primitive art that we need not here assume Egyptian influence. The garments of Perseus and Athena show so much progress in the representation of folds that one scruples to put this temple back into the seventh century, as some would have us do. Like the *poros* sculptures of Attica, these

Selinus metopes seem to have been covered with color.

Fig. 85 takes us back again to the island of Delos, where the statue came to light in 1877. It is of Parian marble, and is considerably less than life-sized. A female figure is here represented, the body unnaturally twisted at the hips, as in the Selinus metopes, the legs bent in the attitude of rapid motion. At the back there were wings, of which only the stumps now remain. A comparison of this statue with similar figures from the Athenian Acropolis has shown that the feet did not touch the pedestal, the drapery serving as a support. The intention of the artist, then, was to represent a flying figure, probably a Victory. The goddess is dressed in a *chiton* (shift), which shows no trace of folds above the girdle, while below the girdle, between the legs, there is a series of flat, shallow ridges. The face shows the usual archaic fea-

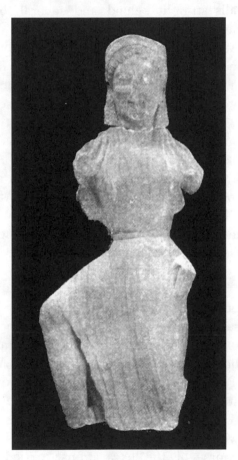

FIG. 85.—ARCHAIC VICTORY (?), FROM DELOS. Athens, National Museum.

tures—the prominent eyeballs, cheeks, and chin, and the smiling mouth. The hair is represented as fastened by a sort of hoop, into which metallic ornaments, now lost, were inserted. As usual, the main mass of the hair falls straight behind, and several locks, the same number on each side, are brought forward upon the breast. As usual, too, the front hair is disposed symmetrically ; in this case, a smaller and a larger flat curl on each side of the middle of the forehead are succeeded by a continuous tress of hair arranged in five scallops.

If, as has been generally thought, this statue belongs on an inscribed pedestal which was found near it, then we have before us the work of one Archermus of Chios, known to us from literary tradition as the first sculptor to represent Victory with wings. At all events, this, if a Victory, is the earliest that we know. She awakens our interest, less for what she is in herself than because she is the forerunner of the magnificent Victories of developed Greek art.

Thus far we have met very few works to which it is possible to assign a precise date. We have now the satisfaction of finding a chronological landmark in our path. This is afforded by some fragments of sculpture belonging to the old Temple of Artemis at Ephesus. The date of this temple is approximately fixed by the statement of Herodotus (I., 92) that most of its columns were presented by Crœsus, king of Lydia, whose reign lasted from 560 to 546 B. C. In the course of the excavations carried on for the British Museum upon the site of Ephesus there were brought to light, in 1872 and 1874, a few fragments of this sixth century edifice. Even some letters of Crœsus's dedicatory inscription have been found on the bases of the Ionic columns, affording a welcome confirmation to the

testimony of Herodotus. It appears that the columns, or some of them, were treated in a very exceptional fashion, the lowest drums being adorned with relief-sculpture. The British Museum authorities have partially restored one such drum (Fig. 86), though without guaranteeing that the pieces of sculpture here combined actually belong to the same column. The male figure is not very prepossessing, but that is partly due to the battered condition of the face. Much more attractive is the female head, of which unfortunately only the back is seen in our illustration.

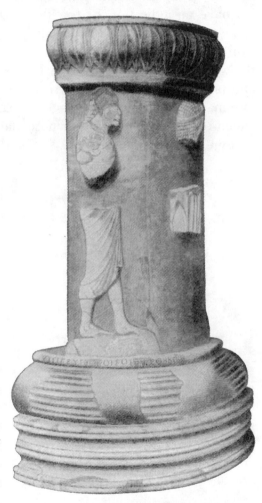

FIG. 86.—LOWER PART OF ARCHAIC SCULPTURED COLUMN FROM EPHESUS. London, British Museum.

It bears a strong family likeness to the head of the Victory of Delos, but shows marked im-

provement over that. Some bits of a sculptured cornice belonging to the same temple are also refined in style. In this group of reliefs, fragmentary though they are, we have an indication of the development attained by Ionic sculptors about the middle of the sixth century. For, of course, though Crœsus paid for the columns, the work was executed by Greek artists upon the spot, and presumably by the best artists that could be secured. We may therefore use these sculptures as a standard by which to date other works, whose date is not fixed for us by external evidence.

CHAPTER 6

The Archaic Period of Greek Sculpture
Second Half: 550 - 480 B.C.

GREEK sculpture now enters upon a stage of development which possesses for the modern student a singular and potent charm. True, many traces still remain of the sculptor's imperfect mastery. He cannot pose his figures in perfectly easy attitudes, not even in reliefs, where the problem is easier than in sculpture in the round. His knowledge of human anatomy—that is to say, of the outward appearance of the human body, which is all the artistic anatomy that any one attempted to know during the rise and the great age of Greek sculpture—is still defective, and his means of expression are still imperfect. For example, in the nude male figure the hips continue to be too narrow for the shoulders, and the abdomen too flat. The facial peculiarities mentioned in the preceding chapter—prominent eyeballs, cheeks, and chin, and smiling mouth—are only very gradually modified. As from the first, the upper eyelid does not overlap the lower eyelid at the outer corner, as truth, or rather appearance, requires ; and in relief-sculpture the eye of a face in profile is rendered as in front view. The texture and arrangement of hair are expressed in various ways, but always with a marked love of symmetry and formalism. In the difficult art of representing drapery there is much experimentation and great progress. It seems to have been among the eastern Ionians, perhaps at Chios, that

the deep cutting of folds was first practiced, and from Ionia this method of treatment spread to Athens and elsewhere. When drapery is used, there is a manifest desire on the sculptor's part to reveal what he can, more, in fact, than in reality could appear, of the form underneath. The garments fall in formal folds, sometimes of great elaboration. They look as if they were intended to represent garments of irregular cut, carefully starched and ironed. But one must be cautious about drawing inferences from an imperfect artistic manner as to the actual fashions of the day.

But whatever shortcomings in technical perfection may be laid to their charge, the works of this period are full of the indefinable fascination of promise. They are marked, moreover, by a simplicity and sincerity of purpose, an absence of all ostentation, a conscientious and loving devotion on the part of those who made them. And in many of them we are touched by great refinement and tenderness of feeling, and a peculiarly Greek grace of line.

To illustrate these remarks we may turn first to Lycia, in southwestern Asia Minor. The so-called " Harpy " tomb was a huge, four-sided pillar of stone, in the upper part of which a square burial-chamber was hollowed out. Marble bas-reliefs adorned the exterior of this chamber. The best of the four slabs is seen in Fig. 87.* At the right is a seated female figure, divinity or deceased woman, who holds in her right hand a pomegranate flower and in her left a pomegranate fruit. To her approach three women, the first raising the lower part of her chiton with her right hand and drawing forward her outer garment with her left, the second bringing a fruit and a flower, the third holding an egg

* Our illustration is not quite complete on the right.

in her right hand and raising her chiton with her left.
Then comes the opening into the burial-chamber, sur-
mounted by a diminutive cow suckling her calf. At
the left is another seated female figure, holding a bowl
for libation. The exact significance of this scene is un-
known, and we may limit our attention to its artistic
qualities. We have here our first opportunity of
observing the principle of *isocephaly* in Greek relief-
sculpture ; *i. e.*, the convention whereby the heads of

FIG. 87.—RELIEF FROM THE "HARPY" TOMB. London, British Museum.

figures in an extended composition are ranged on
nearly the same level, no matter whether the figures are
seated, standing, mounted on horseback, or placed in
any other position. The main purpose of this conven-
tion doubtless was to avoid the unpleasing blank spaces
which would result if the figures were all of the same
proportions. In the present instance there may be the
further desire to suggest by the greater size of the
seated figures their greater dignity as goddesses or
divinized human beings. Note, again, how, in the case
of each standing woman, the garments adhere to the
body behind. The sculptor here sacrifices truth for the
sake of showing the outline of the figure. Finally,

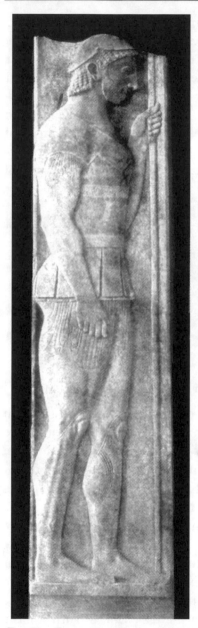

remark the daintiness with which the hands are used, particularly in the case of the seated figure on the right. The date of this work may be put not much later than the middle of the sixth century, and the style is that of the Ionian school.

Under the tyrant Pisistratus and his sons Athens attained to an importance in the world of art which it had not enjoyed before. A fine Attic work, which we may probably attribute to the time of Pisistratus, is the grave-monument of Aristion (Fig. 88). The material is Pentelic marble. The form of the monument, a tall, narrow, slightly tapering slab or *stêlê*, is the usual one in Attica in this period. The man represented in low relief is, of course, Aristion himself. He had probably fallen in battle, and so is put before us armed. Over a short chiton he wears a leather cuirass with a double

FIG. 88.—GRAVE-MONUMENT OF ARISTION. Athens, National Museum.

row of flaps below ; on his head is a small helmet, which leaves his face entirely exposed ; on his legs are greaves ; and in his left hand he holds a spear. There is some constraint in the position of the left arm and hand, due to the limitations of space. In general, the anatomy, so far as exhibited, is creditable, though fault might be found with the shape of the thighs. The hair, much shorter than is usual in the archaic period, is arranged in careful curls. The beard, trimmed to a point in front, is rendered by parallel grooves. The chiton, where it shows from under the cuirass, is arranged in symmetrical plaits. There are considerable traces of color on the relief, as well as on the background. Some of these may be seen in our illustration on the cuirass.

Our knowledge of early Attic sculpture has been immensely increased by the thorough exploration of the summit of the Athenian Acropolis in 1885–90. In regard to these important excavations it must be remembered that in 480 and again in 479 the Acropolis was occupied by Persians belonging to Xerxes' invading army, who reduced the buildings and sculptures on that site to a heap of fire-blackened ruins. This débris was used by the Athenians in the generation immediately following toward raising the general level of the summit of the Acropolis. All this material, after having been buried for some twenty-three and a half centuries, was finally recovered. With the help of these remains, which include numerous inscribed pedestals, it is seen that under the rule of Pisistratus and his sons Athens attracted to itself talented sculptors from other Greek communities, notably from Chios and Ionia generally. It is to Ionian sculptors and to Athenian sculptors brought under Ionian influences that

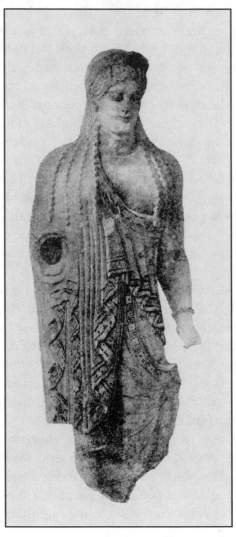

FIG. 89.—ARCHAIC FEMALE FIGURE.
Athens, Acropolis Museum.

we must attribute almost all those standing female figures which form the chief part of this fine collection of the Acropolis Museum.

The figures of this type stand with the left foot, as a rule, a little advanced, the body and head facing directly forward with primitive stiffness. But the arms no longer hang straight at the sides, one of them, regularly the right, being extended from the elbow, while the other holds up the voluminous drapery. Many of the statues retain copious traces of color on hair, eyebrows, eyes, draperies, and ornaments; in no case does the flesh give any evidence of having been painted (*cf.* page 119). Fig. 89 is taken from an illustration which gives the shade as it

was when the statue was first found, before it had suffered from exposure.

Fig. 90 is not in itself one of the most pleasing of the series, but it has a special interest, not merely on account of its exceptionally large size—it is over six and a half feet high—but because we probably know the name and something more of its sculptor. If, as seems altogether likely, the statue belongs upon the inscribed pedestal upon which it is placed in the illustration, then we have before us an original work of that Antenor who was commissioned by the Athenian people, soon after the expulsion of the

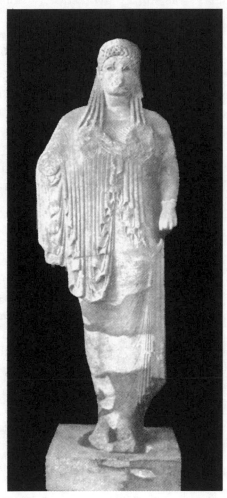

FIG. 90.—STATUE BY ANTENOR (?). Athens, Acropolis Museum.

tyrant Hippias and his family in 510, to make a group in bronze of Harmodius and Aristogiton (*cf.* pages 160–4). This statue might, of course, be one of his earlier productions.

At first sight these figures strike many untrained observers as simply grotesque. Some of them are indeed odd; Fig. 91 reproduces one which is especially so. But they soon become absorbingly interesting and then delightful. The strange-looking, puzzling garments,* which cling to the figure behind and fall in formal folds in front, the elaborately, often impossibly, arranged hair, the gracious countenances, a certain quaintness and refinement and unconsciousness of self—these things exercise over us an endless fascination.

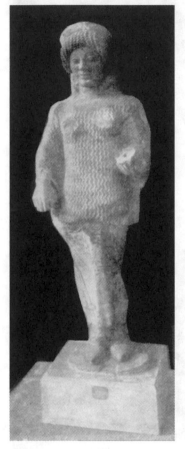

FIG. 91.—ARCHAIC FEMALE FIGURE. Athens, Acropolis Museum.

Who are these mysterious beings? We do not know. There are those who would see in them, or in some of them, representations of Athena, who was not only a martial goddess, but also patroness of spinning and weaving and all cunning handiwork. To others, including the writer, they seem, in their manifold variety, to be daughters of Athens.

* Fig. 91 wears only one garment, the Ionic chiton, a long linen shift, girded at the waist and pulled up so as to fall over and conceal the girdle. Figs. 89, 90, 92, 93 wear over this a second garment, which goes over the right shoulder and under the left. This over-garment reaches to the feet, so as to conceal the lower portion of the chiton. At the top it is folded over, or perhaps rather another piece of cloth is sewed on. This over-fold, if it may be so called, appears as if cut with two or more long points below.

But, if so, what especial claim these women had to be set up in effigy upon Athena's holy hill is an unsolved riddle.

Before parting from their company we must not fail to look at two fragmentary figures (Figs. 94, 95), the most advanced in style of the whole series and doubtless executed shortly before 480. In the former, presumably the earlier of the two, the marvelous arrangement of the hair over the forehead survives and the eyeballs still protrude unpleasantly. But the mouth has lost the conventional smile and the modeling of the face is of great beauty. In the other, alone of the series, the hair presents a fairly natural appearance, the eyeballs lie at their proper depth, and the beautiful curve

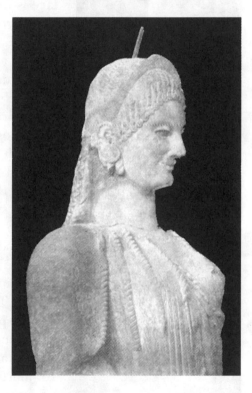

FIG. 92.—UPPER PART OF ARCHAIC FEMALE FIGURE. Athens, Acropolis Museum.

of the neck is not masked by the locks that fall upon the breasts. In this head, too, the mouth actually droops at the corners, giving a perhaps unintended look of seriousness to the face. The ear, though set rather high, is exquisitely shaped.

Still more lovely than this lady is the youth's head shown in Fig. 96. Fate has robbed us of the body to which it belonged, but the head itself is in an excellent state of preservation. The face is one of singular purity and sweetness. The hair, once of a golden tint, is long behind and is gathered into two braids, which start from just behind the ears, cross one another, and are fastened together in front ; the short front hair is combed forward and conceals the ends of the braids ; and there is a mysterious puff in front of each ear. In the whole work, so far at least as appears in a profile view, there is nothing to mar our pleasure. The sculptor's hand has responded cunningly to his beautiful thought.

It is a pity not to be able to illustrate another group of Attic sculptures of the late archaic period, some more recent additions to our store. The metope of the Treasury of the Athenians at Delphi, discovered during

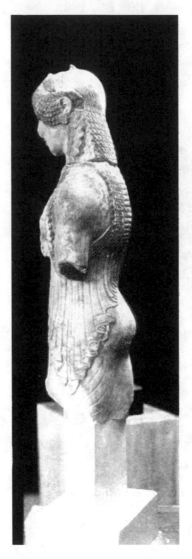

FIG. 93.—ARCHAIC FEMALE FIGURE.
Athens, Acropolis Museum.

extensive excavations, are of extraordinary

interest and importance ; but only two or three of them were made available, and these in a form not suited for reproduction. The same is the case with another of the notable finds at Delphi, the sculptured frieze of the Treasury of the Siphnians, already famous among professional students and destined to be known and admired by a wider public. Here, however, it is possible to submit a single fragment, which was found years ago (Fig. 97). It represents a four-horse chariot approaching an altar. Strikingly, some pieces of this frieze

FIG. 94.—FRAGMENT OF ARCHAIC FEMALE FIGURE. Athens, Acropolis Museum.

have abundant remains of color. The work is dated at approximately 525 B.C.

The pediment-figures from Ægina, the chief treasure of the Munich collection of ancient sculpture, were found in 1811 by a party of scientific explorers and were restored in Italy under the superintendence of the Danish sculptor, Thorwaldsen. For many years these Æginetan figures were our only important group of late archaic Greek sculptures ; and, though that is no longer the case, they still retain, and will always retain, an especial interest and significance. They once filled the

pediments of a Doric temple of Aphaia, of which considerable remains are still standing. There is no trustworthy external clue to the date of the building, and we are therefore obliged to depend for that on the style of the architecture and sculpture, especially the latter. In the dearth of accurately dated monuments which might serve as standards of comparison, great difference of opinion on this point has prevailed. But many clues exist within the detailed statues; they've been compared to works at Athens and Delphi, and we shall probably not go far wrong in assigning the temple with its sculptures to about 480 B. C. Fig. 52 illustrates, though somewhat incorrectly, the composition of the western pediment. The subject was a combat, in the presence of Athena, between Greeks and Trojans, probably

FIG. 95.—FRAGMENT OF ARCHAIC FEMALE FIGURE. Athens, Acropolis Museum.

on the plain of Troy. A close parallelism existed between the two halves of the pediment, each figure, except the goddess and the fallen warrior at her feet, correspond-

ing to a similar figure on the opposite side. Athena, protectress of the Greeks, stands in the center (Fig. 98). She wears two garments, of which the outer one (the

only one seen in the illustration) is a marvel of formalism. Her ægis covers her breasts and hangs far down behind ; the points of its scalloped edge once bristled with serpents' heads, and there was a Gorgon's head in the middle of the front. She has upon her head a helmet with lofty crest, and carries shield and lance. The men, with the exception of the two archers, are naked, and their helmets, which are

FIG. 96.—HEAD OF A YOUTH. Athens, Acropolis Museum.

of a form intended to cover the face, are pushed back. Of course, men did not actually go into battle in this fashion ; but the sculptor did not care for realism, and he did care for the exhibition of the body. He belonged to a school which had made an especially careful study of anatomy, and his work shows a great improvement in this respect over anything we have yet had the opportunity to consider. Still, the men are decidedly lean in appearance and their angular attitudes are a

little suggestive of prepared skeletons. They have oblique and prominent eyes, and, whether fighting or

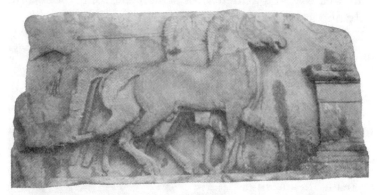

FIG. 97.—FRAGMENT OF FRIEZE FROM THE TREASURY OF THE SIPHNIANS.
Delphi.

dying, they wear upon their faces the same conventional smile.

The group in the eastern pediment corresponds closely in subject and composition to that in the western, but is

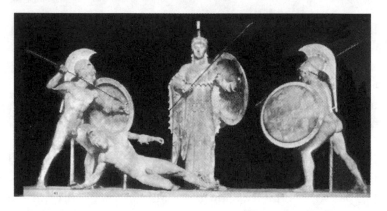

FIG. 98.—FIGURES FROM THE WESTERN PEDIMENT OF THE ÆGINETAN
TEMPLE. Munich.

of a distinctly more advanced style. Only five figures of this group were sufficiently preserved to be restored.

Of these perhaps the most admirable is the dying warrior from the southern corner of the pediment (Fig. 99), in which the only considerable modern part is the right leg, from the middle of the thigh. The superiority of this and its companion figures to those of the western pediment lies, as the Munich catalogue points out, in the juster proportions of body, arms, and legs, the greater fulness of the muscles, the more careful attention to the veins and to the qualities of the skin, the more natural position of eyes and mouth. This dying man does not

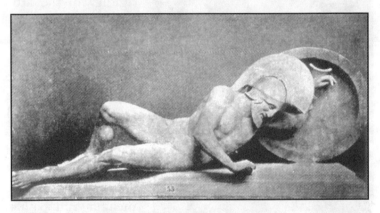

FIG. 99.—DYING WARRIOR FROM THE EASTERN PEDIMENT OF THE ÆGINETAN TEMPLE. Munich.

smile meaninglessly. His lips are parted, and there is a suggestion of death-agony on his countenance. In both pediments the figures are carefully finished all round ; there is no neglect, or none worth mentioning, of those parts which were destined to be invisible so long as the figures were in position.

The Strangford "Apollo" (Fig. 100) is of uncertain provenience, but is nearly related in style to the marbles of Ægina. This statue, by the position of body, legs, and head, belongs to the series of "Apollo" figures

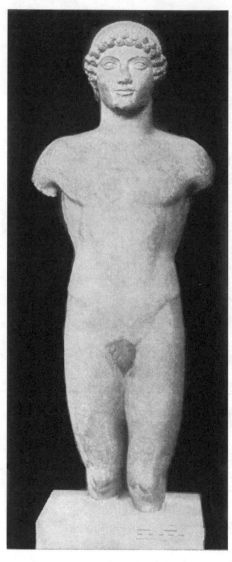

FIG. 100.—STRANGFORD "APOLLO." London, British Museum.

discussed above (pages 129–32); but the arms were no longer attached to the sides, and were probably bent at the elbows. The most obvious traces of a lingering archaism, besides the rigidity of the attitude, are the narrowness of the hips and the formal arrangement of t h e hair, with its double r o w o f snail-shell curls. The statue has been spoken of by a high authority* as showing only "a meager and painful rendering of nature." That is one way of looking at it. But there is another way, which has been finely expressed by Pater, in a n essay o n "The Marbles of Ægina": "As art which has passed its prime has sometimes the charm of

* Newton, " Essays on Art and Archæology," page 81.

an absolute refinement in taste and workmanship, so immature art also, as we now see, has its own attractiveness in the *naiveté*, the freshness of spirit, which finds power and interest in simple motives of feeling, and in the freshness of hand, which has a sense of enjoyment in mechanical processes still performed unmechanically, in the spending of care and intelligence on every touch. . . . The workman is at work in dry earnestness, with a sort of hard strength of detail, a scrupulousness verging on stiffness, like that of an early Flemish painter ; he communicates to us his still youthful sense of pleasure in the experience of the first rudimentary difficulties of his art overcome."*

* Pater, "Greek Studies," page 285.

The Transitional Period of Greek Sculpture: 480 - 450 B.C.

THE term "Transitional period" is rather meaningless in itself, but has acquired considerable currency as denoting that stage in the history of Greek art in which the last steps were taken toward perfect freedom of style. It is convenient to reckon this period as extending from the year of the Persian invasion of Greece under Xerxes to the middle of the century. In the artistic as in the political history of this generation Athens held a position of commanding importance, while Sparta, the political rival of Athens, was as barren of art as of literature. The other principal artistic center was Argos, whose school of sculpture had been and was destined long to be widely influential. As for other local schools, the question of their centers and mutual relations is too perplexing and uncertain to be here discussed.

In the two preceding chapters we studied only original works, but from this time on we shall have to pay a good deal of attention to copies (*cf.* pages 114–16). We begin with two statues in Naples (Fig. 101). The story of this group—for the two statues were designed as a group—is interesting. The two friends, Harmodius and Aristogiton, who in 514 had formed a conspiracy to rid Athens of her tyrants, but who had succeeded only in killing one of them, came to be regarded after the expulsion of the remaining tyrant and his family in 510

as the liberators of the city. Their statues in bronze, the work of Antenor, were set up on a terrace above

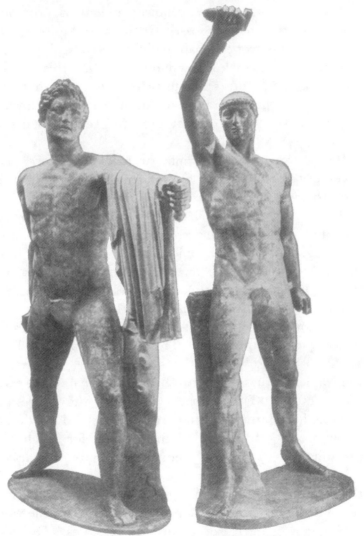

Fig. 101.—Harmodius and Aristogiton. Naples.

the market-place (*cf.* pages 124, 149). In 480 this group was carried off to Persia by Xerxes and there it

remained for a hundred and fifty years or more, when it was restored to Athens by Alexander the Great or one of his successors. Athens, however, had as promptly as possible repaired her loss. Critius and Nesiotes, two sculptors who worked habitually in partnership, were commissioned to make a second group, and this was set up in 477–6 on the same terrace where the first had been. After the restoration of Antenor's statues toward the end of the fourth century the two groups stood side by side.

It was argued by a German archæologist more than a century ago that the two marble statues shown in Fig. 101 are copied from one of these bronze groups, and this identification has been all but universally accepted. The proof may be stated briefly, as follows : First, several Athenian objects of various dates, from the fifth century B. C. onward, bear a design to which the Naples statues clearly correspond. One of these is a relief on a marble throne, formerly in Athens. Our illustration of this (Fig. 102) is taken from a "squeeze," or wet paper impression. This must, then, have been an important group in Athens. Secondly, the style of the Naples statues points to a bronze original of the early fifth century. Thirdly, the attitudes of the figures are suitable for Harmodius and Aristogiton, and we do not know of any other group of that period for which they are suitable. This proof, though not quite as complete as we should like, is as good as we generally get in these matters. The only question that remains in serious doubt is whether our copies go back to the work of Antenor or to that of Critius and Nesiotes. Opinions have been much divided on this point, but the prevailing tendency now is to connect them with the later artists. That is the view here adopted.

In studying the two statues it is important to recognize the work of the modern "restorer." The figure of

FIG. 102.—RELIEF ON A MARBLE THRONE.
Broom Hall, near Dunfermline, Scotland.

Aristogiton (the one on your left as you face the group) having been found in a headless condition, the restorer provided it with a head, which is antique, to be sure,

but which is outrageously out of keeping, being of the style of a century later. The chief modern portions are the left hand of Aristogiton and the arms, right leg, and lower part of the left leg of Harmodius. As may be learned from the small copies, Aristogiton should be bearded, and the right arm of Harmodius should be in the act of being raised to bring down a stroke of the sword upon his antagonist. We have, then, to correct in imagination the restorer's misdoings, and also to omit the tree-trunk supports, which the bronze originals did not need. Further, the two figures should probably be advancing in the same direction, instead of in converging lines.

When these changes are made, the group cannot fail to command our admiration. It would be a mistake to fix our attention exclusively on the head of Harmodius. Seen in front view, the face, with its low forehead and heavy chin, looks dull, if not ignoble. But the bodies ! In complete disregard of historic truth, the two men are represented in a state of ideal nudity, like the Æginetan figures. The anatomy is carefully studied, the attitudes lifelike and vigorous. Finally, the composition is fairly successful. This is the earliest example preserved to us of a group of sculpture other than a pediment-group. The interlocking of the figures is not yet so close as it was destined to be in many a more advanced piece of Greek statuary. But already the figures are not merely juxtaposed ; they share in a common action, and each is needed to complete the other.

Of about the same date, it would seem, or not much later, must have been a lost bronze statue, whose fame is attested by the existence of several marble copies. The best of these was found in 1862, in the course of excavating the great theater on the southern slope of the

Athenian Acropolis (Fig. 103). The naming of this figure is doubtful. It has been commonly taken for Apollo, while another view sees in it a pugilist. Recently the suggestion has been thrown out that it is Heracles. Be that as it may, the figure is a fine example of youthful strength a n d beauty. In pose it shows a decided advance upon the Strangford "Apollo" (Fig. 100). The left leg is still slightly advanced, and both feet were planted flat on the ground ; but more than half the weight of the body is thrown upon the right leg, with the result of giving a slight curve to the trunk, and the head is turned to one side. The upper part of the body is very powerful, the shoulders broad and held well back, the chest prominently developed. The face, in spite of its injuries, is one of singular refinement and sweetness. The long hair is arranged in two braids, as in Fig. 96, the only difference being that here the braids

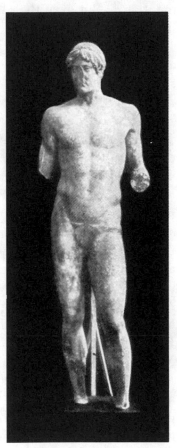

FIG. 103.—"APOLLO ON THE OMPHA-LOS." Athens, National Museum.

pass over instead of under the fringe of front hair. The rendering of the hair is in a freer style than in the case just cited, but of this difference a part may be chargeable to the copyist. Altogether we see here the stamp of an

artistic manner very different from that of Critius and Nesiotes. Possibly, as some have conjectured, it is the manner of Calamis, an Attic sculptor of this period, whose eminence at any rate entitles him to a passing mention. But even the Attic origin of this statue is in dispute.

We now reach a name of commanding importance, and one with which we are fortunately able to associate some definite ideas. It is the name of Myron of Athens, who ranks among the six most illustrious sculptors of Greece. It is worth remarking, as an illustration of the scantiness of our knowledge regarding the lives of Greek artists, that Myron's name is not so much as mentioned in extant literature before the third century B. C. Except for a precise, but certainly false, notice in Pliny, who represents him as flourishing in 420–416, our literary sources yield only vague indications as to his date. These indications, such as they are, point to the "Transitional period." This inference is strengthened by the recent discovery on the Athenian Acropolis of a pair of pedestals inscribed with the name of Myron's son and probably datable about 446. Finally, the argument is clinched by the style of Myron's most certainly identifiable work.

Pliny makes Myron the pupil of an influential Argive master, Ageladas, who belongs in the late archaic period. Whether or not such a relation actually existed, the statement is useful as a reminder of the probability that Argos and Athens were artistically in touch with one another. Beyond this, we get no direct testimony as to the circumstances of Myron's life. We can only infer that his genius was widely recognized in his lifetime, seeing that commissions came to him, not from Athens only, but also from other cities of Greece

proper, as well as from distant Samos and Ephesus. His chief material was bronze, and colossal figures of gold and ivory are also ascribed to him. So far as we know, he did not work in marble at all. His range of subjects included divinities, heroes, men, and animals. Of no work of his do we hear so often or in terms of such high praise as of a certain figure of a cow, which stood on or near the Athenian Acropolis. A large number of athlete statues from his hand were to be seen at Olympia, Delphi, and perhaps elsewhere, and this side of his activity was certainly an important one. Perhaps it is a mere accident that we hear less of his statues of divinities and heroes.

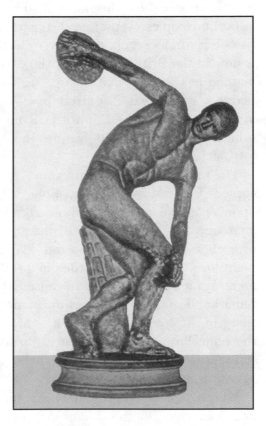

FIG. 104.—COPY OF THE DISCOBOLUS OF MYRON. Rome, Lancellotti Palace.

The starting point in any study of Myron must be his Discobolus (Discus-thrower). Fig. 104 reproduces the best copy. This statue was found in Rome in 1781,

and is in an unusually good state of preservation. The head has never been broken from the body ; the right arm has been broken off, but is substantially antique ; and the only considerable restoration is the right leg from the knee to the ankle. The two other most important copies were found together in 1791 on the site of Hadrian's villa at Tibur (Tivoli). One of these is now in the British Museum, the other in the Vatican ; neither has its original head. A fourth copy of the body, a good deal disguised by "restoration," exists in the Museum of the Capitol in Rome. There are also other copies of the head besides the one on the Lancellotti statue.

The proof that these statues and parts of statues were copied from Myron's Discobolus depends principally upon a passage in Lucian (about 160 A. D.).* He gives a circumstantial description of the attitude of that work, or rather of a copy of it, and his description agrees point for point with the statues in question. This agreement is the more decisive because the attitude is a very remarkable one, no other known figure showing anything in the least resembling it. Moreover, the style of the Lancellotti statue points to a bronze original of the "Transitional period," to which on historical grounds Myron is assigned.

Myron's statue represented a young Greek who had been victorious in the *pentathlon*, or group of five contests (running, leaping, wrestling, throwing the spear, and hurling the discus), but we have no clue as to where in the Greek world it was set up. The attitude of the figure seems a strange one at first sight, but other ancient representations, as well as modern experiments, leave little room for doubt that the sculptor has

* *Philopseudes*, § 18.

truthfully caught one of the rapidly changing positions which the exercise involved. Having passed the discus from his left hand to his right, the athlete has swung the missile as far back as possible. In the next instant he will hurl it forward, at the same time, of course, advancing his left foot and recovering his erect position. Thus Myron has preferred to the comparatively easy task of representing the athlete at rest, bearing some symbol of victory, the far more difficult problem of exhibiting him in action. It would seem that he delighted in the expression of movement. So his Ladas, known to us only from two epigrams in the Anthology, represented a runner panting toward the goal; and others of his athlete statues may have been similarly conceived. His temple-images, on the other hand, must have been as composed in attitude as the Discobolus is energetic.

The face of the Discobolus is rather typical than individual. If this is not immediately obvious to the reader, the comparison of a closely allied head may make it clear. Of the numerous works which have been brought into relation with Myron by reason of their likeness to the Discobolus, none is so unmistakable as a fine bust in Florence (Fig. 105). The general form of the head, the rendering of the hair, the anatomy of the forehead, the form of the nose and the angle it makes with the forehead—these and other features noted by Professor Furtwängler are alike in the Discobolus and the Riccardi head. These detailed resemblances cannot be verified without the help of casts or at least of good photographs taken from different points of view; but the general impression of likeness will be felt convincing, even without analysis. Now these two works represent different persons, the Riccardi head being probably copied from the statue of some ideal hero. And the

point to be especially illustrated is that in the Discobolus we have not a realistic portrait, but a generalized type. This is not the same as to say that the face bore no recognizable resemblance to the young man whom the statue commemorated. Portraiture admits of many

degrees, from literal fidelity to an idealization in which the identity of the subject is all but lost. All that is meant is that the Discobolus belongs somewhere near the latter end of the scale. In this absence of individualization we have a trait, not of Myron alone, but of Greek sculpture generally in its rise

FIG. 105.—BUST, PROBABLY AFTER MYRON. Florence, Riccardi Palace.

and in the earlier stages of its perfection (*cf.* page 126).

Another work of Myron has been plausibly recognized in a statue of a satyr in the Lateran Museum (Fig. 106). The evidence for this is too complex to be stated here. If the identification is correct, the Lateran statue is copied from the figure of Marsyas in a bronze group of Athena and Marsyas which stood on the Athenian Acropolis. The goddess was represented as having just flung down in disdain a pair of flutes ; the satyr, advancing on tiptoe, hesitates between cupidity and the fear of Athena's displeasure. Marsyas has a

lean and sinewy figure, coarse stiff hair and beard, a wrinkled forehead, a broad flat nose which makes a marked angle with the forehead, pointed ears (modern, but guaranteed by another copy of the head), and a short tail sprouting from the small of the back. The arms, which were missing, have been incorrectly restored with casta-nets. The right should be held up, the left down, in a gesture of astonish-ment. In this work we see again Myron's skill in suggesting movement. We get a lively impression of an advance suddenly checked and changed to a recoil.

Thus far in this chapter we have been dealing with copies. Our stock of original works of this period, however, is not small; it consists, as usual, largely of architec-tural sculpture. Fig. 107 shows four meto-pes from a temple at Selinus. They repre-

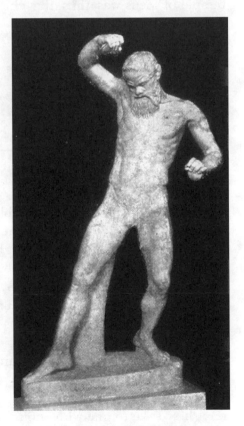

FIG. 106.—SATYR, PROBABLY AFTER MYRON. Rome, Lateran Museum.

sent (beginning at the left) Heracles in combat with an Amazon, Hera unveiling herself before Zeus, Actæon torn by his dogs in the presence of Artemis, and Athena

overcoming the giant Enceladus. These reliefs would repay the most careful study, but the sculptures of another temple have still stronger claims to attention.

Olympia was one of the two most important religious centers of the Greek world, the other being Delphi. Olympia was sacred to Zeus, and the great Doric temple of Zeus was thus the chief among the group of

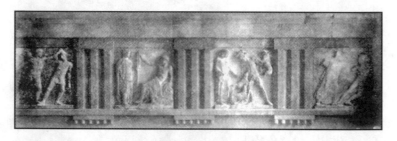

FIG. 107.—PORTION OF DORIC FRIEZE WITH SCULPTURED METOPES,
FROM SELINUS. Palermo.

religious buildings there assembled. The erection of this temple probably falls in the years just preceding and following 460 B. C. A slight exploration carried on by the French in 1829 and the thorough excavation of the site by the Germans in 1875–81 brought to light extensive remains of its sculptured decoration. This consisted of two pediment-groups and twelve sculptured metopes, besides the acroteria. In the eastern pediment the subject is the preparation for the chariot-race of Pelops and Œnomaus. The legend ran that Œnomaus, king of Pisa in Elis, refused the hand of his daughter save to one who should beat him in a chariot-race. Suitor after suitor tried and failed, till at last Pelops, a young prince from over sea, succeeded. In the pediment-group Zeus, as arbiter of the impending contest, occupies the center. On one side of him stand Pelops and his destined bride, on the other Œnomaus

and his wife, Sterope (Fig. 108). The chariots, with attendants and other more or less interested persons follow (Fig. 109). The moment chosen by the sculp-

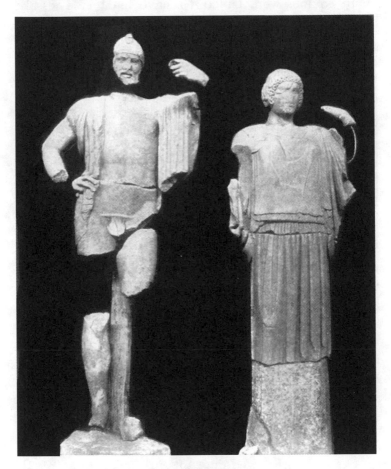

FIG. 108.—ŒNOMAUS AND STEROPE. Olympia.

tor is one of expectancy rather than action, and the various figures are in consequence simply juxtaposed, not interlocked. Far different is the scene presented by the western pediment. The subject here is the

combat between Lapiths and Centaurs, one of the
favorite themes of Greek sculpture, as of Greek paint-
ing. The Centaurs, brutal creatures, partly human,
partly equine, were fabled to have lived in Thessaly.
There too was the home of the Lapiths, who were

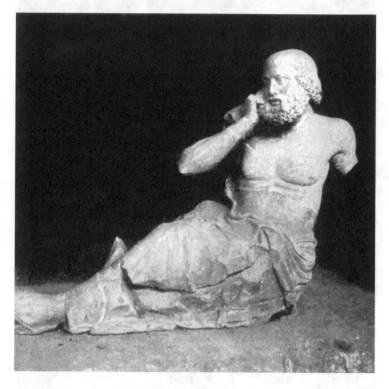

FIG. 109.—ELDERLY MAN. Olympia.

Greeks. At the wedding of Pirithoüs, king of the
Lapiths, the Centaurs, who had been bidden as guests,
became inflamed with wine and began to lay hands
on the women. Hence a general· *mêlée*, in which the
Greeks were victorious. The sculptor has placed the
god Apollo in the center (Fig. 110), undisturbed amid

the wild tumult ; his presence alone assures us what the issue is to be. The struggling groups (Figs. 111, 112) extend nearly to the corners, which are occupied each by two reclining female figures, spectators of the scene. In each pediment the composition is symmetrical, every figure having its corresponding figure on the opposite side. Yet the law of symmetry is interpreted much more freely than in the Ægina pediments of a generation earlier; the

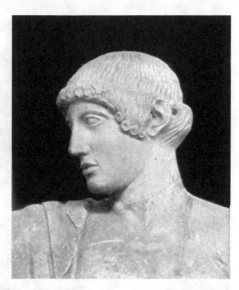

FIG. 110.—HEAD OF APOLLO. Olympia.

corresponding figures often differ from one another a good deal in attitude, and in one instance even in sex.

Our illustrations, which give a few representative specimens of these sculptures, suggest some comments. To begin with, the workmanship here displayed is rapid and far from faultless. Unlike the Eginetan pediment-figures and those of the Parthenon, these figures are left rough at the back. Moreover, even in the visible portions there are surprising evidences of carelessness, as in the portentously long left thigh of the Lapith in Fig. 112. It is, again, evidence of rapid, though not exactly of faulty, execution, that the hair is in a good many cases only blocked out, the form of the mass being given, but its texture not indicated (*e. g.*, Fig. 111).

In the pose of the standing figures (*e. g.*, Fig. 108), with the weight borne about equally by both legs, we see a modified survival of the usual archaic attitude. A lin-

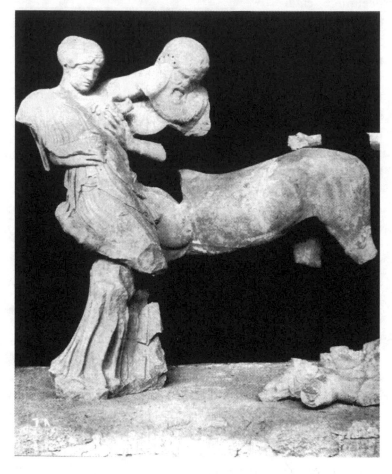

FIG. 111.—LAPITH BRIDE AND CENTAUR. Olympia.

gering archaism may be seen in other features too ; very plainly, for example, in the arrangement of Apollo's hair (Fig. 110). The garments represent a thick woolen stuff, whose folds show very little pliancy. The

drapery of Sterope (Fig. .108) should be especially noted, as it is a characteristic example for this period of a type which has a long history. She wears the Doric

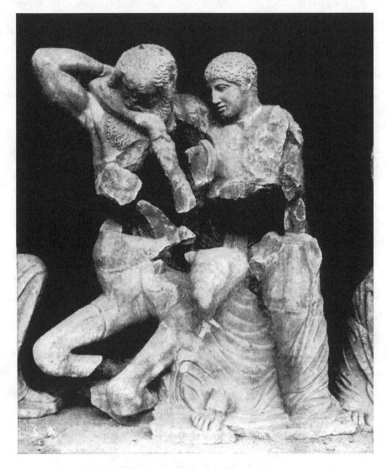

FIG. 112.—LAPITH AND CENTAUR. Olympia.

chiton, a sleeveless woolen garment girded and pulled over the girdle and doubled over from the top. The formal, starched-looking folds of the archaic period have disappeared. The cloth lies pretty flat over the chest

and waist ; there is a rather arbitrary little fold at the neck. Below the girdle the drapery is divided vertically into two parts ; on the one side it falls in straight folds to the ankle, on the other it is drawn smooth over the bent knee.

Another interesting fact about these sculptures is a certain tendency toward realism. The figures and faces and attitudes of the Greeks, not to speak of the Centaurs, are not all entirely beautiful and noble. This is illustrated by Fig. 109, a bald-headed man, rather fat. Here is realism of a very mild type, to be sure, in comparison with what we are accustomed to nowadays ; but the old men of the Parthenon frieze bear no disfiguring marks of age. Again, in the face of the young Lapith whose arm is being bitten by a Centaur (Fig. 112), there is a marked attempt to express physical pain ; the features are more distorted than in any other fifth century sculpture, except representations of Centaurs or other inferior creatures. In the other heads of imperiled men and women in this pediment, *e. g.*, in that of the bride (Fig. 111), the ideal calm of the features is overspread with only a faint shadow of distress.

Lest what has been said should suggest that the sculptors of the Olympia pediment-figures were indifferent to beauty, attention may be drawn again to the superb head of the Lapith bride. Apollo, too (Fig. 110), though not that radiant god whom a later age conceived and bodied forth, has an austere beauty which only a dull eye can fail to appreciate.

The twelve sculptured metopes of the temple do not belong to the exterior frieze, whose metopes were plain, but to a second frieze, placed above the columns and antæ of pronaos and opisthodomos. Their subjects are the twelve labors of Heracles, beginning with

the slaying of the Nemean lion and ending with the cleansing of the Augean stables. The one selected for illustration is one of the two or three best preserved members of the series (Fig. 113). Its subject is the

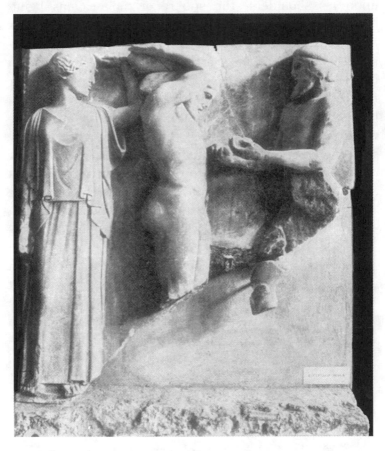

FIG. 113.—ATLAS METOPE. Olympia.

winning of the golden apples which grew in the garden of the Hesperides, near the spot where Atlas stood, evermore supporting on his shoulders the weight of the heavens. Heracles prevailed upon Atlas to go and

fetch the coveted treasure, himself meanwhile assuming the burden. The moment chosen by the sculptor is that of the return of Atlas with the apples. In the middle stands Heracles, with a cushion, folded double, upon his shoulders, the sphere of the heavens being barely suggested at the top of the relief. Behind him is his companion and protectress, Athena, once recognizable by a lance in her right hand.* With her left hand she seeks to ease a little the hero's heavy load. Before him stands Atlas, holding out the apples in both hands. The main lines of the composition are somewhat monotonous, but this is a consequence of the subject, not of any incapacity of the artist, as the other metopes testify. The figure of Athena should be compared with that of Sterope in the eastern pediment. There is a substantial resemblance in the drapery, even to the arbitrary little fold in the neck ; but the garment here is entirely open on the right side, after the fashion followed by Spartan maidens, whereas there it is sewed together from the waist down ; there is here no girdle ; and the broad, flat expanse of cloth in front observable there is here narrowed by two folds falling from the breasts.

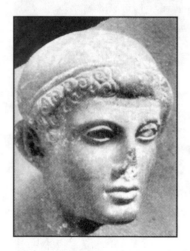

FIG. 114.—HEAD OF ATHENA (?), FROM LION METOPE. Olympia.

Fig. 114 is added as a last example of the severe beauty to be found in these sculptures. It will be ob-

* Such at least seems to be the view adopted in the latest official publication on the subject : "Olympia ; Die Bildwerke in Stein und Thon," Pi. LXV.

served that the hair of this head is not worked out in detail, except at the front. This summary treatment of the hair is, in fact, more general in the metopes than in the pediment-figures. The upper eyelid does not yet overlap the under eyelid at the outer corner (*cf.* Fig. 110).

The two pediment-groups and the metopes of this temple show such close resemblances of style among themselves that they must all be regarded as products of a single school of sculpture, if not as designed by a single man. Pausanias says nothing of the authorship of the metopes ; but he tells us that the

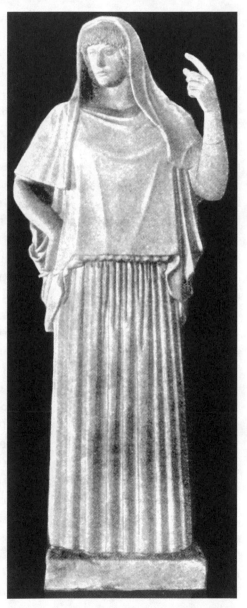

FIG. 115.—THE GIUSTINIANI "VESTA." Rome, Torlonia Palace.

sculptures of the eastern pediment were the work of Pæonius of Mende, an indisputable statue by whom is known (*cf.* page 213), and those of the western by Alcamenes, who appears elsewhere in literary tradition as a pupil of Phidias. On various grounds it seems almost certain that Pausanias was misinformed on this point. Thus we are left without trustworthy testimony as to the affiliations of the artist or artists to whom the sculptured decoration of this temple was intrusted.

The so-called Hestia (Vesta) which formerly belonged to the Giustiniani family (Fig. 115), has of late years been inaccessible even to professional students. It must be one of the very best preserved of ancient statues in marble, as it is not reported to have anything modern about it except the index finger of the left hand. This hand originally held a scepter. The statue represents some goddess, it is uncertain what one. In view of the likeness in the drapery to some of the Olympia figures, no one can doubt that this is a product of the same period.

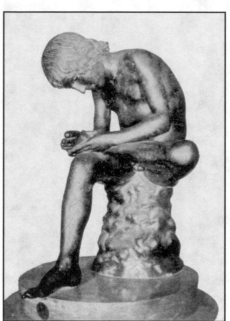

FIG. 116.—THE "SPINARIO."
Rome, Palace of the Conservatori.

In regard to the bronze statue shown in Fig. 116 there is more room for doubt, but the weight of opinion is in

favor of placing it here. It is confidently claimed by a high authority that this is an original Greek bronze. There exist also fragmentary copies of the same in marble and free imitations in marble and in bronze. The statue represents a boy of perhaps twelve, absorbed in pulling a thorn from his foot. We do not know the original purpose of the work ; perhaps it commemorated a victory won in a foot-race of boys. The left leg of the figure is held in a position which gives a somewhat ungraceful outline ; Praxiteles would not have placed it so. But how delightful is the picture of childish innocence and self-forgetfulness ! This statue might be regarded as an epitome of the artistic spirit and capacity of the age —its simplicity and purity and freshness of feeling, its not quite complete emancipation from the formalism of an earlier day.

CHAPTER 8

The Great Age of Greek Sculpture: First Period: 450 - 400 B.C.

THE Age of Pericles, which, if we reckon from the first entrance of Pericles into politics, extended from about 466 to 429, has become proverbial as a period of extraordinary artistic and literary splendor. The real ascendancy of Pericles began in 447, and the achievements most properly associated with his name belong to the succeeding fifteen years. Athens at this time possessed ample material resources, derived in great measure from the tribute of subject allies ; and wealth was freely spent upon noble monuments of art. The city was filled with artists of high and low degree. Above them all in genius towered Phidias, and to him, if we may believe the testimony of Plutarch,* a general superintendence of all the artistic undertakings of the state was intrusted by Pericles.

Great as was the fame of Phidias in after ages, we are left in almost complete ignorance as to the circumstances of his life. If he was really the author of certain works ascribed to him, he must have been born about 500 B.C. This would make him as old, perhaps, as Myron. Another view would put his birth between 490 and 485 ; still another, as late as 480. The one undisputed date in his life is the year 438, when the gold and ivory statue of Athena in the Parthenon was completed. Touching the time and circumstances of his

* " Life of Pericles," §13.

death we have two inconsistent traditions. According to the one, he was brought to trial in Athens immediately after the completion of the Athena on the charge of misappropriating some of the ivory with which he had been intrusted, but made his escape to Elis, where, after executing the gold and ivory Zeus for the temple of that god at Olympia, he was put to death for some unspecified reason by the Eleans in 432–1. According to the other tradition, he was accused in Athens, apparently not before 432, of stealing some of the gold destined for the Athena, and, when this charge broke down, of having sacrilegiously introduced his own and Pericles's portraits into the relief on Athena's shield ; being cast into prison, he died there of disease, or, as some said, of poison.

The most famous works of Phidias were the two chryselephantine statues to which reference has just been made, and two or three other statues of the same materials were ascribed to him. He worked also in bronze and in marble. From a reference in Aristotle's '' Ethics '' it might seem as if he were best known as a sculptor in marble, but only three statues by him are expressly recorded to have been of marble, against a larger number of bronze. His subjects were chiefly divinities ; we hear of only one or two figures of human beings from his hands.

Of the colossal Zeus at Olympia, the most august creation of Greek artistic imagination, we can form only an indistinct idea. The god was seated upon a throne, holding a figure of Victory upon one hand and a scepter in the other. The figure is represented on three Elean coins of the time of Hadrian (117–138 A. D.), but on too small a scale to help us much. Another coin of the same period gives a fine head of Zeus in profile (Fig.

117),* which is plausibly supposed to preserve some likeness to the head of Phidias's statue.

In regard to the Athena of the Parthenon we are considerably better off, for we possess a number of marble statues which, with the aid of Pausanias's description and by comparison with one another, can be proved to be copies of that work. But a warning is necessary here. The Athena, like the Zeus, was of colossal size. Its height, with the pedestal, was about thirty-eight feet.

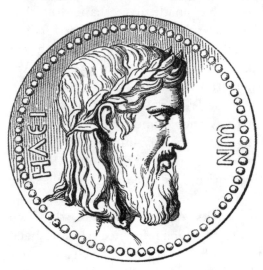

FIG. 117.—BRONZE COIN OF ELIS (ENLARGED).

Now it is not likely that a really exact copy on a small scale could possibly have been made from such a statue, nor, if one had been made, would it have given the effect of the original. With this warning laid well to heart the reader may venture to examine that one among our copies which makes the greatest attempt at exactitude (Fig. 118). It is a statuette, not quite 3½ feet high with the basis, found in Athens in 1880. The goddess stands with her left leg bent a little and pushed to one side. She is dressed in a heavy Doric chiton, open at the side. The girdle, whose ends take the form of snakes' heads, is

*A more truthful representation of this coin may be found in Gardner's "Types of Greek Coins," Pl. XV., 19.

worn outside the doubled-over portion of the garment. Above it the folds are carefully adjusted, drawn in symmetrically from both sides toward the middle ; in the lower part of the figure there is the common vertical division into two parts, owing to the bending of one leg. Over the chiton is the ægis, much less long behind than in earlier art (*cf.* Fig. 98), fringed with snakes' heads and having a Gorgon's mask in front. The helmet is an elaborate affair with three crests, the central one supported by a sphinx, the others by winged horses ; the hinged cheek-pieces are turned up. At the left of the goddess is her shield, within which coils a serpent. On her extended right hand stands a Victory.

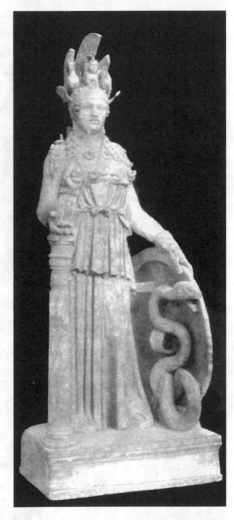

FIG. 118.—REDUCED COPY OF THE ATHENA OF THE PARTHENON. Athens, National Museum.

The face of Athena is the most disappointing part of it all, but it is just there that the copyist must have failed

most completely. Only the eye of faith, or better, the eye trained by much study of allied works, can divine in

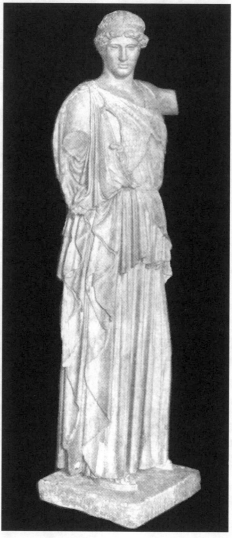

FIG. 119.—ATHENA. Dresden.

this poor little figure the majesty which awed the beholder of Phidias's work.

Speculation has been busy in attempting to connect other statues that have been preserved to us with the name of Phidias. The most probable case that has yet been made out concerns two closely similar marble figures in Dresden, one of which is shown in Fig. 119. The head of this statue is missing, but its place has been supplied by a cast of a head in Bologna (Fig. 120), which has been proved to be another copy from the same original. This proof, about which there seems to be no room for question, is due to

Professor Furtwängler,* who argues further that the statue as thus restored is a faithful copy of the Lemnian Athena of Phidias, a bronze work which stood on the Athenian Acropolis. The proof of this depends upon (1) the resemblance in the standing position and in the drapery of this figure to the Athena of the Parthenon, and (2) the fact that Phidias is known to have made a statue of Athena (thought to be the Lemnian Athena) without a helmet on the head—an exceptional, though not wholly unique, representation in sculpture in the round.

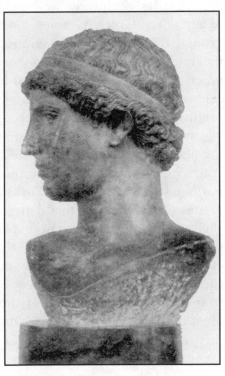

If this demonstration be thought insufficient, there cannot, at all events, be much doubt that we have here the copy of an original of about the middle of the fifth century. The style is severely simple, as we ought to expect of a religious work of

FIG. 120.—HEAD OF ATHENA. Bologna.

that period. The virginal face, conceived and wrought with ineffable refinement, is as far removed from sensual charm as from the ecstasy of a Madonna. The goddess does not reveal herself as one who can be "touched

* "Masterpieces of Greek Sculpture," pages 4 *ff.*

with a feeling of our infirmities"; but by the power of her pure, passionless beauty she sways our minds and hearts.

The supreme architectural achievement of the Periclean age was the Parthenon, which crowned the Athenian Acropolis. It appears to have been begun in 447, and was roofed over and perhaps substantially finished by 438. Its sculptures were more extensive than those of any other Greek temple, comprising two pediment-groups, the whole set of metopes of the exterior frieze, ninety-two in number, and a continuous frieze of bas-relief, 522 feet 10 inches in total length, surrounding the cella and its vestibules (*cf.* Fig. 56). After serving its original purpose for nearly a thousand years, the building was converted into a Christian church and then, in the fifteenth century, into a Mohammedan mosque. In 1687 Athens was besieged by the forces of Venice. The Parthenon was used by the Turks as a powder-magazine, and was consequently made the target for the enemy's shells. The result was an explosion, which converted the building into a ruin. Of the sculptures which escaped from this catastrophe, many small pieces were carried off at the time or subsequently, while other pieces were used as building stone or thrown into the lime-kiln. Most of those which remained down to the beginning of this century were acquired by Lord Elgin, acting under a permission from the Turkish government (1801–3), and in 1816 were bought for the British Museum. The rest are in Athens, either in their original positions on the building, or in the Acropolis Museum.

The best preserved metopes of the Parthenon belong to the south side and represent scenes from the contest between Lapiths and Centaurs (*cf.* page 174). These metopes differ markedly in style from one another, and

must have been not only executed, but designed, by different hands. One or two of them are spiritless and uninteresting. Others, while fine in their way, show little vehemence of action. Fig. 121 gives one of this class. Fig. 122 is very different. In this "the Lapith presses forward, advancing his left hand to seize the rearing Centaur by the throat, and forc-

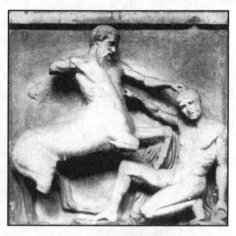

FIG. 121.—PARTHENON METOPE.
London, British Museum.

ing him on his haunches ; the right arm of the Lapith is drawn back, as if to strike; his right hand, now wanting, probably held a sword. The Centaur, rearing up against his antagonist, tries in vain to pull away the left hand of the Lapith, which, in Carrey's drawing [made in 1674] he grasps."*

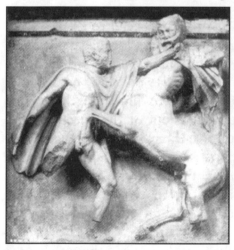

FIG. 122.—PARTHENON METOPE.
London, British Museum.

Observe how skilfully the design is adapted to the square field, so as to leave no unpleasant blank

* A. H. Smith, " Catalogue of Sculpture in the British Museum," page 136.

spaces, how flowing and free from monotony are the lines of the composition, how effective (in contrast with Fig. 121) is the management of the drapery, and, above all, what vigor is displayed in the attitudes. Fig.

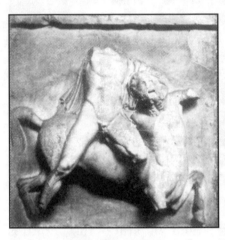

123 is of kindred character. These two metopes and two others, one representing a victorious Centaur prancing in savage glee over the body of his prostrate foe, the other showing a Lapith about to strike a Centaur already wounded in the back, are among the very best works of Greek sculpture preserved to us.

FIG. 123.—PARTHENON METOPE.
London, British Museum.

The Parthenon frieze presents an idealized picture of the procession which wound its way upward from the market-place to the Acropolis on the occasion of Athena's chief festival. Fully to illustrate this extensive and varied composition is out of the question here. All that is possible is to give three or four representative pieces and a few comments. Fig. 124 shows the best preserved piece of the entire frieze. It belongs to a company of divinities, seated to right and left of the central group of the east front, and conceived as spectators of the scene. The figure at the left of the illustration is almost certainly Posidon, and the others are perhaps Apollo and Artemis. In Fig. 125 three youths advance with measured step, carrying jars filled with wine, while a fourth youth stoops to lift his jar ; at the

extreme right may be seen part of a flute-player, whose figure was completed on the next slab. The attitudes and draperies of the three advancing youths, though similar, are subtly varied. So everywhere monotony is absent from the frieze. Fig. 126 is taken from the most animated and crowded part of the design. Here Athenian youths, in a great variety of dress and undress, dash

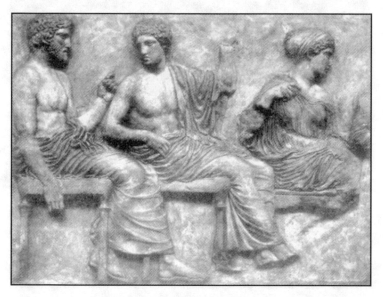

FIG. 124.—PORTION OF SLAB OF PARTHENON FRIEZE (EAST).
Athens, Acropolis Museum.

forward on small, mettlesome horses. Owing to the principle of *isocephaly* (*cf.* page 145), the mounted men are of smaller dimensions than those on foot, but the difference does not offend the eye. In Fig. 127 we have, on a somewhat larger scale, the heads of four chariot-horses instinct with fiery life. Fig. 132 may also be consulted. An endless variety in attitude and spirit, from the calm of the ever-blessed gods to the most impetuous movement ; grace and harmony of line ;

an almost faultless execution—such are some of the qualities which make the Parthenon frieze the source of inexhaustible delight.

The composition of the group in the western pediment is fairly well known, thanks to a French artist, Jacques Carrey, who made a drawing of it in 1674, when

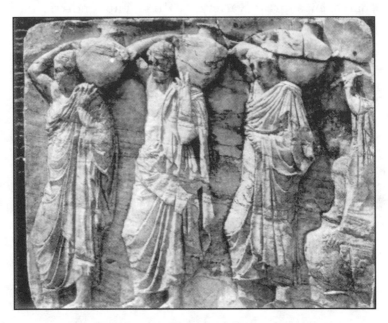

FIG. 125.—SLAB OF PARTHENON FRIEZE (NORTH).
Athens, Acropolis Museum.

it was still in tolerable preservation. The subject was, in the words of Pausanias, ''the strife of Posidon with Athena for the land'' of Attica. In the eastern pediment the subject was the birth of Athena. The central figures, eleven in number, had disappeared long before Carrey's time, having probably been removed when the temple was converted into a church. On the other hand, the figures near the angles have been better preserved than any of those from the western pediment,

with one exception. The names of these eastern figures have been the subject of endless guess-work. All that is really certain is that at the southern corner Helios (the Sun-god) was emerging from the sea in a chariot drawn by four horses, and at the northern corner Selene (the Moon-goddess) or perhaps Nyx (Night) was descending in a similar chariot. Fig. 128 is the figure that was placed next to the horses of Helios. The young god or hero reclines in an easy attitude on a rock ; under him are spread his mantle and the skin of

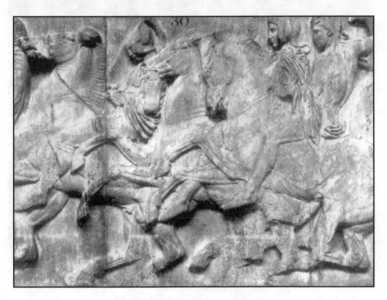

FIG. 126.—PORTIONS OF TWO SLABS OF PARTHENON FRIEZE (NORTH).
London, British Museum.

a panther or some such animal. In Fig. 129 we have, beginning on the right, the head of one of Selene's horses and the torso of the goddess herself, then a group of three closely connected female figures, known as the "Three Fates," seated or reclining on uneven, rocky ground, and last the body and thighs of a winged god-

dess, Victory or Iris, perhaps belonging in the western pediment. Fig. 130, from the northern corner of the western pediment, is commonly taken for a river-god.

We possess but the broken remnants of these two pediment-groups, and the key to the interpretation of much that we do possess is lost. We cannot then fully appreciate the intention of the great artist who conceived these works. Yet even in their ruin and their isolation

FIG. 127.—HEADS OF CHARIOT-HORSES, FROM PARTHENON FRIEZE (SOUTH).
London, British Museum.

the pediment-figures of the Parthenon are the sublimest creations of Greek art that have escaped annihilation.

We have no ancient testimony as to the authorship of the Parthenon sculptures, beyond the statement of Plutarch, quoted above, that Phidias was the general

superintendent of all artistic works undertaken during Pericles's administration. If this statement be true, it still leaves open a wide range of conjecture as to the nature and extent of his responsibility in this particular case. Appealing to the sculptures themselves for information, we find among the metopes such differences of

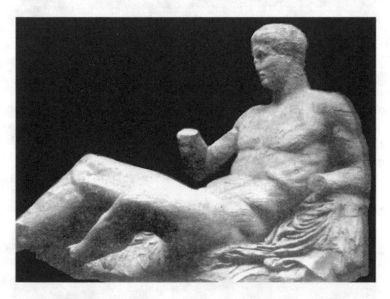

FIG. 128.— DIONYSUS OF THE PARTHENON.
London, British Museum.

style as exclude the notion of single authorship. With the frieze and the pediment-groups, however, the case is different. Each of these three compositions must, of course, have been designed by one master-artist and executed by or with the help of subordinate artists or workmen. Now the pediment-groups, so far as preserved, strongly suggest a single presiding genius for both, and there is no difficulty in ascribing the design of the frieze to the same artist. Was it Phidias? The question has been much agitated of late years, but the evidence at our dis-

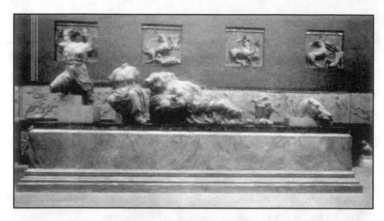

FIG. 129.—GROUP OF PEDIMENT-FIGURES FROM THE PARTHENON.
London, British Museum.

posal does not admit of a decisive answer. The great argument for Phidias lies in the incomparable merit of these works ; and with the probability that his genius is

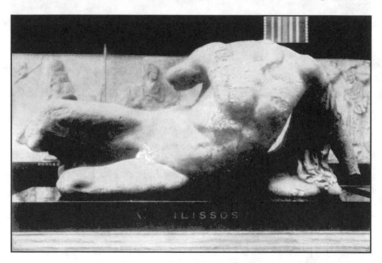

FIG. 130.—SO-CALLED "ILISSOS" OF THE PARTHENON.
London, British Museum.

here in some degree revealed to us we must needs be content. After all, it is of much less consequence to be

assured of the master's name than to know and enjoy the masterpieces themselves.

The great statesman under whose administration these immortal sculptures were produced was commemorated by a portrait statue or head, set up during his lifetime on the Athenian Acropolis; it was from the hand of Cresilas, of Cydonia in Crete. It is perhaps this portrait of which copies have come down to us. The best of these is given in Fig. 131. The features are, we may believe, the authentic features of Pericles, somewhat idealized, according to the custom of portraiture in this age. The helmet characterizes the wearer as general.

The artistic activity in Athens did not cease with the outbreak of the Peloponnesian War in 431. The city was full of sculptors, many of whom had come directly under the influence of Phidias, and

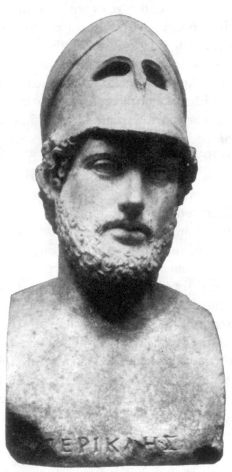

FIG. 131.—HEAD OF PERICLES.
London, British Museum.

they were not left idle. The demand from private indi-
viduals for votive sculptures and funeral reliefs must in-
deed have been abated, but was not extinguished ; and
in the intervals of the protracted war the state undertook
important enterprises with an undaunted spirit. It is to
this period that the Erechtheum probably belongs
(421?–405), though all that we certainly know is that
the building was nearly finished some time before 409
and that the work was resumed in that year. The tem-
ple had a sculptured frieze of which fragments are extant,
but these are far surpassed in interest by the Caryatides
of the southern porch (Fig. 67). The name Cary-
atides, by the way, meets us first in the pages of Vitru-
vius, a Roman architect of the time of Augustus ; a
contemporary Athenian inscription, to which we are
indebted for many details concerning the building, calls
them simply "maidens." As you face the front of the
porch, the three maidens on your right support them-
selves chiefly on the left leg, the three on your left on
the right leg (Fig. 132), so that the leg in action is the
one nearer to the end of the porch. The arms hung
straight at the sides, one of them grasping a corner
of the small mantle. The pose and drapery show what
Attic sculpture had made of the old Peloponnesian
type of standing female figure in the Doric chiton (*cf.*
page 177). The fall of the garment preserves the same
general features, but the stuff has become much more
pliable. It is interesting to note that, in spite of a close
general similarity, no two maidens are exactly alike, as
they would have been if they had been reproduced
mechanically from a finished model. These subtle
variations are among the secrets of the beauty of this
porch, as they are of the Parthenon frieze. One may
be permitted to object altogether to the use of human

figures as architectural supports, but if the thing was to be done at all, it could not have been better done. The weight that the maidens bear is comparatively small, and their figures are as strong as they are graceful.

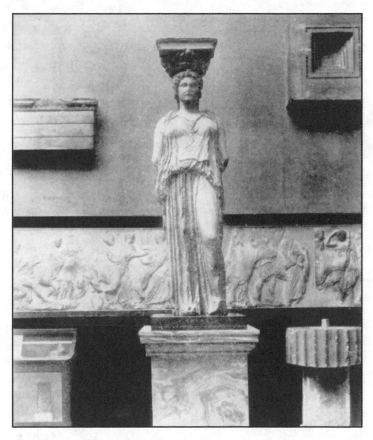

FIG. 132.—CARYATID FROM THE ERECHTHEUM. London, British Museum.

To the period of the Peloponnesian War may also be assigned a sculptured balustrade which inclosed and protected the precinct of the little Temple of Athena Nike on the Acropolis (Fig. 70). One slab of this balustrade is shown in Fig. 133. It represents a

winged Victory stooping to tie (or, as some will have it, to untie) her sandal. The soft Ionic chiton, clinging to the form, reminds one of the drapery of the reclining goddess from the eastern pediment of the Parthenon (Fig. 129), but it finds its closest analogy, among datable sculptures, in a fragment of relief that was found at Rhamnus in Attica. This belonged to the pedestal of a statue by Agoracritus, one of the most famous pupils of Phidias.

FIG. 133.—RELIEF OF A VICTORY.
Athens, Acropolis Museum.

The Attic grave-relief given in Fig. 134 seems to belong somewhere near the end of the fifth century. The subject is a common one on this class of monuments, but is nowhere else so exquisitely treated. There is no allusion to the fact of death. Hegeso, the deceased lady, is seated and is holding up a necklace or some such object (originally, it may be supposed, indicated by color), which she has just taken from the jewel-box held out by the standing slave-woman. Another fine grave-relief (Fig. 135) may be introduced here,

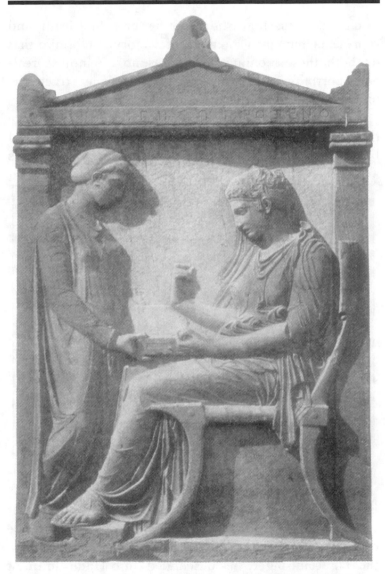

FIG. 134.—GRAVE-RELIEF OF HEGESO. Athens, National Museum.

though it perhaps belongs to the beginning of the fourth century rather than to the end of the fifth. It must commemorate some young Athenian cavalryman. It

is characteristic that the relief ignores his death and represents him in a moment of victory. Observe that on both these monuments there is no attempt at realistic portraiture and that on both we may trace the influence of the style of the Parthenon frieze.

Among the other bas-reliefs which show that influence there is no difficulty in choosing one of exceptional beauty, the so-called Orpheus relief (Fig. 136). This

FIG. 135.—ATTIC GRAVE-RELIEF. Rome, Villa Albani.

is known to us in three copies, unless indeed the Naples example be the original. The story here set forth is one of the most touching in Greek mythology. Orpheus, the Thracian singer, has descended into Hades in quest of his dead wife, Eurydice, and has so charmed by his music the stern Persephone that she has suffered him to lead back his wife to the upper air, provided only he will not look upon her on the way. But love has over-

come him. He has turned and looked, and the doom of
an irrevocable parting is sealed. In no unseemly

FIG. 136.—RELIEF REPRESENTING ORPHEUS, EURYDICE, AND HERMES.
Naples.

paroxysm of grief, but tenderly, sadly, they look their
last at one another, while Hermes, guide of departed
spirits, makes gentle signal for the wife's return. In the
chastened pathos of this scene we have the quintessence

of the temper of Greek art in dealing with the fact of death.

Turning now from Athens to Argos, which, though politically weak, was artistically the rival of Athens in importance, we find Polyclitus the dominant master there, as Phidias was in the other city. Polyclitus survived Phidias and may have been the younger of the two. The only certain thing is that he was in the plenitude of his powers as late as 420, for his gold and ivory statue of Hera was made for a temple built to replace an earlier temple destroyed by fire in 423. His principal material was bronze. As regards subjects, his great specialty was the representation of youthful athletes. His reputation in his own day and afterwards was of the highest ; there were those who ranked him above Phidias. Thus Xenophon represents* an Athenian as assigning to Polyclitus a preëminence in sculpture like that of Homer in epic poetry and that of Sophocles in tragedy ; and Strabo† pronounced his gold and ivory statues in the Temple of Hera near Argos the finest in artistic merit among all such works, though inferior to those of Phidias in size and costliness. But probably the more usual verdict was that reported by Quintilian,‡ which, applauding as unrivaled his rendering of the human form, found his divinities lacking in majesty.

In view of the exalted rank assigned to Polyclitus by Greek and Roman judgment, his identifiable works are a little disappointing. His Doryphorus, a bronze figure of a young athlete holding a spear such as was used in the *pentathlon* (*cf.* page 168), exists in numerous copies. The Naples copy (Fig. 137), found in Pompeii

* *Memorabilia* I., 4, 3 (written about 390 B. C.).
† VIII., page 372 (written about 18 A. D.).
‡ *De Institutione Oratoria* XII., 10, 7 (written about 90 A. D.).

in 1797, is the best preserved, being substantially antique throughout, but is of indifferent workmanship.

The young man, of massive build, stands supporting his weight on the right leg ; the left is bent backward from the knee, the foot touching the ground only in front. Thus the body is a good deal curved. This attitude is an advance upon any standing motive attained in the "Transitional period" (*cf.* page 165). It was much used by Polyclitus, and is one of the marks by which statues of his may be recognized. The head of the Doryphorus, as seen from the side, is more nearly rectangular than the usual Attic

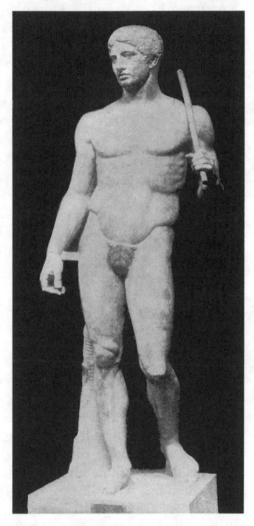

Fig. 137.—Copy of the Doryphorus of Polyclitus. Naples.

heads of the period, *e. g.*, in the Parthenon frieze. For the characteristic face our best guide is a bronze copy

of the head from Herculaneum (Fig. 138), to which our illustration does less than justice.

A strong likeness to the Doryphorus exists in a whole series of youthful athletes, which are therefore with probability traced to Polyclitus as their author or inspirer. Such is a statue of a boy in Dresden, of which the head is shown in Fig. 139. One of these obviously allied works can be identified with a statue by Polyclitus known to us from our literary sources. It is the so-called Diadumenos, a youth binding the fille·t of victory about his head. This exists in several copies, the best of which has been of which has been recently found on

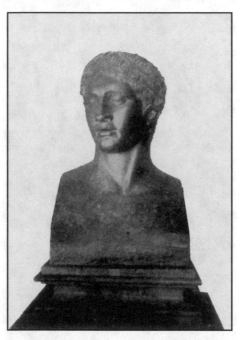

FIG. 138.—BRONZE COPY OF THE HEAD OF THE DORYPHORUS. Naples.

the island of Delos and is not yet published.

An interesting statue of a different order, very often attributed to Polyclitus, may with less of confidence be accepted as his. Our illustration (Fig. 140) is taken from the Berlin copy of this statue, in which the arms, pillar, nose, and feet are modern, but are guaranteed by other existing copies. It is the figure of an Amazon, who has been wounded in the right breast. She leans upon a support at her left side and raises her right hand

to her head in an attitude perhaps intended to suggest
exhaustion, yet hardly suitable to the position of the
wound. The attitude of the figure, especially the legs,
is very like that of the Doryphorus, and the face is
thought by many to show a family likeness to his.
There are three other types of Amazon which seem to be
connected with this one, but the mutual relations of
the four types are too perplexing to be here discussed.

It is a welcome change to turn from copies to
originals. The American School of Classical Studies at
Athens has carried on excavations (1890–95) on the site
of the famous sanct-
uary of Hera near
Argos, and has un-
covered the foun-
dations both of the
earlier temple,
burned in 423, and
of the later temple,
in which stood the
gold and ivory im-
age by Polyclitus,
as well as of adjacent
buildings. Besides
many other objects
of interest, there
have been brought
to light several frag-
ments of the meto-
pes of the second
temple, which, to-

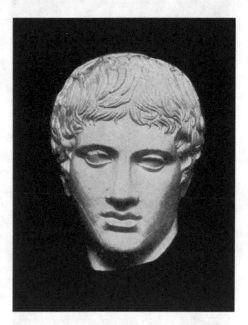

FIG. 139.—HEAD OF A BOY, AFTER POLYCLITUS.
Dresden.

gether with a few fragments from the same source found
earlier, form a precious collection of materials for the
study of the Argive school of sculpture of about 420.

Still more interesting, at least to such as are not specialists, is a head which was found on the same site (Fig. 141), and which, to judge by its style, must date from the same period. It is a good illustration of the uncertainty which besets the attempt to classify extant Greek sculptures into local schools that this head has been claimed with equal confidence as Argive* and as Attic in style. In truth, Argive and Attic art had so acted and reacted upon one another that it is small wonder if their productions are in some cases indistinguishable by us.

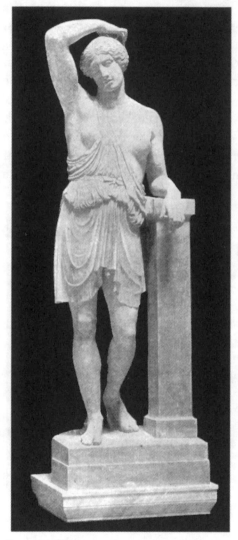

FIG. 140.—WOUNDED AMAZON, PERHAPS AFTER POLYCLITUS. Berlin.

The last remark applies also to the bronze statue shown in Fig. 142, which is believed by high authorities to be an original Greek

* So by Professor Charles Waldstein, who directed the excavations.

work and which has been claimed both for Athens and for Argos. The standing position, while not identical with that of the Doryphorus, the Diadumenos, and the wounded Amazon, is strikingly similar, as is also the

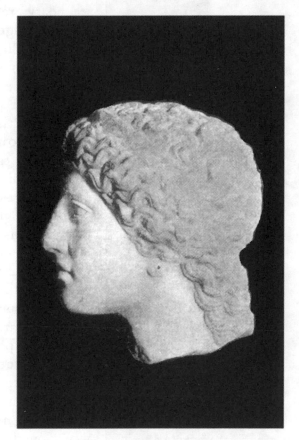

FIG. 141.—HEAD FROM THE ARGIVE HERÆUM.
Athens, National Museum.

form of the head. At all events, the statue is a fine example of apparently unstudied ease, of that consummate art which conceals itself.

The only sculptor of the fifth century who is at once

known to us from literary tradition and represented by an authenticated and original work is Pæonius of Mende in Thrace. He was an artist of secondary rank, if we may judge from the fact that his name occurs only in Pausanias; but in the brilliant period of Greek history even secondary artists were capable of work which less fortunate ages could not rival. Pausanias mentions a Victory by Pæonius at Olympia, a votive offering of the Messenians for successes gained in war. Portions of the pedestal of this statue with the dedicatory inscription and the artist's signature were found on December 20, 1875, at the beginning of

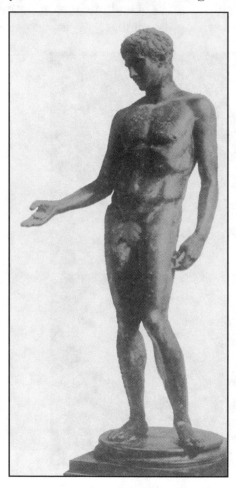

FIG. 142.—THE " IDOLINO."
Florence, Archæological Museum.

the German excavations, and the mutilated statue itself on the following day (Fig. 143). A restoration of the figure by a German sculptor (Fig. 144) may be trusted for nearly everything but the face. The goddess is

represented in descending flight. Poised upon a triangular pedestal about thirty feet high, she seems all but independent of support. Her draperies, blown by the wind, form a background for her figure. An eagle at her feet suggests the element through which she moves. Never was a more audacious design executed in marble. Yet it does not impress us chiefly as a *tour de force*. The beholder forgets the triumph over material difficulties in the sense of buoyancy, speed, and grace which the figure inspires. Pausanias records that the Messenians of his day believed the statue to commemorate an event which happened in 425, while he himself preferred to con-

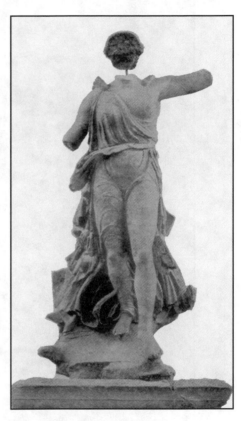

Fig. 143.—Victory of Pæonius. Olympia.

nect it with an event of 453. The inscription on the pedestal is indecisive on this point. It runs in these terms: "The Messenians and Naupactians dedicated [this statue] to the Olympian Zeus, as a tithe [of the spoils] from their enemies. Pæonius of Mende made it; and he was victorious [over his competitors] in making

the *acroteria* for the temple.'' The later of the two dates mentioned by Pausanias has been generally ac-

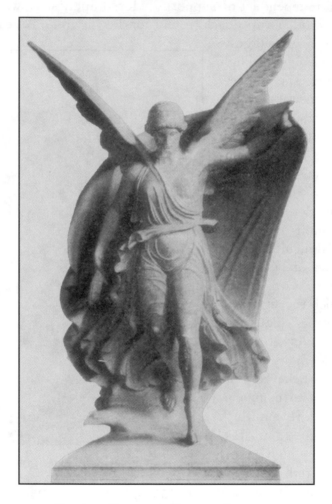

FIG. 144.—VICTORY OF PÆONIUS, RESTORED.

cepted, though not without recent protest. This would give about the year 423 for the completion and erection of this statue.

CHAPTER 9

The Great Age of Greek Sculpture: Second Period: 400 - 323 B.C.

In the fourth century art became even more cosmopolitan than before. The distinctions between local schools were nearly effaced and the question of an artist's birthplace or residence ceases to have much importance. Athens, however, maintained her artistic preeminence through the first half or more of the century. Several of the most eminent sculptors of the period were certainly or probably Athenians, and others appear to have made Athens their home for a longer or shorter time. It is therefore common to speak of a "younger Attic school," whose members would include most of the notable sculptors of this period. What the tendencies of the times were will best be seen by studying the most eminent representatives of this group or school.

The first great name to meet us is that of Scopas of Paros. His artistic career seems to have begun early in the fourth century, for he was the architect of a temple of Athena at Tegea in Arcadia which was built to replace one destroyed by fire in 395–4. He was active as late as the middle of the century, being one of four sculptors engaged on the reliefs of the Mausoleum or funeral monument of Maussollus, satrap of Caria, who died in 351–0, or perhaps two years earlier. That is about all we know of his life, for it is hardly more than a conjecture that he took up his abode in Athens for a term of

years. The works of his hands were widely distributed in Greece proper and on the coast of Asia Minor.

Until lately nothing very definite was known of the style of Scopas. While numerous statues by him, all representing divinities or other imaginary beings, are mentioned in our literary sources, only one of these is described in such a way as to give any notion of its artistic character. This was a Mænad, or female attendant of the god Bacchus, who was represented in a frenzy of religious excitement. The theme suggests a strong tendency on the part of Scopas toward emotional expression, but this inference does not carry us very far.

The study of Scopas has entered upon a new stage since some fragments of sculpture belonging to the Temple of Athena at Tegea have become known. The presumption is that, as Scopas was the architect of the building, he also designed, if he did not execute, the pediment-sculptures. If this be true, then we have at last authentic, though scanty, evidence of his style. The fragments thus far discovered consist of little more than two human heads and a boar's head. One of the

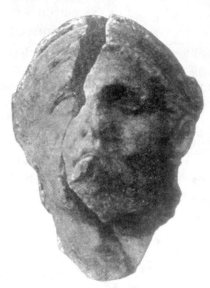

Fig. 145.—Head from Tegea.
Athens, National Museum.

human heads is here reproduced (Fig. 145). Sadly mutilated as it is, is has become possible by its help and that of its fellow to recognize with great probability the

authorship of Scopas in a whole group of allied works. Not to dwell on anatomical details, which need casts for their proper illustration, the obvious characteristic mark of Scopadean heads is a tragic intensity of expression unknown to earlier Greek art. It is this which makes the Tegea heads so impressive in spite of the "rude wasting of old Time."

The magnificent head of Meleager in the garden of the Villa Medici in Rome (Fig. 146) shows this same quality. A fiery eagerness of temper animates the marble, and a certain pathos, as if born of a consciousness of approaching doom. So masterly is the workmanship here, so utterly removed from the mechanical, uninspired manner of Roman copyists, that this head has been claimed as an original from the hand of Scopas, and so it may well be. Something of the same character belongs to a head of a goddess in Athens, shown in Fig. 147.

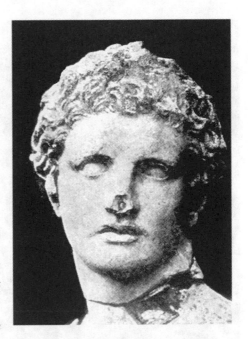

FIG. 146.—HEAD OF MELEAGER.
Rome, Villa Medici.

Fig. 148 introduces us to another tendency of fourth century art. The group represents Eirene and Plutus (Peace and Plenty). It is in all probability a copy of a

bronze work by Cephisodotus, which stood in Athens and was set up, it is conjectured, soon after 375, the year in which the worship of Eirene was officially established in Athens. The head of the child is antique, but does not belong to the figure; copies of the child with

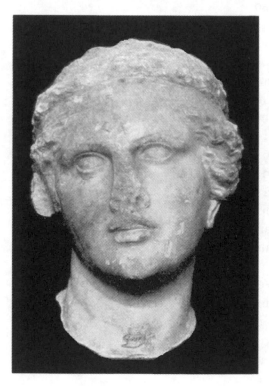

the true head exist in Athens and Dresden. The principal modern parts are: the right arm of the goddess (which should hold a scepter), her left hand with the vase, and both arms of the child; in place of the vase there should be a small horn of plenty, resting on the child's left arm. The sentiment of this group is such as we have not met before. The tenderness ex-

FIG. 147.—HEAD OF A GODDESS.
Athens, National Museum.

pressed by Eirene's posture is as characteristic of the new era as the intensity of look in the head from Tegea.

Cephisodotus was probably a near relative of a much greater sculptor, Praxiteles, perhaps his father. Praxiteles is better known to us than any other Greek artist. For we have, to begin with, one authenticated original

statue from his hand, besides three fourths of a bas-relief probably executed under his direction. In the second place, we can gather from our literary sources a catalogue of toward fifty of his works, a larger list than can be made out for any other sculptor. Moreover, of several pieces we get really enlightening descriptions, and there are in addition one or two valuable general comments on his style. Finally two of his statues that are mentioned in literature can be identified with sufficient certainty in copies.

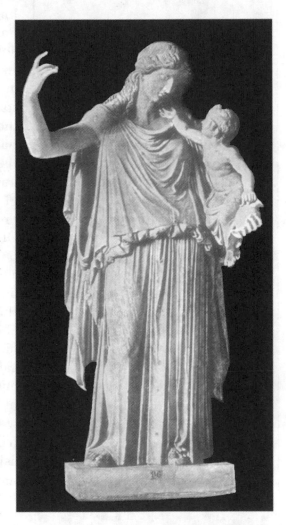

FIG. 148.—EIRENE AND PLUTUS. Munich.

The basis of judgment is thus wide enough to warrant us in bringing numerous other works into relation with him.

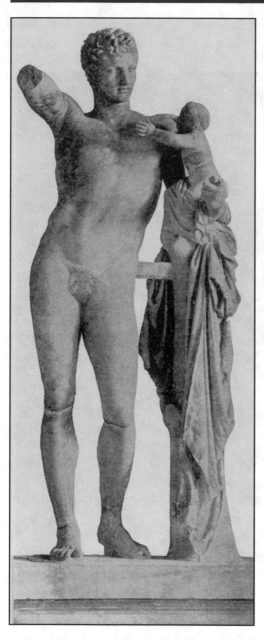

FIG. 149.—HERMES, BY PRAXITELES. Olympia.

About his life, however, we know, as in other cases, next to nothing. He was an Athenian and must have been somewhere near the age of Scopas, though seemingly rather younger. Pliny gives the hundred and fourth Olympiad (370–66) as the date at which he flourished, but this was probably about the beginning of his artistic career. Only one anecdote is told of him which is worth repeating here. When asked what ones among his marble statues he rated highest he answered that those which Nicias had tinted were the best.

Nicias was an eminent painter of the period (see page 282, foot-note).

The place of honor in any treatment of Praxiteles

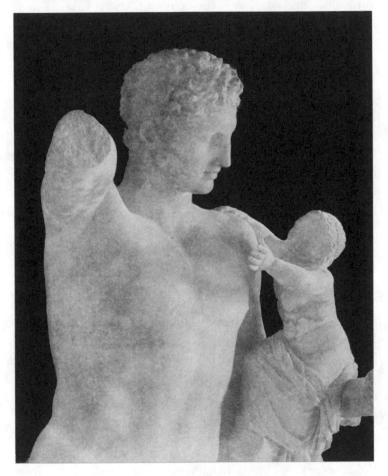

FIG. 150.—HEAD AND BODY OF THE HERMES OF PRAXITELES. Olympia.

must be given to the Hermes with the infant Dionysus on his arm (Figs. 149, 150). This statue was found on May 8, 1877, in the Temple of Hera at Olympia, lying in front of its pedestal. Here it had stood when Pau-

sanias saw it and recorded that it was the work of Praxiteles. The legs of Hermes below the knees have been restored in plaster (only the right foot being antique), and so have the arms of Dionysus. Except for the loss of the right arm and the lower legs, the figure of Hermes is in admirable preservation, the surface being uninjured. Some notion of the luminosity of the Parian marble may be gained from Fig. 150.

Hermes is taking the new-born Dionysus to the Nymphs to be reared by them. Pausing on his way, he has thrown his mantle over a convenient tree-trunk and leans upon it with the arm that holds the child. In his closed left hand he doubtless carried his herald's wand ; the lost right hand must have held up some object— bunch of grapes or what-not—for the entertainment of the little god. The latter is not truthfully proportioned ; in common with almost all sculptors before the time of Alexander, Praxiteles seems to have paid very little attention to the characteristic forms of infancy. But the Hermes is of unapproachable perfection. His symmetrical figure, which looks slender in comparison with the Doryphorus of Polyclitus, is athletic without exaggeration, and is modeled with faultless skill. The attitude, with the weight supported chiefly by the right leg and left arm, gives to the body a graceful curve which Praxiteles loved. It is the last stage in the long development of an easy standing pose. The head is of the round Attic form, contrasting with the squarer Peloponnesian type ; the face a fine oval. The lower part of the forehead between the temples is prominent ; the nose not quite straight, but slightly arched at the middle. The whole expression is one of indescribable refinement and radiance. The hair, short and curly, illustrates the possibilities of marble in the treatment of

that feature ; in place of the wiry appearance of hair in bronze we find here a slight roughness of surface, suggestive of the soft texture of actual hair (*cf.* Fig. 146 and contrast Fig. 138). The drapery that falls over the tree-trunk is treated with a degree of elaboration and richness which does not occur in fifth century work ; but beautiful as it is, it is kept subordinate and does not unduly attract our attention.

For us the Hermes stands alone and without a rival. The statue, however, did not in antiquity enjoy any extraordinary celebrity, and is in fact not even mentioned in extant literature except by Pausanias. The most famous work of Praxiteles was the Aphrodite of Cnidus in southwestern Asia Minor. This was a temple-statue ; yet the sculptor, departing from the practice of earlier times, did not scruple to represent the goddess as nude. With the help of certain imperial coins of Cnidus this Aphrodite has been identified in a great number of copies. She is in the act of dropping her garment from her left hand in preparation for a bath ; she supports herself chiefly by the right leg, and the body has a curve approaching that of the Hermes, though here no part of the weight is thrown upon the arm. The subject is treated with consummate delicacy, far removed from the sensuality too usual in a later age ; and yet, when this embodiment of Aphrodite is compared with fifth century ideals, it must be recognized as illustrating a growing fondness on the part of sculptor and public for the representation of physical charm. Not being able to offer a satisfactory illustration of the whole statue, I have chosen for reproduction a copy of the head alone (Fig. 151). It will help the reader to divine the simple loveliness of the original.

Pliny mentions among the works in bronze by Prax-

iteles a youthful Apollo, called "Sauroctonos" (Lizard-slayer). Fig. 152 is a marble copy of this, considerably restored. The god, conceived in the likeness of a beautiful boy, leans against a tree, preparing to stab a lizard with an arrow, which should be in the right hand. The graceful, leaning pose and the soft beauty of the youthful face and flesh are characteristically Praxitelean.

Two or three satyrs by Praxiteles are mentioned by Greek and Roman writers, and an anecdote is told by Pausanias which implies that one of them enjoyed an exceptional fame. Unfortunately they are

FIG. 151.—COPY OF THE HEAD OF THE APHRO-DITE OF CNIDUS. Berlin, in private possession.

not described ; but among the many satyrs to be found in museums of ancient sculpture there are two types in which the style of Praxiteles, as we have now learned to know it, is so strongly marked that we can hardly go wrong in ascribing them both to him. Both exist in numerous copies. Our illustration of the first (Fig. 153) is taken from the copy of which Hawthorne wrote so subtle a description in "The Marble Faun." The statue is somewhat restored, but the restoration is not open to doubt, except as regards the single pipe held in

the right hand. No animal characteristic is to be found here save the pointed ears ; the face, however, retains a suggestion of the traditional satyr-type. " The whole statue, unlike anything else that ever was wrought in that severe material of marble, conveys the idea of an amiable and sensual creature—easy, mirthful, apt for jollity, yet not incapable of being touched by pathos."*

In the Palermo copy of the other Praxitelean satyr (Fig. 154) the right arm is modern, but the restoration is substantially correct. The face of this statue has purely Greek features, and only the pointed ears remain to betray the mixture of animal nature with the human form. The original was probably of bronze.

With Fig. 155 we revert from copies to an original work. This is one of three slabs which proba-bly decorated the

FIG. 152.—COPY OF THE APOLLO SAUROCTONOS.
Rome, Vatican Museum.

pedestal of a group by Praxiteles representing Apollo, Leto, and Artemis ; a fourth slab, needed to complete

* Hawthorne, " The Marble Faun," Vol. I., Chapter I.

FIG. 153.—LEANING SATYR. Rome, Capitoline Museum.

the series, has not been found. The presumption is strong that these reliefs were executed under the direction of Praxiteles, perhaps from his design. The subject of one slab is the musical contest between Apollo and Marsyas, while the other two bear figures of Muses. The latter are posed and draped with that delightful grace of which Praxiteles was master, and with which he seems to have inspired his pupils. The execution, however, is not quite faultless, as witness the distortion in the right lower leg of the seated Muse in Fig. 155—otherwise an exquisite figure.

Among the many other works that have been claimed for Praxiteles on grounds of style, I venture to single out one (Fig. 156). The illustration is taken from one of several copies of a lost original, which, if it was not by Praxiteles himself, was by some one who had marvelously caught his spirit. That it represents the goddess Artemis we may probably infer from the short chiton, an appropriate garment often worn by the divine huntress, but not by human maidens. Otherwise the goddess has no conventional attribute to mark her divinity. She is just a beautiful

Fig. 154.—Satyr Pouring Wine. Palermo.

girl, engaged in fastening her mantle together with a brooch. In this way of conceiving a goddess, we see the same spirit that created the Apollo Sauroctonos.

The genius of Praxiteles, as thus far revealed to us, was preëminently sunny, drawn toward what is fair and graceful and untroubled, and ignoring what is tragic in human existence. This view of him is confirmed by what is known from literature of his subjects. The list includes five figures of Aphrodite, three or four of Eros, two of Apollo, two of Artemis, two of Dionysus, two or three of satyrs, two of the courtesan Phryne, and one of

Fig. 155.—Relief from Mantinea. Athens, National Museum.

a beautiful human youth binding a fillet about his hair, but no work whose theme is suffering or death is definitely ascribed to him. It is strange therefore to find Pliny saying that it was a matter of doubt in his time whether a group of the dying children of Niobe which stood in a temple of Apollo in Rome was by Scopas or Praxiteles. It is commonly supposed, though without decisive proof, that certain statues of Niobe and her children which exist in Florence and elsewhere are

copied from the group of which Pliny speaks. The
story was that Niobe vaunted herself before Leto
because she had seven sons
and seven daughters, while
Leto had borne only Apollo
and Artemis. For her pre-
sumption all her children
were stricken down by
the arrows of Apollo and
Artemis. This punishment
is the subject of the group.
Fig. 157 gives the central
figures; they are Niobe
herself and her youngest
daughter, who has fled to
her for protection. The
Niobe has long been
famous as an embodiment
of haughtiness, maternal
love, and sharp distress.
But much finer in compo-
sition, to my thinking, is
Fig. 158. In this son of
Niobe the end of the right
arm and the entire left arm
are modern. Originally
this youth was grouped
with a sister who has been
wounded unto death. She
has sunk upon the ground
and her right arm hangs
limply over his left knee,

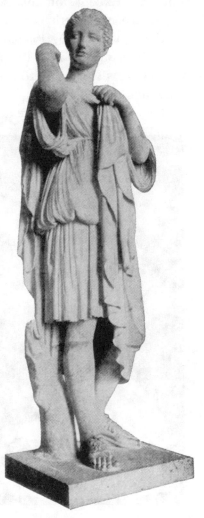

FIG. 156.—ARTEMIS, CALLED THE DI-
ANA OF GABII. Paris, Louvre.

thus preventing his garment from falling. His left arm
clasps her and he seeks ineffectually to protect her.

That this is the true restoration is known from a copy
in the Vatican of the wounded girl with a part of the
brother. Except for this son of Niobe the Florentine
figures are not worthy of their old-time reputation. As
for their authorship, Praxiteles seems out of the ques-
tion. The subject is in keeping with the genius of Sco-
pas, but it is safer not to associate the group with any
individual name.

This reserve is the more advisable because Scopas and
Praxiteles a r e
but two stars,
b y f a r t h e
brightest, to
be sure, in a
brilliant constel-
lation of con-
temporary art-
ists. For the
others it is im-
possible to do
m u c h m o r e
here than to
mention the
most important
names: Leocha-
res and Timo-
theus, whose
civic ties a r e
unknown, Bry-
axis and Silani-
on of Athens,
and Euphranor

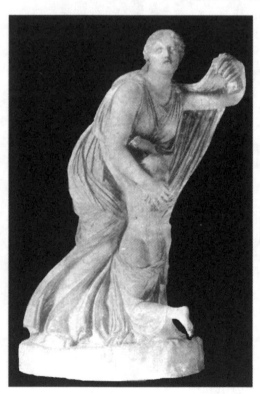

FIG. 157.—NIOBE AND A DAUGHTER OF NIOBE.
Florence, Uffizi.

of Corinth, the last equally famous as painter and sculp-
tor. These artists seem to be emerging a little from

the darkness that has enveloped them, and it may be hoped that discoveries of new material and further study of already existing material will reveal them to us with some degree of clearness and certainty. A good illustration of how new acquisitions may help us is afforded by a group of fragmentary sculptures found in the sanctuary of Asclepius near Epidauros in the years 1882–84 and belonging to the pediments of the principal temple. An inscription was found on the same site which records the expenses incurred in building this tem-

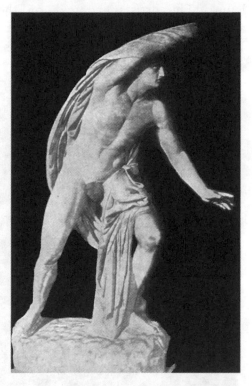

FIG. 158.—A SON OF NIOBE. Florence, Uffizi.

ple, and one item in it makes it probable that Timotheus, the sculptor above mentioned, furnished the models after which the pediment-sculptures were executed. The largest and finest fragment of these sculptures that has been found is given in Fig. 159. It belongs to the western pediment, which seems to have contained a battle of Greeks and Amazons. The Amazon of our illustration, mounted upon a rearing horse, is about to bring down her lance upon a fallen foe. The action is

rendered with splendid vigor. The date of this temple and its sculptures may be put somewhere about 375.

Reference was made above (page 215) to the Mausoleum. The artists engaged on the sculptures which adorned that magnificent monument were, according to Pliny, Scopas, Leochares, Bryaxis, and Timotheus.*

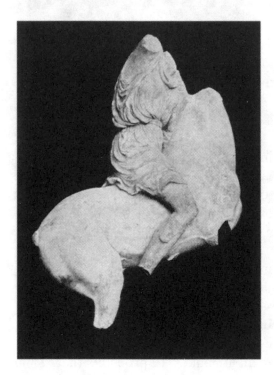

FIG. 159.—MOUNTED AMAZON.
Athens, National Museum.

There seem to have been at least three sculptured friezes, but of only one have considerable remains been preserved (*cf.* Fig. 65). This has for its subject a battle of Greeks and Amazons, a theme which Greek sculptors and painters never wearied of reproducing. The preserved portions of this frieze amount in all to about eighty feet, but the slabs are not consecutive. Figs. 160 and 161 give two of the best pieces. The design falls into groups of two or three combatants, and these groups are varied with inexhaustible fertility and liveliness of

* The tradition on this point was not quite uniform. Vitruvius names Praxiteles as the fourth artist, but adds that some believed that Timotheus also was engaged.

imagination. Among the points which distinguish this from a work of the fifth century may be noted the

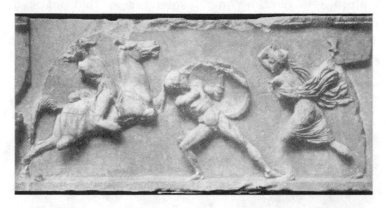

FIG. 160.—SLAB OF MAUSOLEUM FRIEZE. London, British Museum.

slenderer forms of men and women and the more expressive faces. The existing slabs, moreover, differ among themselves in style and merit, and an earnest at-

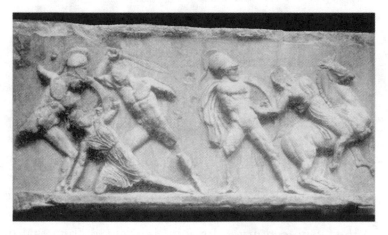

FIG. 161.—SLAB OF MAUSOLEUM FRIEZE. London, British Museum.

tempt has been made to distribute them among the four artists named by Pliny, but without conclusive results.

Since the Hermes of Praxiteles was brought to light at Olympia there has been no discovery of Greek sculpture so dazzling in its splendor as that made in 1887 on the site of the necropolis of Sidon in Phenicia. There, in a group of communicating subterranean chambers, were found, along with an Egyptian sarcophagus, sixteen others of Greek workmanship, four of them adorned with reliefs of extraordinary beauty. They are

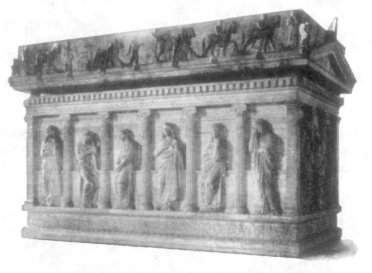

Fig. 162.—Sarcophagus of " The Mourning Women." Istanbul

all now in the Istanbul Archaeological Museum, which has thus become one of the places of foremost consequence to every student and lover of Greek art. The sixteen sarcophagi are of various dates, from early in the fifth to late in the fourth century. The one shown in Fig. 162 may be assigned to about the middle of the fourth century. Its form is adapted from that of an Ionic temple. Between the columns are standing or seated women, their faces and attitudes expressing varying degrees of grief. Our illustration is on too small a

scale to convey any but the dimmest impression of the dignity and beauty of this company of mourners. Above, on a sort of balustrade, may be seen a funeral procession.

The old Temple of Artemis at Ephesus (*cf.* page 140) was set on fire and reduced to ruins by an incendiary in 356 B. C., on the very night, it is said, in which Alexander the Great was born. The Ephesians rebuilt the temple on a much more magnificent scale, making of it the most extensive and sumptuous columnar edifice ever erected by a Greek architect. How promptly the work was begun we do not know, but it lasted into the reign of Alexander, so that its date may be given approximately as 350-30. Through the indefatigable perseverance of Mr. J. T. Wood, who conducted excavations at Ephesus for the British Museum in 1863-74, the site of this temple, long unknown, was at last discovered and its remains unearthed. Following the example of the sixth century temple, it had the lowest drums of a number of its columns covered with relief sculpture. Of the half dozen recovered specimens Fig. 163 shows the finest. The subject is an unsolved riddle. The most prominent figure in the illustration is the god Hermes, as the herald's staff in his right hand shows. The female figures to right and left of him are good examples of that grace in pose and drapery which was characteristic of Greek sculpture in the age of Scopas and Praxiteles.

The most beautiful Greek portrait statue that we possess is the Lateran Sophocles (Fig. 164). The figure has numerous small restorations, including the feet and the box of manuscript rolls. That Sophocles, the tragic poet, is represented, is known from the likeness of the head to a bust inscribed with his name. He

died in 406 B. C. The style of our statue, however, points to an original (if it be not itself the original) of about the middle of the fourth century. There were probably in existence at this time authentic likenesses of the poet, on which the sculptor based his work. The

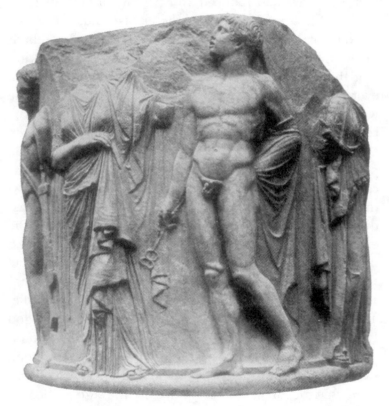

FIG. 163.—SCULPTURED DRUM OF COLUMN FROM EPHESUS.
London, British Museum.

attitude of the figure is the perfection of apparent ease, but in reality of skilful contrivance to secure a due balance of parts and variety and grace of line. The one garment, drawn closely about the person, illustrates the inestimable good fortune enjoyed by the Greek sculptor,

in contrast with the sculptor of to-day, in having to represent a costume so simple, so pliant, so capable of graceful adjustment. The head, however much it may contain of the actual look of Sophocles, must be idealized. To appreciate it properly one must remember that this poet, though he dealt with tragic themes, was not wont to brood over the sin and sorrow and unfathomable mystery of the world, but was serene in his temper and prosperous in his life.

The colossal head of Zeus shown in Fig. 165 was found two hundred years or more ago at Otricoli, a small village to the north of Rome. The antique part is a mere mask ; the back of the head and the bust

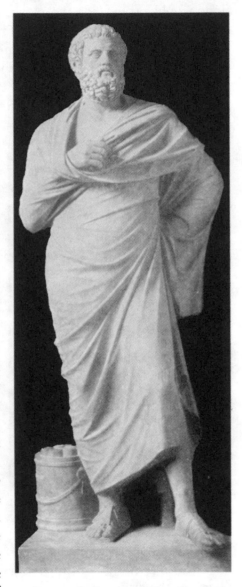

FIG. 164.—SOPHOCLES.
Rome, Lateran Museum.

are modern. The material is Carrara marble, a fact which

alone would prove that the work was executed in Italy and in the imperial period. At first this used to be regarded as copied from the Olympian Zeus of Phidias (page 185), but in the light of increased acquaintance

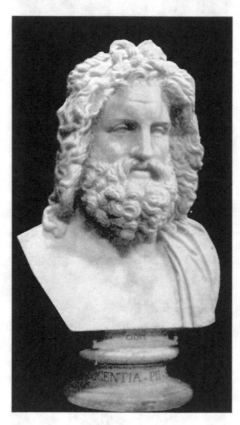

with the style of Phidias and his age, this attribution has long been seen to be impossible. The original belongs about at the end of the period now under review, or possibly still later. Although only a copy, the Otricoli Zeus is the finest representation we have of the father of gods and men. The predominant expression is one of gentleness and benevolence, but the lofty brow, transversely furrowed, tells of thought and will, and the leonine hair of strength.

FIG. 165.—HEAD OF ZEUS. Rome, Vatican Museum.

With Lysippus of Sicyon we reach the last name of first-rate importance in the history of Greek sculpture. There is the usual uncertainty about the dates of his life, but it is certain that he was in his prime during the reign of Alexander (336–23). Thus he belongs essen-

tially to the generation succeeding that of Scopas and Praxiteles. He appears to have worked exclusively in bronze ; at least we hear of no work in marble from his hands. He must have had a long life. Pliny credits him with fifteen hundred statues, but this is scarcely credible. His subjects suggest that his genius was of a very different bent from that of Praxiteles. No statue of Aphrodite or indeed of any goddess (except the Muses) is ascribed to him ; on the other hand, he made at least four statues of Zeus, one of them nearly sixty feet high, and at least four figures of Heracles, of which one was colossal, while one was less than a foot high, besides groups representing the labors of Heracles. In short, the list of his statues of superhuman beings, though it does include an Eros and a Dionysus, looks as if he had no especial predilection for the soft loveliness of youth, but rather for mature and vigorous forms. He was famous as a portrait-sculptor and made numerous statues of Alexander, from whom he received conspicuous recognition. Naturally, too, he accepted commissions for athlete statues ; five such are mentioned by Pausanias as existing at Olympia. An allegorical figure by him of Cairos (Opportunity) receives lavish praise from a late rhetorician. Finally, he is credited with a statue of a tipsy female flute-player. This deserves especial notice as the first well-assured example of a work of Greek sculpture ignoble in its subject and obviously unfit for any of the purposes for which sculpture had chiefly existed (*cf.* page 124).

It is Pliny who puts us in the way of a more direct acquaintance with this artist than the above facts can give. He makes the general statement that Lysippus departed from the canon of proportions previously followed (*i. e.*, probably, by Polyclitus and his imme-

diate followers), making the head smaller and the body slenderer and "dryer," and he mentions a statue by him in Rome called an Apoxyomenos, *i. e.*, an athlete

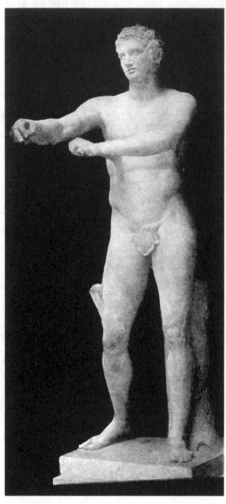

scraping himself with a strigil. A copy of such a statue was found in Rome in 1849 (Fig. 166). The fingers of the right hand with the inappropriate die are modern, as are also some additional bits here and there. Now the coincidence in subject between this statue and that mentioned by Pliny would not alone be decisive. Polyclitus also made an Apoxyomenos, and, for all we know, other sculptors may have used the same motive. But the statue in question is certainly later than Polyclitus, and its agreement with what Pliny tells us of the proportions adopted by Lysippus is as

FIG. 166.—COPY OF THE APOXYOMENOS OF LYSIPPUS. Rome, Vatican Museum.

close as could be desired (contrast Fig. 137). We therefore need not scruple to accept it as Lysippian.

Our young athlete, before beginning his exercise, had rubbed his body with oil and, if he was to wrestle, had sprinkled himself with sand. Now, his exercise over, he is removing oil and sweat and dirt with the instrument regularly used for that purpose. His slender figure suggests elasticity and agility rather than brute strength. The face (Fig. 167) has not the radiant charm which Praxiteles would have given it, but it is both fine and alert. The eyes are deeply set ; the division of the upper from the lower forehead is marked by a groove; the hair lies in expressive disorder. In the bronze original the tree-trunk behind the left leg was doubtless absent, as

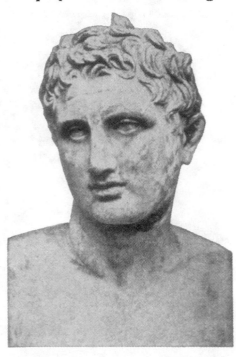

FIG. 167.—HEAD OF THE APOXYOMENOS.

also the disagreeable support (now broken) which extended from the right leg to the right fore-arm.

The best authenticated likeness of Alexander the Great is a bust in the Louvre (Fig. 168) inscribed with his name : "Alexander of Macedon, son of Philip." The surface has been badly corroded and the nose is restored. The work, which is only a copy, may go back to an original by Lysippus, though the evidence

for that belief, a certain resemblance to the head of the Apoxyomenos, is hardly as convincing as one could desire. The king is here represented, one would guess, at the age of thirty or thereabouts. Now as he was absent from Europe from the age of twenty-two

until his death at Babylon at the age of thirty-three (323 B. C.), it would seem likely that Lysippus, or whoever the sculptor was, based his portrait upon likenesses taken some years earlier. Consequently, although portraiture in the age of Alexander had become prevailingly realistic, it would be unsafe to regard this head as a conspicuous example of the new tendency. The

FIG. 168.—HEAD OF ALEXANDER. Paris, Louvre.

artist probably aimed to present a recognizable likeness and at the same time to give a worthy expression to the great conqueror's qualities of character. If the latter object does not seem to have been attained, one is free to lay the blame upon the copyist and time.

CHAPTER 10

The Hellenistic Period of Greek Sculpture: 323 - 146 B.C.

THE reign of Alexander began a new era in Greek history, an era in which the great fact was the dissemination of Greek culture over wide regions to which it had been alien. This period, in which Egypt and western Asia were ruled by men of Greek or Macedonian blood and gradually took on more or less of Greek civilization, is often called the Hellenistic period.

Under the new political and social order new artistic conditions were developed. For one thing, Athens and the other old centers of artistic activity lost their pre-eminence, while new centers were created in the East. The only places which our literary sources mention as seats of important schools of sculpture in the two centuries following the death of Alexander are Rhodes and Pergamum.

Then again a demand now grew up for works of sculpture to be used as mere ornaments in the interiors of palaces and private houses, as well as in public buildings and places. This of course threw open the door for subjects which had been excluded when sculpture was dominated by a sacred purpose. Sculptors were now free to appeal to the lower tastes of their patrons. The practice of " art for art's sake " had its day, and trivial, comical, ugly, harrowing, or sensual themes were treated with all the resources of technical skill. In short, the position and purposes of the art of sculpture

became very like what they are to-day. Hence the untrained modern student feels much more at home in a collection of Hellenistic sculpture than in the presence of the severer, sublimer creations of the age of Phidias.

It is by no means meant to pass a sweeping condemnation upon the productions of the post-classical period. Realistic portraiture was now practiced with great frequency and high success. Many of the *genre* statues and decorative reliefs of the time are admirable and delightful. Moreover, the old uses of sculpture were not abandoned, and though the tendency toward sensational-

FIG. 169.—THREE TANAGRA FIGURINES. London, British Museum.

ism was strong, a dignified and exalted work was sometimes achieved. But, broadly speaking, we must admit the loss of that "noble simplicity and quiet grandeur" —the phrase is Winckelmann's—which stamped the creations of the age of Phidias. Greek sculpture gained immensely in variety, but at the expense of its elevation of spirit.

Although this sketch is devoted principally to bronze and marble sculpture, I cannot resist the temptation to illustrate by a few examples the charming little terra-cotta figurines which have been found in such great numbers in graves at Tanagra and elsewhere in Bœotia

FIG. 170.—THREE TANAGRA FIGURINES. London, British Museum.

(Figs. 169, 170). It is a question whether the best of them were not produced before the end of the period covered by the last chapter. At all events, they are post-Praxitelean. The commonest subjects are standing or seated women ; young men, lads, and children are also often met with. Fig. 170 shows another favorite figure, the winged Eros, represented as a chubby boy of four or five—a conception of the god of Love which makes its first appearance in the Hellenistic period. The men who modeled these statuettes were doubtless

Fig. 171. — The "Alexander" Sarcophagus. Istanbul

regarded in their own day as very humble craftsmen, but the best of them had caught the secret of graceful poses and draperies, and the execution of their work is as delicate as its conception is refined.

Returning now to our proper subject, we may begin with the latest and most magnificent of the sarcophagi found at Sidon (Fig. 171; *cf.* page 234). This belongs somewhere near the end of the fourth century. It is decorated with relief-sculpture on all four sides and in the gables of the cover. On the long side shown in our illustration the subject is a battle between Greeks and Persians, perhaps the battle of Issus, fought in 333. Alexander the Great, recognizable by the skin of a lion's head which he wears like Heracles, instead of a helmet, is to be seen at the extreme left. The design, which looks crowded and confused when reduced to a small scale, is in reality well arranged and extremely spirited, besides being exquisitely wrought. But the crowning interest of the work lies in the unparalleled freshness with which it has kept its color. Garments, saddle-cloths, pieces of armor, and so on, are tinted in delicate colors, and the finest details, such as bow-strings, are perfectly distinct. The nude flesh, though not covered with opaque paint, has received some application which differentiates it from the glittering white background, and gives it a sort of ivory hue. The effect of all this color is thoroughly refined, and the work is a revelation of the beauty of polychromatic sculpture.

The Nike of Samothrace (Fig. 172), however, is dated approximately 200 – 190 B. C. The figure is considerably above life-size. It was found in 1863, broken into a multitude of fragments, which have been carefully united. There are no modern pieces, ex-

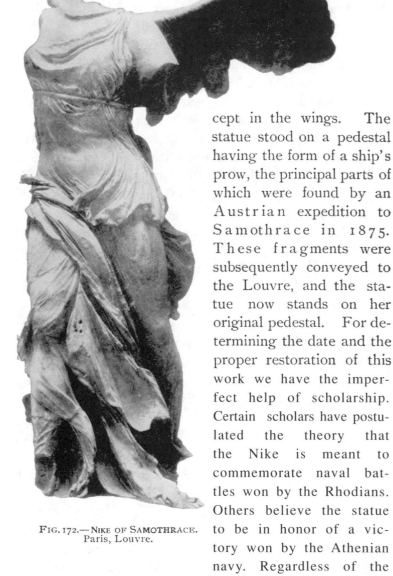

FIG. 172.—NIKE OF SAMOTHRACE.
Paris, Louvre.

cept in the wings. The statue stood on a pedestal having the form of a ship's prow, the principal parts of which were found by an Austrian expedition to Samothrace in 1875. These fragments were subsequently conveyed to the Louvre, and the statue now stands on her original pedestal. For determining the date and the proper restoration of this work we have the imperfect help of scholarship. Certain scholars have postulated the theory that the Nike is meant to commemorate naval battles won by the Rhodians. Others believe the statue to be in honor of a victory won by the Athenian navy. Regardless of the

exact victory celebrated, it is agreed that the commemorative group the statue was a part of included a ship's prow upon which the Nike was set. The statue is considered one of the great Hellenistic masterpieces, and relates to the space around it in the best fashion of that era.

The goddess held a trumpet to her lips with her right hand and in her left carried a support such as was used for the erection of a trophy. The ship upon which she has just alighted is conceived as under way, and the fresh breeze blows her garments backward in tumultuous folds. Compared with the Victory of Pæonius (Figs. 143, 144) this figure seems more impetuous and imposing. That leaves us calm ; this elates us with the sense of onward motion against the salt sea air. Yet there is nothing unduly sensational about this work. It exhibits a magnificent idea, magnificently rendered.

From this point on no attempt will be made to preserve a chronological order, but the principal classes of sculpture belonging to the Hellenistic period will be illustrated, each by two or three examples. Religious sculpture may be put first. Here the chief place belongs to the Aphrodite of Melos, called the Venus of Milo (Fig. 173). This statue was found by accident in 1820 on the island of Melos (Milo) near the site of the ancient city. According to the best evidence available, it was lying in the neighborhood of its original pedestal, in a niche of some building. Near it were found a piece of an upper left arm and a left hand holding an apple ; of these two fragments the former certainly and perhaps the latter belong to the statue. The prize was bought by M. de Rivière, French ambassador at Con-

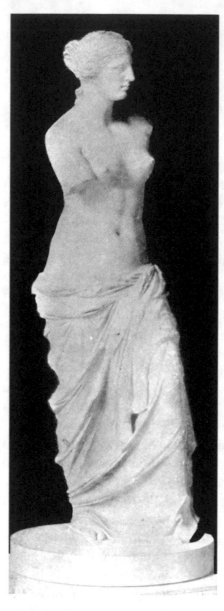

FIG. 173.—THE APHRODITE OF MELOS.
Paris, Louvre.

stantinople, and presented by him to the French king, L o u i s XVIII. The s a m e vessel which conveyed it to France brought some other m a r b l e fragments from Melos, including a piece of an inscribed statue-base with an artist's inscription in characters of the second century B. C. or later. A drawing exists of this fragment, but the object itself has disappeared, and in spite of much acute argumentation it remains u n c e r t a i n whether it did or did not form a part of the basis of the Aphrodite.

Still greater uncertainty prevails as to the proper restoration of the statue, and no one of the many suggestions that have been made is free from difficulties. It s e e m s probable, as has readily been set forth with great force and

clearness by Professor Furtwangler,* that the figure is an adaptation from an Aphrodite of the fourth century, who rests her left foot upon a helmet and, holding a shield on her left thigh, looks at her own reflection. On this view the difficulty of explaining the attitude of the Aphrodite of Melos arises from the fact that the motive was created for an entirely different purpose and is not altogether appropriate to the present one, whatever precisely that may be.

It has seemed necessary, in the case of a statue of so much importance, to touch upon these learned perplexities ; but let them not greatly trouble the reader or turn him aside from enjoying the superb qualities of the work. One of the Aphrodites of Scopas or Praxiteles, if we had it in the original, would perhaps reveal to us a still diviner beauty. As it is, this is the worthiest existing embodiment of the goddess of Love. The ideal is chaste and noble, echoing the sentiment of the fourth century at its best ; and the execution is worthy of a work which is in some sense a Greek original.

The Apollo of the Belvedere (Fig. 174), on the other hand, is only a copy of a bronze original. The principal restorations are the left hand and the right fore-arm and hand. The most natural explanation of the god's attitude is that he held a bow in his left hand and has just let fly an arrow against some foe. His figure is slender, according to the fashion which prevailed from the middle of the fourth century onward, and he moves over the ground with marvelous lightness. His appearance has an effect of almost dandified elegance, and critics to-day cannot feel the reverent raptures which this statue used to evoke. Yet still the Apollo of the Belvedere remains a radiant apparition. An attempt has re-

*" Masterpieces of Greek Sculpture," pages 384 *ff.*

cently been made to promote the figure, or rather its original, to the middle of the fourth century.

As a specimen of the portrait-sculpture of the Hellenistic period I have selected the seated statue of Posidippus (Fig. 175), an Athenian dramatist of the so-called New Comedy, who flourished in the early part of the third century. The preservation of the statue is extraordinary; there is nothing modern about it except the thumb of the left hand. It produces strongly the impression of being an original work and also of being a speaking likeness. It may have been modeled in the actual presence of the subject, but in

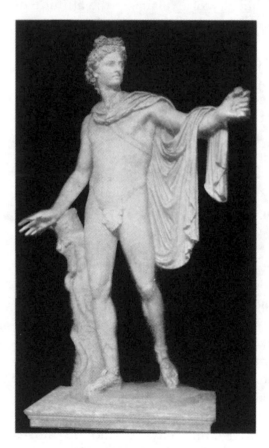

FIG. 174.—THE APOLLO OF THE BELVEDERE.
Rome, Vatican Museum.

that case the name on the front of the plinth was doubtless inscribed later, when the figure was removed from its pedestal and taken to Rome. Posidippus is clean-shaven, according to the fashion that came in about the

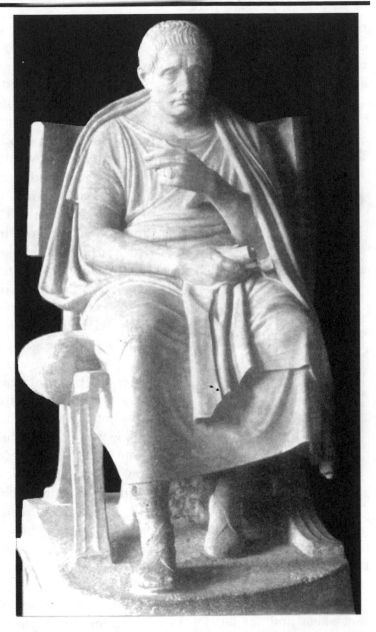

FIG. 175. — POSIDIPPUS. Rome, Vatican Museum.

time of Alexander.　There is a companion statue of equal merit, which commonly goes by the name of Menander.　The two men are strongly contrasted with one another by the sculptor in features, expression, and bod-

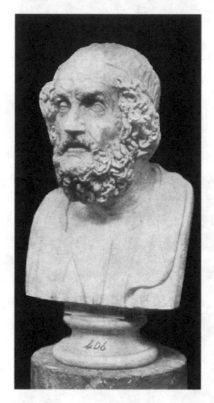

ily carriage.　Both statues show, as do many others of the period, how mistaken it would be to form our idea of the actual appearance of the Greeks from t h e purely ideal creations of Greek sculpture.

　Besides real portraits, imaginary portraits of great excellence were produced in the Hellenistic period.　Fig. 176 is a good specimen of these.　Only the head is antique, and there are some restorations, including the nose.　This is one of a considerable number of heads which reproduce an ideal portrait of Homer, con-

FIG. 176.—HEAD OF HOMER.　Naples.

ceived as a blind old man.　The marks of age and blindness are rendered with great fidelity.　There is a variant type of this head which is much more suggestive of poetical inspiration.

　Portraiture, of course, did not confine itself to men of refinement and intellect.　As an extreme example of what was possible in the opposite direction nothing could

be better than the original bronze statue shown in Fig.
177. It was found in Rome in 1885, and is essentially
complete, except for the missing eyeballs ; the seat is
new. The statue represents a naked boxer of herculean
frame, his hands armed with the *cæstus* or boxing-
gloves made of leather. The man is evidently a profes-
sional "bruiser" of the lowest type. He is just resting
after an encounter, and no detail is spared to bring out
the nature of his oc-
cupation. Swollen
ears were the con-
ventional mark of the
boxer at all periods,
but here the effect is
still further enhanced
by scratches and
drops of blood.
Moreover, the nose
and cheeks bear evi-
dence of having been
badly "punished,"
and the moustache is
clotted with blood.
From top to toe the
statue exhibits the
highest grade of
technical skill. One
would like very
much to know what

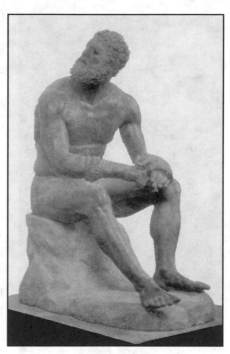

FIG. 177.—SEATED BOXER. Rome,
Museo delle Terme.

was the original purpose of the work. It may have
been a votive statue, dedicated by a victorious boxer at
Olympia or elsewhere. A bronze head of similar brutal-
ity found at Olympia bears witness that the refined stat-
ues of athletes produced in the best period of Greek art

and set up in that precinct were forced at a later day to accept such low companionship. Or it may be that this boxer is not an actual person at all, and that the statue belongs to the domain of *genre*. In either case it testifies to the coarse taste of the age.

By *genre* sculpture is meant sculpture which deals with incidents or situations illustrative of every-day life. The conditions of the great age, although they permitted a *genre*-like treatment in votive sculptures and in grave-reliefs (*cf.* Fig. 134), offered few or no occasions for works of pure *genre*, whose sole purpose is to gratify the spectator. In the Hellenistic period, however, such works became plentiful. Fig. 178 gives a good specimen. A boy of four or five is struggling in play with a goose and is triumphant. The composition of the group is admirable, and the zest of the sport is delightfully

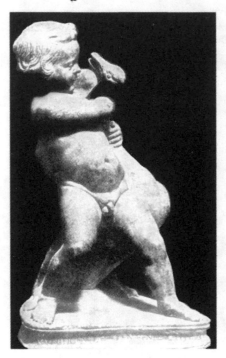

FIG. 178.—BOY AND GOOSE. Rome, Capitoline Museum.

brought out. Observe too that the characteristic forms of infancy—the large head, short legs, plump body and limbs—are truthfully rendered (*cf.* page 222). There is a large number of representations in ancient sculpture of boys with geese or other aquatic birds; among them are

at least three other copies of this same group. The original is thought to have been of bronze.

Fig. 179 is *genre* again, and is as repulsive as the last example is charming. It is a drunken old woman, lean and wrinkled, seated on the ground and clasping her wine-jar between her knees, in a state of maudlin ecstasy. The head is modern, but another copy of the statue has the original head, which is of the same character as this. Ignobility of subject could go no further than in this work.

It is a pleasure to turn to Fig. 180, which in purity of spirit is

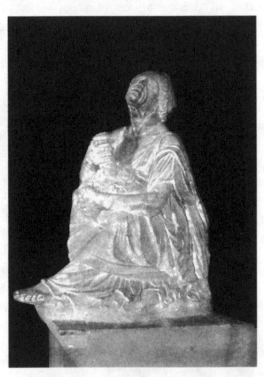

FIG. 179.—TIPSY OLD WOMAN. Rome, Capitoline Museum.

worthy of the best time. The arms are modern, and their direction may not be quite correct, though it must be nearly so. This original bronze figure represents a boy in an attitude of prayer. It is impossible to decide whether the statue was votive or is simply a *genre* piece.

Hellenistic art struck out a new path in a class of reliefs of which Figs. 181 and 182 are examples. There are some restorations. A gulf separates these works

from the friezes of the Parthenon and the Mausoleum. Whereas relief-sculpture in the classical period abjured backgrounds and picturesque accessories, we find here a highly pictorial treatment. The subjects moreover are, in the instances chosen, of a character to which

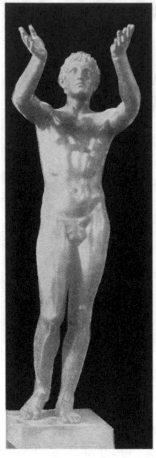

Greek sculpture before Alexander's time hardly offers a parallel (yet *cf.* Fig. 87). In Fig. 181 we see a ewe giving suck to her lamb. Above, at the right, is a hut or stall, from whose open door a dog is just coming out ; at the left is an oak tree. In Fig. 182 a lioness crouches with her two cubs. Above is a sycamore tree, and to the right of it a group of objects which tell of the rustic worship of Bacchus. Each of the two reliefs decorated a fountain or something of the sort. In the one the overturned milk-jar served as a water-spout ; in the other the open mouth of one of the cubs answered the same purpose. Generally speaking, the pictorial reliefs seem to have been used for the interior decoration of private and public buildings.

FIG. 180.—PRAYING BOY. Berlin. By their subjects many of them bear witness to that love of country life and that feeling for the charms of landscape which are the most attractive traits of the Hellenistic period.

The kingdom of Pergamum in western Asia Minor was one of the smaller states formed out of Alexander's dominions. The city of Pergamum became a center of Greek learning second only to Alexandria in importance. Moreover, under Attalus I. (241-197 B. C.) and Eumenes II. (197-159 B. C.) it developed an independent and powerful school of sculpture, of whose productions we fortunately possess numerous examples. The most famous of these is the Dying Gaul or Galatian (Fig. 183), once erroneously called the Dying Gladiator. Hordes of Gauls had invaded Asia Minor as early as 278 B. C., and, making their head-quarters in the interior, in the district afterwards known from them as Galatia, had become the terror and the scourge of the whole region. Attalus I. early in his reign gained an important victory over these fierce tribes, and this victory was commemorated by extensive groups of sculpture both at Pergamum and at Athens. The figure of the Dying Gaul belongs to this series. The statue

FIG. 181.—HELLENISTIC RELIEF. Vienna.

was in the possession of Cardinal Ludovisi as early as 1633, along with a group closely allied in style, representing a Gaul and his wife, but nothing is certainly known as to the time and place of its discovery. The restorations are said to be : the tip of the nose, the left knee-pan, the toes, and the part of the plinth on which the right arm rests,* together with the objects on it.

FIG. 182.—HELLENISTIC RELIEF. Vienna.

That the man represented is not a Greek is evident from the large hands and feet, the coarse skin, the un-Greek character of the head (Fig. 184). That he is a Gaul is proved by several points of agreement with what is known from literary sources of the Gallic peculiarities—the moustache worn with shaven cheeks and chin, the stiff, pomaded hair growing low in the neck, the twisted collar or torque. He has been mortally wounded in battle—the wound is on the right side—and sinks with drooping head upon his shield and broken battle-horn. His death-struggle, though clearly marked, is not made

* Helbig, " Guide to the Public Collections of Classical Antiquities in Rome," Vol. I., No. 533.

violent or repulsive. With savage heroism he "consents to death, and conquers agony."* Here, then, a powerful realism is united to a tragic idea, and amid all vicissitudes of taste this work has never ceased to command a profound admiration.

Our knowledge of Pergamene art has favorably received a great extension in consequence of excavations

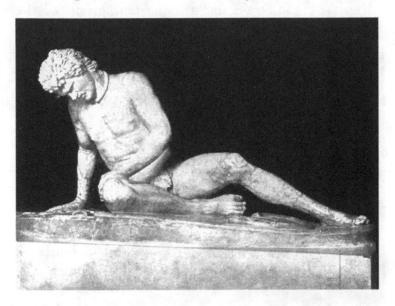

FIG. 183.—DYING GAUL. Rome, Capitoline Museum.

carried on in 1878-86 upon the acropolis of Pergamum in the interest of the Royal Museum of Berlin. Here were found the remains of numerous buildings, including an immense altar, or rather altar-platform, which was perhaps the structure referred to in Revelation II. 13, as "Satan's throne." This platform, a work of great architectural magnificence, was built under Eumenes II. Its exterior was decorated with a sculptured frieze, 7½

* Byron, "Childe Harold," IV., 140.

feet in height and something like 400 feet in total length. The fragments of this great frieze which were found in the course of the German excavations have been pieced together with infinite patience and ingenuity and amount to by far the greater part of the whole. The subject is the *gigantomachy*, *i. e.*, the battle between the gods and the rebellious sons of earth (*cf.* page 134).

Fig. 185 shows the most important group of the whole composition. Here Zeus, recognizable by the

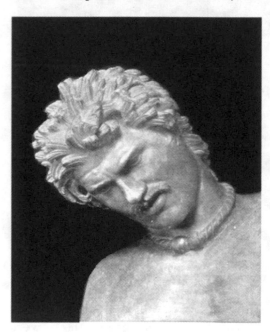

FIG. 184.—HEAD OF DYING GAUL.

thunderbolt in his outstretched right hand and the ægis upon his left arm, is pitted against three antagonists. Two of the three are already disabled. The one at the left, a youthful giant of human form, has sunk to earth, pierced through the left thigh with a huge, flaming thunderbolt. The second, also youthful and human, has fallen upon his knees in front of Zeus and presses his left hand convulsively to a wound (?) in his right shoulder. The third still fights desperately. This is a bearded giant, with animal ears and with legs that pass into long snaky bodies. Around his left arm is wrapped

the skin of some animal ; with his right hand (now missing) he is about to hurl some missile ; the left snake, whose head may be seen just above the giant's left shoulder, is contending, but in vain, with an eagle, the bird of Zeus.

Fig. 186 adjoins Fig 185 on the right of the latter.* Here we have a group in which Athena is the central figure. The goddess, grasping her antagonist by the

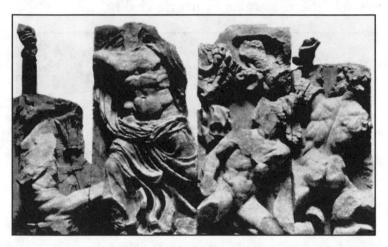

FIG. 185.—GROUP FROM THE ALTAR OF PERGAMUM. Berlin.

hair, sweeps to right. The youthful giant has great wings, but is otherwise purely human in form. A serpent, attendant of Athena, strikes its fangs into the giant's right breast. In front of Athena, the Earth-goddess, mother of the giants, half emerging from the ground, pleads for mercy. Above, Victory wings her way to the scene to place a crown upon Athena's head.

If we compare the Pergamene altar-frieze with scenes of combat from the best period of Greek art, say with

* Fig. 186 is more reduced in scale, so that the slabs incorrectly appear to be of unequal height.

the metopes of the Parthenon or the best preserved frieze of the Mausoleum, we see how much more complicated and confused in composition and how much more violent in spirit is this later work. Yet, though we miss the "noble simplicity" of the great age, we cannot fail to be impressed with the Titanic energy which surges through this stupendous composition. The "decline" of Greek art, if we are to use that term, cannot be taken to imply the exhaustion of artistic vitality.

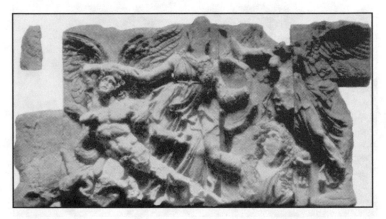

FIG. 186.—GROUP FROM THE ALTAR OF PERGAMUM. Berlin.

The existence of a flourishing school of sculpture at Rhodes during the Hellenistic period is attested by our literary sources, as well as by artists' inscriptions found on the spot. Of the actual productions of that school we possess only the group of Laocoön and his sons (Fig. 187). This was found in Rome in 1506, on the site of the palace of Titus. The principal modern parts were: the right arm of Laocoön with the adjacent parts of the snake, the right arm of the younger son with the coil of the snake around it, and the right hand and wrist of the older son. The restorations have since been removed; the right arm of Laocoön is bent as it was meant to be, and

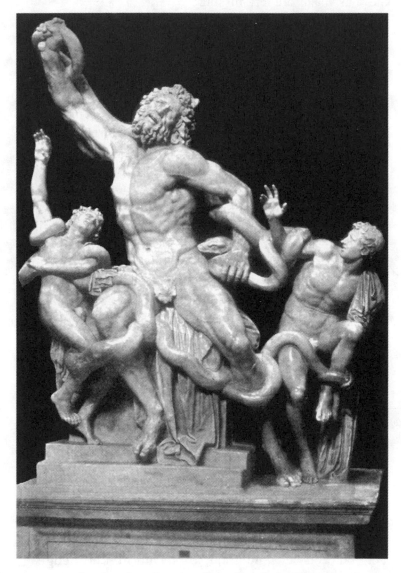

FIG. 187. — LAOCOÖN AND HIS SONS. Rome, Vatican Museum.

the sons' hands are left missing.

Laocoön was a Trojan priest who, having committed grievous sin, was visited with a fearful punishment. On a certain occasion when he was engaged with his two sons in performing sacrifice, they were attacked by a pair of huge serpents, miraculously sent, and died a miserable death. The sculptors—for the group, according to Pliny, was the joint work of three Rhodian artists—have put before us the moving spectacle of this doom. Laocoön, his body convulsed and his face distorted by the torture of poison, his mouth open for a groan or a cry, has sunk upon the altar and struggles in the agony of death. The younger son is already past resistance ; his left hand lies feebly on the head of the snake that bites him and the last breath escapes his lips. The older son, not yet bitten, but probably not destined to escape, strives to free himself from the coil about his ankle and at the same time looks with sympathetic horror upon his father's sufferings.

No work of sculpture of ancient or modern times has given rise to such an extensive literature as the Laocoön. None has been more lauded and more blamed. Hawthorne "felt the Laocoön very powerfully, though very quietly ; an immortal agony, with a strange calmness diffused through it, so that it resembles the vast rage of the sea, calm on account of its immensity."* Ruskin, on the other hand, thinks "that no group has exercised so pernicious an influence on art as this ; a subject ill chosen, meanly conceived, and unnaturally treated, recommended to imitation by subtleties of execution and accumulation of technical knowledge."†

* " Italian Note-books," under date of March 10, 1858.

† " Modern Painters," Part II, § II, Chap. III.

Of the two verdicts the latter is surely much nearer the truth. The calmness which Hawthorne thought he saw in the Laocoön is not there ; there is only a terrible torment. Battle, wounds, and death were staple themes of Greek sculpture from first to last ; but nowhere else is the representation of physical suffering, pure and simple, so forced upon us, so made the "be-all and end-all" of a Greek work. As for the date of the group, opinion still varies considerably. The probabilities seem to point to a date not far removed from that of the Pergamene altar, but slightly later, circa the first century A.D.

Macedonia and Greece became a Roman province in 146 B. C. ; the kingdom of Pergamum in 133 B. C. These political changes, it is true, made no immediate difference to the cause of art. Greek sculpture went on, presently transferring its chief seat to Rome, as the most favorable place of patronage. What is called Roman sculpture is, for the most part, simply Greek sculpture under Roman rule. But in the Roman period we find no great, creative epoch of art history ; moreover, the tendencies of the times have already received considerable illustration. At this point, therefore, we may break off this sketch.

CHAPTER 11

Greek Painting

THE art of painting was in as high esteem in Greece as the art of sculpture and, if we may believe the testimony of Greek and Roman writers, achieved results as important and admirable. But the works of the great Greek painters have utterly perished, and imagination, though guided by ancient descriptions and by such painted designs as have come down to us, can restore them but dimly and doubtfully. The subject may therefore here be dismissed with comparative brevity.

In default of pictures by the great Greek masters, an especial interest attaches to the work of humbler craftsmen of the brush. One class of such work exists in abundance—the painted decorations upon earthenware vases. Tens of thousands of these vases have been brought to light from tombs and sanctuaries on Greek and Italian sites and the number is constantly increasing. Thanks to the indestructible character of pottery, the designs are often intact. Now the materials and methods employed by the vase-painters and the spaces at their disposal were very different from those of mural or easel paintings. Consequently inferences must not be hastily drawn from designs upon vases as to the composition and coloring of the great masterpieces. But the best of the vase-painters, especially in the early fifth century, were men of remarkable talent, and all of them were influenced by the general artistic tendencies of their respective periods. Their work, therefore, con-

tributes an important element to our knowledge of Greek art history.

Having touched in Chapter II. upon the earlier styles

FIG. 188.—THE FRANÇOIS VASE. Florence, Archæological Museum.

of Greek pottery, I begin here with a vase of Attic manufacture, decorated, as an inscription on it shows, by Clitias, but commonly called from its finder the François vase (Fig. 188). It may be assigned to the

first half of the sixth century, and probably to somewhere near the beginning of that period. It is an early specimen of the class of black-figured vases, as they are called. The propriety of the name is obvious from the illustration. The objects represented were painted in black varnish upon the reddish clay, and the vase was then fired. Subsequently anatomical details, patterns of garments, and so on were indicated by means of lines cut through the varnish with a sharp instrument. Moreover, the exposed parts of the female figures—faces, hands, arms, and feet—were covered with white paint, this being the regular method in the black-figured style of distinguishing the flesh of female from that of male figures.

The decoration of the François vase is arranged in horizontal bands or zones. The subjects are almost

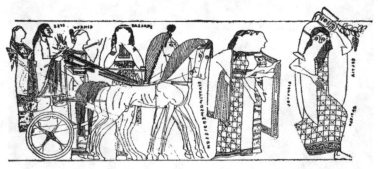

Fig. 189.—Detail from the François Vase.

wholly legendary and the vase is therefore a perfect mine of information for the student of Greek mythology. Our present interest, however, is rather in the character of the drawing. This may be better judged from Fig. 189, which is taken from the zone encircling the middle of the vase. The subject is the wedding of the mortal, Peleus, to the sea-goddess, Thetis, the wedding whose

issue was Achilles, the great hero of the Iliad. To this
ceremony came gods and goddesses and other super-
natural beings. Our illustration shows Dionysus (Bac-
chus), god of wine, with a wine-jar on his shoulder and
what is meant for a vine-branch above him. Behind him
walk three female figures, who are the personified
Seasons. Last comes a group consisting of two Muses
and a four-horse chariot bearing Zeus, the chief of the
gods, and Hera, his wife. The principle of *isocephaly*
is observed on the vase as in a frieze of relief-sculpture
(page 145). The figures are almost all drawn in profile,
though the body is often shown more nearly from the
front, *e. g.*, in the case of the Seasons, and the eyes are
always drawn as in front view. Out of the great multi-
tude of figures on the vase there are only four in which
the artist has shown the full face. Two of these are
intentionally ugly Gorgons on the handles ; the two
others come within the limits of our specimen illustra-
tion. If Dionysus here appears almost like a caricature,
that is only because the decorator is so little accustomed
to drawing the face in front view. There are other
interesting analogies between the designs on the vase
and contemporary reliefs. For example, the bodies,
when not disguised by garments, show an unnatural
smallness at the waist, the feet of walking figures are
planted flat on the ground, and there are cases in which
the body and neck are so twisted that the face is turned
in exactly the opposite direction to the feet. On the
whole, Clitias shows rather more skill than a contempo-
rary sculptor, probably because of the two arts that of
the vase-painter had been the longer cultivated.

The black-figured ware continued to be produced in
Attica through the sixth century and on into the fifth.
Fig. 190 gives a specimen of the work of an interesting

vase-painter in this style, Execias by name, who probably belongs about the middle of the sixth century. The subject is Achilles slaying in battle the Amazon queen, Penthesilea. The drawing of Execias is distinguished by an altogether unusual care and minuteness of detail, and if the whole body of his work, as known to

FIG. 190.—DESIGN FROM AN AMPHORA OF EXECIAS. London, British Museum.

us from several signed vases, could be here presented, it would be easily seen that his proficiency was well in advance of that of Clitias. Obvious archaisms, however, remain. Especially noticeable is the unnatural twisting of the bodies. A minor point of interest is afforded by the Amazon's shield, which the artist has not succeeded in rendering truthfully in side view.

That is a rather difficult problem in perspective, which was not solved until after many experiments.

Some time before the end of the sixth century, perhaps as early as 540, a new method of decorating pottery was invented in Attica. The principal coloring matter used continued to be the lustrous black varnish ; but instead of filling in the outlines of the figures with black, the decorator, after outlining the figures by means of a broad stroke of the brush, covered with black the spaces between the figures, leaving the figures themselves in the color of the clay. Vases thus decorated are called ''red-figured.'' In this style incised lines ceased to be used, and details were rendered chiefly by means of the black varnish or, for certain purposes, of the same material diluted till it became of a reddish hue. The red-figured and black-figured styles coexisted for perhaps half a century, but the new style ultimately drove the old one out of the market.

The development of the new style was achieved by men of talent, several of whom fairly deserve to be called artists. Such an one was Euphronius, whose long career as a potter covered some fifty years, beginning at the beginning of the fifth century or a little earlier. Fig. 191 gives the design upon the outside of a *cylix* (a broad, shallow cup, shaped like a large saucer, with two handles and a foot), which bears his signature. Its date is about 480, and it is thus approximately contemporary with the latest of the archaic statues of the Athenian Acropolis (pages 151 *f.*). On one side we have one of the old stock subjects of the vase-painters, treated with unapproached vivacity and humor. Among the labors of Heracles, imposed upon him by his taskmaster, Eurystheus, was the capturing of a certain destructive wild boar of Arcadia and the bringing of the

creature alive to Mycenæ. In the picture, Heracles is returning with the squealing boar on his shoulder. The cowardly Eurystheus has taken refuge in a huge earthenware jar sunk in the ground, but Heracles, pretending to be unaware of this fact, makes as though he would deposit his burden in the jar. The agitated man and

Fig. 191.—Design from a Cylix of Euphronius. London, British Museum.

woman to the right are probably the father and mother of Eurystheus. The scene on the other side of the *cylix* is supposed to illustrate an incident of the Trojan War : two warriors, starting out on an expedition, are met and stopped by the god Hermes. In each design

the workmanship, which was necessarily rapid, is marvelously precise and firm, and the attitudes are varied and telling. Euphronius belonged to a generation which was making great progress in the knowledge of anatomy and in the ability to pose figures naturally and

FIG. 192.—CYLIX. London, British Museum.

expressively. It is interesting to note how close is the similarity in the method of treating drapery between the vases of this period and contemporary sculpture.

The *cylix* shown in Fig. 192 is somewhat later, dating from about 460. The technique is here different from that just described, inasmuch as the design is painted in reddish brown upon a white ground. The subject is the goddess Aphrodite, riding upon a goose. The painter, some unnamed younger contemporary of

Euphronius, has learned a freer manner of drawing. He gives to the eye in profile its proper form, and to the drapery a simple and natural fall. The subject does not call, like the last, for dramatic vigor, and the pre-eminent quality of the work is an exquisite purity and refinement of spirit.

If we turn now from the humble art of vase-decoration to painting in the higher sense of the term, the first eminent name to meet us is that of Polygnotus, who was born on the island of Thasos near the Thracian coast. His artistic career, or at least the later part of it, fell in the "Transitional period" (480–450 B. C.), so that he was a contemporary of the great sculptor Myron. He came to Athens at some unknown date after the Persian invasion of Greece (480 B. C.) and there executed a number of important paintings. In fact, he is said to have received Athenian citizenship. He worked also at Delphi and at other places, after the ordinary manner of artists.

Painting in this period, as practiced by Polygnotus and other great artists, was chiefly mural ; the painting of easel pictures seems to have been of quite secondary consequence. Thus the most famous works of Poly-gnotus adorned the inner faces of the walls of temples and stoas. The subjects of these great mural paintings were chiefly mythological. For example, the two com-positions of Polygnotus at Delphi, of which we possess an extremely detailed account in the pages of Pausanias, depicted the sack of Troy and the descent of Odysseus into Hades. But it is worth remarking, in view of the extreme rarity of historical subjects in Greek relief-sculpture, that in the Stoa Poicilê (Painted Portico) of Athens, alongside of a Sack of Troy by Polygnotus and a Battle of Greeks and Amazons by his contemporary,

Micon, there were two historical scenes, a Battle of
Marathon and a Battle of Œnoê. In fact, historical
battle-pieces were not rare among the Greeks at any
period.

As regards the style of Polygnotus we can glean a
few interesting facts from our ancient authorities. His
figures were not ranged on a single line, as in contem-
porary bas-reliefs, but were placed at varying heights,
so as to produce a somewhat complex composition.
His palette contained only four colors, black, white,
yellow, and red, but by mixing these he was enabled to
secure a somewhat greater variety. He laid his colors
on in ''flat'' tints, just as the Egyptian decorators did,
making no attempt to render the gradations of color due
to varying light and shade. His pictures were therefore
rather colored drawings than genuine paintings, in our
sense of the term. He often inscribed beside his figures
their names, according to a common practice of the
time. Yet this must not be taken as implying that he
was unable to characterize his figures by purely artistic
means. On the contrary, Polygnotus was preëminently
skilled in expressing character, and it is recorded that
he drew the face with a freedom which archaic art had
not attained. In all probability his pictures are not to
be thought of as having any depth of perspective ; that
is to say, although he did not fail to suggest the nature
of the ground on which his figures stood and the objects
adjacent to them, it is not likely that he represented his
figures at varying distances from the spectator or gave
them a regular background.

It is clear that Polygnotus was gifted with artistic
genius of the first rank and that he exercised a powerful
influence upon contemporaries and successors. Yet,
alas ! in spite of all research and speculation, our

knowledge of his work remains very shadowy. A single drawing from his hand would be worth more than all that has ever been written about him. But if one would like to dream what his art was like, one may imagine it as combining with the dramatic power of Euphronius and the exquisite loveliness of the Aphrodite cup, Giotto's elevation of feeling and Michael Angelo's profundity of thought.

Another branch of painting which began to attain importance in the time of Polygnotus was scene-painting for theatrical performances. It may be, as has been conjectured, that the impulse toward a style of work in which a greater degree of illusion was aimed at and secured came from this branch of the art. We read, at any rate, that one Agatharchus, a scene-painter who flourished about the middle of the fifth century, wrote a treatise which stimulated two philosophers to an investigation of the laws of perspective.

The most important technical advance, however, is attributed to Apollodorus of Athens, a painter of easel pictures. He departed from the old method of coloring in flat tints and introduced the practice of grading colors according to the play of light and shade. How successfully he managed this innovation we have no means of knowing ; probably very imperfectly. But the step was of the utmost significance. It meant the abandonment of mere colored drawing and the creation of the genuine art of painting.

Two artists of the highest distinction now appear upon the scene. They are Zeuxis and Parrhasius. The rather vague remark of a Roman writer, that they both lived "about the time of the Peloponnesian War" (431–404 B. C.) is as definite a statement as can safely be made about their date. Parrhasius was born at

Ephesus, Zeuxis at some one or other of the numerous cities named Heraclea. Both traveled freely from place to place, after the usual fashion of Greek artists, and both naturally made their home for a time in Athens. Zeuxis availed himself of the innovation of Apollodorus and probably carried it farther. Indeed, he is credited by one Roman writer with being the founder of the new method. The strength of Parrhasius is said to have lain in subtlety of line, which would suggest that with him, as with Polygnotus, painting was essentially outline drawing. Yet he too can hardly have remained unaffected by the new *chiaroscuro*.

Easel pictures now assumed a relative importance which they had not had a generation earlier. Some of these were placed in temples and such conformed in their subjects to the requirements of religious art, as understood in Greece. But many of the easel pictures by Zeuxis and his contemporaries can hardly have had any other destination than the private houses of wealthy connoisseurs. Moreover, we hear first in this period of mural painting as applied to domestic interiors. Alcibiades is said to have imprisoned a reluctant painter, Agatharchus (*cf.* page 278), in his house and to have forced him to decorate the walls. The result of this sort of private demand was what we have seen taking place a hundred years later in the case of sculpture, viz.: that artists became free to employ their talents on any subjects which would gratify the taste of patrons. For example, a painting by Zeuxis of which Lucian has left us a description illustrates what may be called mythological *genre*. It represented a female Centaur giving suck to two offspring, with the father of the family in the background, amusing himself by swinging a lion's whelp above his head to scare his young. This was, no

doubt, admirable in its way, and it would be narrow-minded to disparage it because it did not stand on the ethical level of Polygnotus's work. But painters did not always keep within the limits of what is innocent. No longer restrained by the conditions of monumental and religious art, they began to pander not merely to what is frivolous, but to what is vile in human nature. The great Parrhasius is reported by Pliny to have painted licentious little pictures, ''refreshing himself'' (says the writer) by this means after more serious labors. Thus at the same time that painting was making great technical advances, its nobility of purpose was on the average declining.

Timanthes seems to have been a younger contemporary of Zeuxis and Parrhasius. Perhaps his career fell chiefly after 400 B. C. The painting of his of which we hear the most represented the sacrifice of Iphigenia at Aulis. The one point about the picture to which all our accounts refer is the grief exhibited in varying degrees by the bystanders. The countenance of Calchas was sorrowful ; that of Ulysses still more so ; that of Menelaus displayed an intensity of distress which the painter could not outdo ; Agamemnon, therefore, was represented with his face covered by his mantle, his attitude alone suggesting the father's poignant anguish. The description is interesting as illustrating the attention paid in this period to the expression of emotion. Timanthes was in spirit akin to Scopas. There is a Pompeian wall-painting of the sacrifice of Iphigenia, which represents Agamemnon with veiled head and which may be regarded, in that particular at least, as a remote echo of Timanthes's famous picture.

Sicyon, in the northeastern part of Peloponnesus—a city already referred to as the home of the sculptor

Lysippus—was the seat of an important school of paint-
ing in the fourth century. Toward the middle of the
century the leading teacher of the art in that place was
one Pamphilus. He secured the introduction of draw-
ing into the elementary schools of Sicyon, and this new
branch of education was gradually adopted in other
Greek communities. A pupil of his, Pausias by name,
is credited with raising the process of encaustic painting
to a prominence which it had not enjoyed before. In
this process the colors, mixed with wax, were applied to
a wooden panel and then burned in by means of a hot
iron held near.

Thebes also, which attained to a short-lived impor-
tance in the political world after the battle of Leuctra
(371 B. C.), developed a school of painting, which
seems to have been in close touch with that of Athens.
There were painters besides, who seem to have had no
connection with any one of these centers of activity.
The fourth century was the Golden Age of Greek
painting, and the list of eminent names is as long and
as distinguished for painting as for sculpture.

The most famous of all was Apelles. He was a Greek
of Asia Minor and received his early training at Ephe-
sus. He then betook himself to Sicyon, in order to
profit by the instruction of Pamphilus and by associa-
tion with the other painters gathered there. It seems
likely that his next move was to Pella, the capital of
Macedon, then ruled over by Philip, the father of Alex-
ander. At any rate, he entered into intimate relations
with the young prince and painted numerous portraits
of both father and son. Indeed, according to an often
repeated story, Alexander, probably after his accession
to the throne, conferred upon Apelles the exclusive
privilege of painting his portrait, as upon Lysippus the

exclusive privilege of representing him in bronze. Later, presumably when Alexander started on his eastern campaigns (334 B. C.), Apelles returned to Asia Minor, but of course not even then to lead a settled life. He outlived Alexander, but we do not know by how much.

Of his many portraits of the great conqueror four are specifically mentioned by our authorities. One of these represented the king as holding a thunderbolt, *i. e.*, in the guise of Zeus—a fine piece of flattery. For this picture, which was placed in the Temple of Artemis at Ephesus, he is reported, though not on very good authority, to have received twenty talents in gold coin. It is impossible to make exact comparisons between ancient and modern prices, but the sum named would perhaps be in purchasing power as large as any modern painter ever received for a work of similar size.* It has been mentioned above that Apelles made a number of portraits of King Philip. He had also many sitters among the generals and associates of Alexander ; and he left at least one picture of himself. His portraits were famous for their truth of likeness, as we should expect of a great painter in this age.

An allegorical painting by Apelles of Slander and Her Crew is interesting as an example of a class of works to which Lysippus's statue of Opportunity belonged (page 239). This picture contained ten figures, whereas most of his others of which we have any description contained only one figure each.

His most famous work was an Aphrodite, originally placed in the Temple of Asclepius on the island of Cos. The goddess was represented, according to the Greek

* Nicias, an Athenian painter and a contemporary of Apelles, is reported to have been offered by Ptolemy, the ruler of Egypt, *sixty* talents for a picture and to have refused the offer.

myth of her birth, as rising from the sea, the upper part of her person being alone distinctly visible. The picture, from all that we can learn of it, seems to have been imbued with the same spirit of refinement and grace as Praxiteles's statue of Aphrodite in the neighboring city of Cnidus. The Coans, after cherishing it for three hundred years, were forced to surrender it to the emperor Augustus for a price of a hundred talents, and it was removed to the Temple of Julius Cæsar in Rome. By the time of Nero it had become so much injured that it had to be replaced by a copy.

Protogenes was another painter whom even the slightest sketch cannot afford to pass over in silence. He was born at Caunus in southwestern Asia Minor and flourished about the same time as Apelles. We read of his conversing with the philosopher Aristotle (died 322 B. C.), of whose mother he painted a portrait, and of his being engaged on his most famous work, a picture of a Rhodian hero, at the time of the siege of Rhodes by Demetrius (304 B. C.). He was an extremely painstaking artist, inclined to excessive elaboration in his work. Apelles, who is always represented as of amiable and generous character, is reported as saying that Protogenes was his equal or superior in every point but one, the one inferiority of Protogenes being that he did not know when to stop. According to another anecdote Apelles, while profoundly impressed by Protogenes's masterpiece, the Rhodian hero above referred to, pronounced it lacking in that quality of grace which was his own most eminent merit.* There are still other anecdotes, which give an entertaining idea of the friendly rivalry between these two masters, but which do not help us much in imagining their artistic qualities.

* Plutarch, " Life of Demetrius," § 22.

As regards technique, it seems likely that both of them practiced principally "tempera" painting, in which the colors are mixed with yolk of eggs or some other sticky non-unctuous medium.* Both Apelles and Protogenes are said to have written technical treatises on the painter's art.

There being nothing extant which would properly illustrate the methods and the styles of the great artists in color, the best substitute that we have from about their period is an Etruscan sarcophagus, found near Corneto in 1869. The material is "alabaster or a marble closely resembling alabaster." It is ornamented on all four sides by paintings executed in tempera representing a battle of Greeks and Amazons. "In the flesh tints the difference of the sexes is strongly marked, . . . the flesh of the fighting Greeks being a tawny red, while that of the Amazons is very fair. For each sex two tints only are used in the shading and modeling of the flesh. . . . Hair and eyes are for the most part a purplish brown; garments mainly reddish brown, whitish grey, or pale lilac and light blue. Horses are uniformly a greyish white, shaded with a fuller tint of grey; their eyes always blue. There are two colors of metal, light blue for swords, spear-heads, and the inner faces of shields, golden yellow for helmets, greaves, reins, and handles of shields, girdles, and chain ornaments."

Our illustration (Fig. 193) is taken from the middle of one of the long sides of the sarcophagus. It represents a mounted Amazon in front of a fully armed foot-soldier, upon whom she turns to deliver a blow with her sword. "Every reader will be struck by the beauty and spirit of the Amazon, alike in her action and her

* Oil painting was unknown in ancient times.

facial expression. The type of head, broad, bold, and powerful, and at the same time young and blooming, with the pathetic-indignant expression, is preserved with little falling off from the best age of Greek art. . . . In spirit and expression almost equal to the Amazon is the horse she bestrides.''* The Greek warrior is also admirable in attitude and expression, full of energy and determination.

Although the paintings of this sarcophagus were

FIG. 193.—DETAIL FROM A PAINTED SARCOPHAGUS. Florence, Archæological Museum.

doubtless executed in Etruria, and probably by an Etruscan hand, they are in their style almost purely Greek. The work is assigned to the earlier half of the third century B. C. If an unknown craftsman was stimulated by Greek models to the production of paintings of such beauty and power, how magnificent must have been the achievements of the great masters of the brush!

*The quotations are from an article by Mr. Sidney Colvin in *The Journal of Hellenic Studies*, Vol. IV., pages 354 *ff*.

For examples of Greek portrait painting we are indebted to Egypt, that country whose climate has preserved so much that elsewhere would have perished. It will be remembered that Egypt, having been conquered by Alexander, fell after his death to the lot of his general, Ptolemy, and continued to be ruled by Ptolemy's descendants until, in 30 B.C., it became a Roman province. During the period of Macedonian rule Alexandria was the chief center of Greek culture in the world, and Greeks and Greek civilization became established also in the interior of the country; nor did these Hellenizing influences abate under Roman domination. To this late period, when Greek and Egyptian customs were largely amalgamated, belongs a class of portrait heads which have been found in the Fayyum,

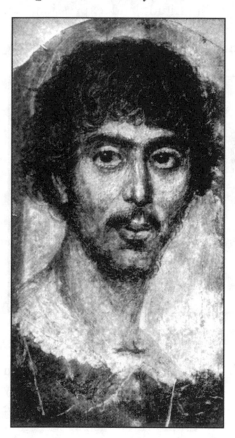

FIG. 194.—PORTRAIT OF A MAN, FROM THE FAYYUM.

around the turn of the 20TH century. They are painted on panels of wood (or rarely on canvas), and were originally attached to mummies. The embalmed body was

carefully wrapped in linen bandages and the portrait placed over the face and secured in position. These pictures are executed principally by the encaustic process, though some use was made also of tempera. The persons represented appear to be of various races— Greek, Egyptian, Hebrew, and mixed; perhaps the Greek type predominates in the specimens now known. At any rate, the artistic methods of the portraits seem to be purely Greek. As for their date, it is the prevailing opinion that they belong to the second century after Christ and later, though an attempt has been made to carry the best of them back to the second century B.C.

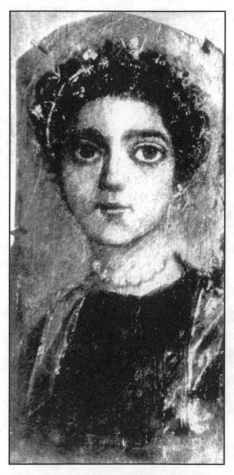

Fig. 195.—Portrait of a Girl, from the Fayyum.

The finest collection of these portraits is one acquired by a Viennese merchant, Herr Theodor Graf. They differ widely in artistic merit; our illustrations show three of the best. Fig. 194 is a man in middle life,

with irregular features, abundant, waving hair, and thin, straggling beard. One who has seen Watts's picture of "The Prodigal Son" may remark in the lower part of

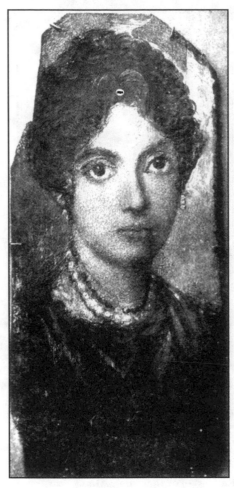

Fig. 196.—Portrait of a Young Woman, from the Fayyum.

this face a likeness to that. Fig. 195 is a charming girl, wearing a golden wreath of ivy-leaves about her hair and a string of great pearls about her neck. Her dark eyes look strangely large, as do those of all the women of the series ; probably the effect of eyes naturally large was heightened, as nowadays in Egypt, by the practice of blackening the edges of the eyelids. Fig. 196 is the most fascinating face of all, and it is artistically unsurpassed in the whole series. This and a portrait of an elderly man, not given here, are the masterpieces of the Graf collection. It is much too little to say of these two heads that they are the best examples of Greek painting that have come down to us. In spite of the great inferiority of the

encaustic technique to that of oil painting, these pictures are not unworthy of comparison with the great portraits of modern times.

The ancient wall-paintings found in and near Rome, but more especially in Pompeii, are also mostly Greek in character, so far as their best qualities are concerned. The best of them, while betraying deficient skill in perspective, show such merits in coloring, such power of expression and such talent for composition, as to afford to the student a lively enjoyment and to intensify tenfold his regret that Zeuxis and Parrhasius, Apelles and Protogenes, are and will remain to us nothing but names.

Knossos Palace. Crete.

INDEX.

REA's Problem Solvers

The "PROBLEM SOLVERS" are comprehensive supplemental text-books designed to save time in finding solutions to problems. Each "PROBLEM SOLVER" is the first of its kind ever produced in its field. It is the product of a massive effort to illustrate almost any imaginable problem in exceptional depth, detail, and clarity. Each problem is worked out in detail with a step-by-step solution, and the problems are arranged in order of complexity from elementary to advanced. Each book is fully indexed for locating problems rapidly.

ACCOUNTING
ADVANCED CALCULUS
ALGEBRA & TRIGONOMETRY
AUTOMATIC CONTROL
 SYSTEMS/ROBOTICS
BIOLOGY
BUSINESS, ACCOUNTING, & FINANCE
CALCULUS
CHEMISTRY
COMPLEX VARIABLES
DIFFERENTIAL EQUATIONS
ECONOMICS
ELECTRICAL MACHINES
ELECTRIC CIRCUITS
ELECTROMAGNETICS
ELECTRONIC COMMUNICATIONS
ELECTRONICS
FINITE & DISCRETE MATH
FLUID MECHANICS/DYNAMICS
GENETICS
GEOMETRY
HEAT TRANSFER

LINEAR ALGEBRA
MACHINE DESIGN
MATHEMATICS for ENGINEERS
MECHANICS
NUMERICAL ANALYSIS
OPERATIONS RESEARCH
OPTICS
ORGANIC CHEMISTRY
PHYSICAL CHEMISTRY
PHYSICS
PRE-CALCULUS
PROBABILITY
PSYCHOLOGY
STATISTICS
STRENGTH OF MATERIALS &
 MECHANICS OF SOLIDS
TECHNICAL DESIGN GRAPHICS
THERMODYNAMICS
TOPOLOGY
TRANSPORT PHENOMENA
VECTOR ANALYSIS

*If you would like more information about any of these books,
complete the coupon below and return it to us or visit your local bookstore.*

RESEARCH & EDUCATION ASSOCIATION
61 Ethel Road W. • Piscataway, New Jersey 08854
Phone: (732) 819-8880 **website: www.rea.com**

Please send me more information about your Problem Solver books

Name _____

Address _____

City _____ State _____ Zip _____